THE ART OF
ARTHUR BOYD

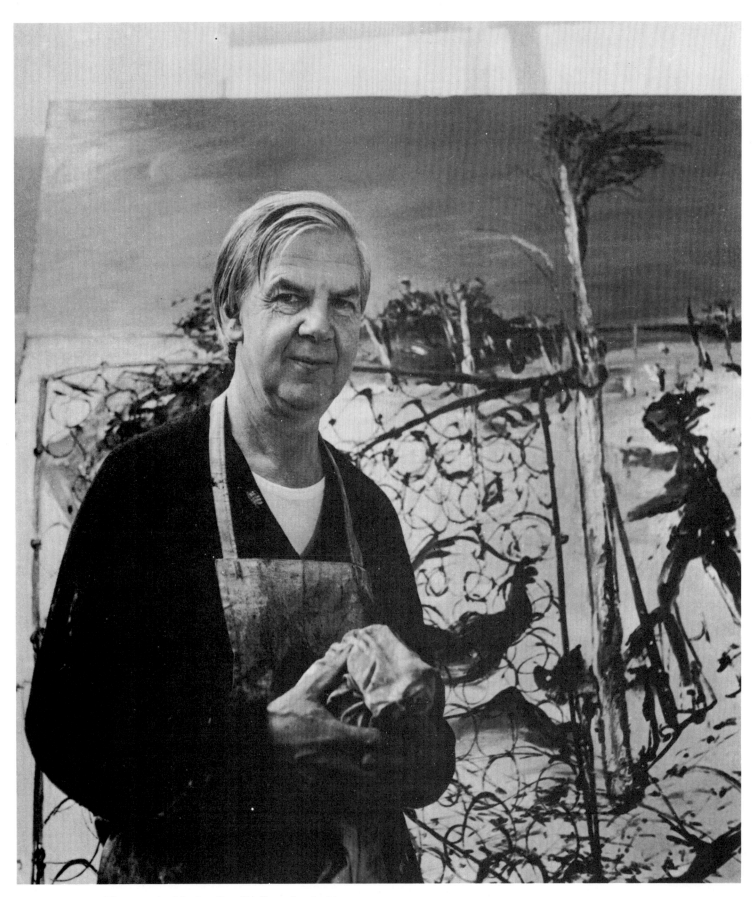

Photograph of Arthur Boyd by Jorge Lewinski

THE ART OF
ARTHUR BOYD

Ursula Hoff

With an Introduction by T. G. Rosenthal

ANDRE DEUTSCH

First published 1986 by
André Deutsch Limited
105 Great Russell Street
London WC1

Copyright © illustrations 1986 Arthur Boyd
Copyright © text 1986 Ursula Hoff
Copyright © introduction 1986 T. G. Rosenthal
All rights reserved

British Library Cataloguing in Publication Data

Hoff, Ursula
 The art of Arthur Boyd.
 1. Boyd, Arthur
 I. Title
 759.994 ND1105.B7

 ISBN 0–233–97824–0

Designed by Behram Kapadia

Printed in Hong Kong

CONTENTS

ACKNOWLEDGEMENTS

This publication has been assisted by the Visual Arts Board of the Australia Council and by the Myer Foundation, Melbourne.

The publishers, the artist and the author are grateful to all those museums, institutions and private collectors who have agreed to the reproduction of the works in their possession; to Thames & Hudson Ltd for permission to reproduce the twelve paintings from *Nebuchadnezzar* by T. S. R. Boase (Plates 83-94 in the present volume); and to the following, who kindly lent or supplied transparencies or photographs:

The Arts Council of Great Britain
The Art Gallery of New South Wales, Sydney
The Art Gallery of South Australia, Adelaide
The Australian National Gallery, Canberra
Bay Books, Sydney
Prudence Cuming Associates Ltd, London
Michael Dudley, Oxford
Fischer Fine Art Ltd, London
Val Forman, Melbourne
Information Service, Canberra
Henry Jolles, Melbourne
Matt Kelso, Canberra
McKenzie Gray and Associates, Melbourne
The National Gallery, London
The National Gallery of Victoria, Melbourne
The Photo Source–Keystone, London
Thames & Hudson Ltd, London
The University of Western Australia
Robert Walker, Sydney.

PREFACE

by Ursula Hoff

When in the early 1940s I came to live in Melbourne, and went in search of private galleries, I was depressed by the scarcity of art made in a contemporary idiom. In early youth I had come to love the work of Franz Marc, Paul Klee, Oskar Kokoschka and their contemporaries; from my years of residence in London in the thirties exhibitions of Cézanne, Picasso and the Surrealists remained in my memory. The tonal realism and belated Impressionism of many Melbourne painters looked distinctly old-fashioned. It is not surprising that, when it came, the work of the Contemporary Art Society had an explosive effect, since not only the subject matter but the very lines, masses and colours mirrored the wish to represent the intrinsic meaning of things rather than their surface appearance.

My first memory of Arthur Boyd's work dates from 1946 when *The Mockers* and *The Mourners* were on view in the Rowden White Library at Melbourne University. I met the painter himself soon afterwards; with my colleague Franz Philipp I paid a visit to the Boyds' home at Murrumbeena. This entailed a train journey to the eastern outskirts of Melbourne. After walking from the station through streets lined with conventional suburban bungalows behind neat front lawns we arrived at a garden densely overgrown with gnarled old pear and mulberry trees; behind these opened up what amounted to a picturesque artists' colony. Boyd's parents, Merric and Doris, inhabited the main house; Arthur and Yvonne were in the stylish modern studio built from designs by Robin Boyd; John Perceval and Mary occupied yet another house in the grounds. Cheerful small children played under the trees. Arthur introduced us to the mysteries of his egg tempera technique, the colours standing ready-mixed in pots among tins of clean brushes of all sizes. The domestic scene seemed to spill over into Boyd's and Perceval's Bruegelian paintings which filled the walls. Drawings appeared from overflowing boards and cupboards. Later we were taken to the Neerim Road pottery nearby, watched a pot being thrown on the wheel, fired pots with shining glaze being taken out of the kiln to be arrayed on high shelves and colourfully decorated tiles being assembled as table tops. This visit must have taken place in the late forties. It left such a vivid impression that to this day the Murrumbeena of my memory resembles the world landscapes of Pieter Bruegel

and I remain convinced that the blue waters of Port Phillip Bay could be seen from the Boyds' garden.

Some time early in 1958 when Arthur and Yvonne had moved to a new house at Beaumaris close to the beach where Charles Conder had painted his Ricketts Point, Arthur gave me a preview of the first paintings of the Bride series and the biographical details on which I based an article published by *Meanjin Quarterly* in 1959. Later that year the Boyds went to London to live. I continued to see all the exhibitions Arthur sent out to the Australian Galleries and some that came to the Adelaide Festival. A London resident since 1975, I had the opportunity to study Arthur's last three exhibitions at Fischer Fine Art Ltd.

My preparations for the present book were greatly assisted by a grant from the Myer Foundation in Melbourne which enabled me to see many pictures in private collections in New South Wales and Victoria, as well as to devote prolonged study to the large Boyd Gift at the Australian National Gallery in Canberra.

The monograph on Arthur Boyd by the late Franz Philipp published in 1967 has remained the definitive text to which all subsequent writings on this artist must be indebted. Philipp's perceptive analysis of Boyd's imaginative repertoire has laid the foundations for later interpretations and has been vindicated by Boyd's recent *oeuvre* which, unhappily, Philipp was not destined to see. His *catalogue raisonné* lists works made between 1934 and 1966.

The present monograph surveys the whole of the painter's output in selected examples. Like Philipp's book, it is a comment on Arthur Boyd's art rather than on his life and times. Extensive biographical notes include references to some works which could not be dealt with in the text. Publications used in preparation have been set out in the bibliography instead of being incorporated in footnotes. It has not been feasible to provide a *catalogue raisonné*.

I am under great obligation to Arthur and Yvonne Boyd for their unfailing assistance. Special thanks are due to Pat Fabian, to Helen and John Brack and June Philipp for helpful comments on the text and to Jocelyn Gray, Rowena Mitchell and Susan Johnston for secretarial aid. Grazia Gunn of the Australian National Gallery supervised the photographing and documentation of the many examples from the Boyd Gift included here. The following galleries have taken much trouble to provide information and to establish contact with private owners: the Australian Galleries, Melbourne: the (former) Brian Johnstone Galleries, Brisbane; the Rudy Komon Gallery, Sydney; the

Lister Gallery, Perth; in London, Fischer Fine Art Ltd and Tooth Painting Ltd.

Among the many people who shared with me their knowledge of the artist and his work were the following: Charles Blackman, Guy Boyd, David Boyd, Joseph Brown, David Chalker, Patricia Davies, Geoffrey Edwards, Gwen Frolich, June Helmer, Friedl Gardner, Dr Richard Haese, Professor Peter Herbst, Terence Lane, Alan McCulloch, Joyce McGrath, Max Nicholson, Dr June Philipp, Professor Margaret Plant, Peter Porter, Anne and Stuart Purves, Bryan Robertson, June M. Stewart, Emeritus Professor Bernard Smith, Elizabeth Summons, Irena Zdanowicz. To all these and others who have not been named, I extend my gratitude.

INTRODUCTION

by T. G. Rosenthal

'*Immature poets imitate ; mature poets steal.*'
T. S. ELIOT

If, after a quarter of a century's knowledge and friendship, I was suddenly faced with the name Arthur Boyd and asked to free-associate, my response would be simultaneously easy and far-ranging. Painter, sculptor, engraver, potter, draughtsman, Australian, thematic, obsessed, obsessive, prolific, versatile, compulsive, innovator, borrower, converter, student of the Bible, cunning observer of Old Masters, profligate of talent, voyeur, erotic, polymorphous and so on – ending, perhaps, with universal genius.

None of the above is wrong or even inappropriate, yet he is at once all of these and more. Boyd is both a prodigy and prodigious. He seems to have endless time to travel – and needs it because he will not fly. He is devoted to a large, sprawling family and, with justice, indulges in a fair amount of ancestor worship. (See family tree on page 14.) Yet, of all the artists I have known and studied, his *oeuvre* is the most massive and varied, though still consistent, in the history of twentieth century painting – with the obvious exception of Picasso, with whom there are indeed one or two parallels. A future art historian, charged with doing a *catalogue raisonné*, including the drawings, will have to work for more than a decade.

That some of Arthur Boyd's work is facile is inevitable ; so was much of Picasso's. But if one discounts the doodles, some of the sketches, the occasional redundant, repetitive reworking of a theme or an idea, there is still an *oeuvre* incomparable in post-1945 art in its richness and vitality, in the sheer abundance of square metres, in all media, covered with glowing paint and imagery.

If this Introduction is both allusive and anecdotal, although these characteristics have no literary virtue, they are at least appropriate to the subject.

Like many visual artists, Boyd is a diffident, indeed occasionally faintly inarticulate speaker, but let the patronizing beware. Behind that shy and gentle surface is what used to be called in academic circles an 'alpha plus mind'. Set a group of Sydney intellectuals or Hampstead literati in a roar at a crowded dinner table, let the pontifical pontificate for an hour or so until there is an accidental pause and, hitherto silent, Boyd will hesitantly utter a few sentences which reveal that he has seen through everyone else's pretensions and will come out

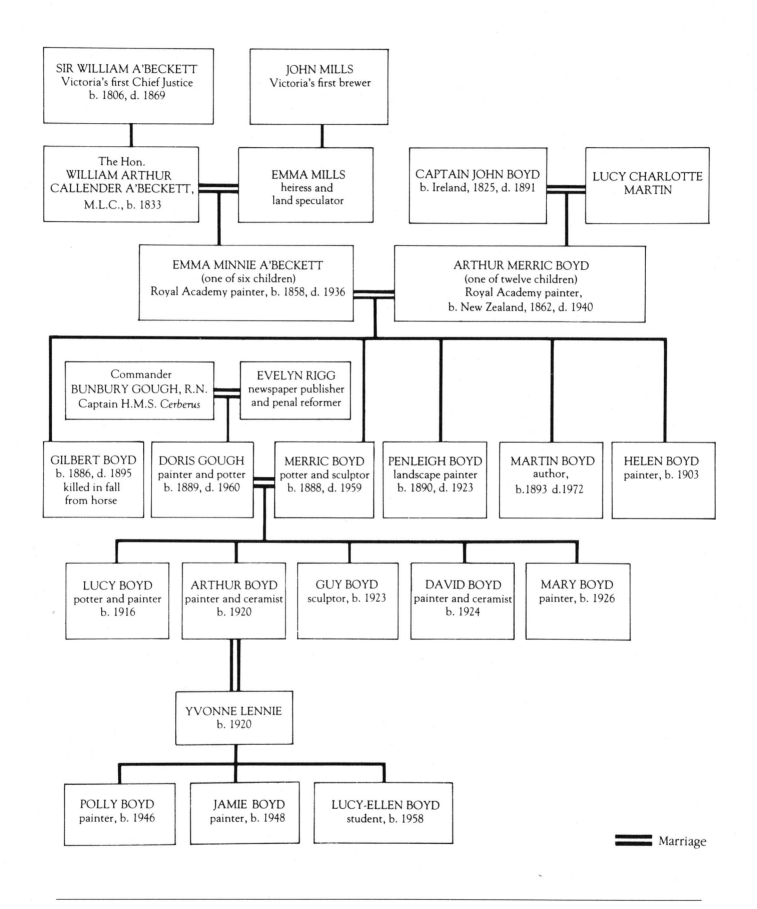

SIR WILLIAM A'BECKETT
Victoria's first Chief Justice
b. 1806, d. 1869

JOHN MILLS
Victoria's first brewer

The Hon.
WILLIAM ARTHUR
CALLENDER A'BECKETT,
M.L.C., b. 1833

EMMA MILLS
heiress and
land speculator

CAPTAIN JOHN BOYD
b. Ireland, 1825, d. 1891

LUCY CHARLOTTE
MARTIN

EMMA MINNIE A'BECKETT
(one of six children)
Royal Academy painter, b. 1858, d. 1936

ARTHUR MERRIC BOYD
(one of twelve children)
Royal Academy painter,
b. New Zealand, 1862, d. 1940

Commander
BUNBURY GOUGH, R.N.
Captain H.M.S. Cerberus

EVELYN RIGG
newspaper publisher
and penal reformer

GILBERT BOYD
b. 1886, d. 1895
killed in fall
from horse

DORIS GOUGH
painter and potter
b. 1889, d. 1960

MERRIC BOYD
potter and sculptor
b. 1888, d. 1959

PENLEIGH BOYD
landscape painter
b. 1890, d. 1923

MARTIN BOYD
author,
b.1893 d.1972

HELEN BOYD
painter, b. 1903

LUCY BOYD
potter and painter
b. 1916

ARTHUR BOYD
painter and ceramist
b. 1920

GUY BOYD
sculptor, b. 1923

DAVID BOYD
painter and ceramist
b. 1924

MARY BOYD
painter, b. 1926

YVONNE LENNIE
b. 1920

POLLY BOYD
painter, b. 1946

JAMIE BOYD
painter, b. 1948

LUCY-ELLEN BOYD
student, b. 1958

Marriage

with a handful of devastating truths that utterly silence the rest of the company.

And, as his brain is manifestly much quicker than most, so is his brush. We have all been pestered in European cafés by artists who, for the price of a meal, will execute an instant sketch of a child or a mistress and very bad they are. Arthur Boyd is that amazing creature, the one who can do an instant sketch with a person, mythological figure or landscape and, in a matter of hours, produce a large canvas, fully worked out and meticulously painted with all the intensity and attention to detail that another obsessive like, say, Francis Bacon, would spend weeks or even months on.

I have never been surprised by Boyd's interest in mythology; he works, despite the travel and the family and the veritable collection of houses in which he lives, as if the Furies themselves were driving him. He once asked me to sit for a portrait. I protested about lack of time, but was told an afternoon would suffice. Inevitably, a mixture of curiosity, vanity and friendship prevailed and, in his house in Hampstead, between lunch and dinner, a full-scale oil on board portrait emerged. Like, I suspect, most sitters, when I first saw it, I was not pleased. That was some twenty years or so ago and I have not seen it since, but I have not forgotten either the experience or the picture itself. It told me things about myself I did not know and perhaps did not want to know. Frankly, it terrified me. But it was a unique insight for me into the frenzied, concentrated energy of Arthur's intellect, vision and almost daemonic technical virtuosity; he had done in a few hours what even the two acknowledged giants of twentieth century portraiture, Oskar Kokoschka and Graham Sutherland, would have spent weeks on – and on which half their not inconsiderable reputations rests. Yet Arthur is relatively unknown as a portraitist. Portraiture is for him merely one of those things he finds it occasionally interesting to do. But let him loose for a year, with the sitters going to him at reasonable intervals, and he could achieve a one-man Australian national portrait gallery. As a portraitist he has that uncanny gift of painting, as it were, for the future.

Looking at his *Self-Portrait in Red Shirt* of 1937 (done when he was seventeen) and a photograph I took of him at the beginning of 1982, one sees the same face, weathered and tempered by the aging process, but the teenager's vision of the artist is acute, self-aware and prophetic. It explains why I was able to go up to a complete stranger at a party and say, to a fully-grown eighteen year old, that he was Matthew Perceval, simply because I had long admired a painting of the son of John

Arthur Boyd in 1982 (*photograph T. G. Rosenthal*)

Perceval and Arthur's sister Mary, done when the boy was about two years old. But in any assessment of Boyd's work his portraiture would probably be seen as only a minor diversion, so strong and varied is the rest of his career.

Eclecticism in the pursuit of art is no vice and imitation, or, better still, theft in Eliot's sense, is in Boyd's case at least, a cardinal virtue. Like many an artist growing up far away from the great galleries of Europe and America, much of his 'environmental' imagery as opposed to his 'inherited' talent must therefore have come from reproductions, mostly in monochrome, in art books. As far as his European influences are concerned, he had to be largely content with Malraux's 'museum without walls'. For his Australian heritage there were galleries enough and, for artistic training, there was his legendary family. While the National Gallery of Victoria has an impressive collection of European works, there was no London National Gallery a bus ride away, no Louvre, no Vienna until long after World War II and adulthood.

Thus, as he began to find his own authentic style after he had come to terms with the countryside around Melbourne and the legacy of Bunny, Conder, Roberts *et al.*, the already fully formed Australian landscape technique gradually became filled with foreign icons, icons which are all familiar images. They are familiar from the Bible, from mythology and from their most potent past manifestations, the

pictures that always get reproduced in art books and in slides at school.

I think that the potency of these images derives not only from their obvious aesthetic merit but also from their constant repetition during a human being's most impressive years. Franz Philipp in his pioneering monograph on Boyd (the standard work, even now, on the *oeuvre* up to 1966) has an acute analysis of *The Mockers*, clearly placing its genesis in Bruegel's great work in Vienna. While Philipp is surely right, it seems to me that this extraordinary painting done in 1945, when the artist was only twenty-five, is the great pointer to Boyd's future. Bruegel and the bush unite in a unique vision which is wholly Boyd's own.

Already the technical virtuosity is there in the handling of a literally crowded painting. The terrain is unmistakably native Australian. The theme and the imagery chosen may be borrowed or stolen from Bruegel, but it has been converted by Boyd's genius into something wholly his own. When considering the origins of this picture, it is interesting to know about Bruegel and to be able to appreciate the biblical reference; but such knowledge is academic, in that it is Boyd's vision, and that alone, which drives this first major thematic work.

It derives naturally from those wartime images such as *The Kite* (1943) and *The Gargoyles* (1944) in which the elements of horrific fantasy are engendered by war – with demons and crutches and stringed humans flying through the air. It also looks forward to the equally Bruegelesque *The Mining Town* of 1946–7, the subtitle of which is *Casting the Moneylenders from the Temple*. A further blend of ancient and modern, naturalistic and grotesque, it pulses with life; though at first glance almost a naive painting, it is primitive only in its vitality and energy.

Significantly a slightly later work, *The Expulsion* (1947–8), is, as they would say in Hollywood, based on a treatment by Masaccio, in turn inspired by an idea from Genesis. The expulsion is, of course, that of Adam and Eve and, while Masaccio's angel is a sword-wielding avenger, Boyd's brandishes a whip and is seen more as a voyeur – outraged but, like all the breed, secretly enjoying the experience. Adam and Eve are terrified and, in a curious way, almost asexual, as if perfect fear has driven out desire. Many of Boyd's paintings show hidden watchers, particularly where sex or love is a vital part of the picture. Angels and other ministers of potential harm are seen as cruel, lovers as victims. Often an overtly erotic theme is shown with a touching innocence. There is nothing sexy about Eve. Her breasts are only sketchily present and the hair on her *mons* merges with a

convenient tree branch. Adam's genitalia are almost hidden by his pubic hair. Yet when the painting first went on show, an outraged elderly Melbourne bourgeoise took out her hatpin and furiously scratched Adam's vital equipment away – and Boyd had to practise some *pentimento* to restore what was there.

One has to remember that Melbourne in the forties was a provincial city and Boyd's eroticism – later, particularly in his graphic works, to become so prominent – was in these early works very restrained. Even, later, at its most blatant, it has never been created merely to titillate.

Indeed in an age when the study of Freud has often produced all sorts of half-baked nonsense that would have made the founder of psychoanalysis snort with derision, Boyd has interpreted sexuality in a wonderfully matter of fact way.

Who but Arthur Boyd would do set and costume designs for Robert Helpmann's ballet of *Electra* at Covent Garden and garnish the dancers with snakeheads over the female pudenda and, in one case, a menacing *vagina dentata*?

After the major religious paintings of the forties, Boyd did, by his own standards at least, his most conventional Australian paintings, very much in the traditional progression of the great nineteenth century Australians. These Wimmera and Berwick landscapes are less frenetic than the earlier work but, with their ubiquitous black birds, are unmistakably from his brush. They form a kind of peaceful interlude before and between the extraordinary ceramic paintings of 1949–52 which, together with his second series in the same medium in England in 1962–3, represent a precise fusion between his vision as a painter and his craftsmanship as a potter. In a sense, these compositions – sometimes individual tiles, sometimes composites of six or nine tiles or more – are his equivalent of Italian frescoes. The whole is often overwhelming because of the accretion of the parts, as in, say, the St Augustine frescoes of Benozzo Gozzoli at San Gimignano. They are the most 'primitive', the most openly emotional of his works, in which the strong vein of fantasy is at its most apparent. Like some of Chagall's work, they have great charm; but happily they lack the Russian's sometimes cloying whimsy. There is something endearing about a *Temptation of St Anthony*, in which the saint, at once tempted and understandably perplexed, stands in a rockpool filling up with bright blue water gushing from his own navel, with his arms raised and caught in a tree from whose branches swings, upside down, a naked and unambiguously tempting blonde. Technically these paintings are immensely striking because of the intense colour effects achieved by

firing metallic oxides such as chrome, cobalt or manganese to a temperature of a thousand degrees Centigrade. The depth and intensity of the colours, aided by the 'crazing' that takes place in the kiln, give this part of his *oeuvre* a unique, heightened quality not seen elsewhere. If they survive for a few centuries, it is perhaps not too fanciful to imagine them being related to the polychrome sculptures of the della Robbias, although they are without the della Robbias' oleaginous sentimentality.

Above all, it is the fantastic imagery of the first series of ceramic paintings which seems to me to form the bridge between what preceded them – which was far from conventional – and the Bride

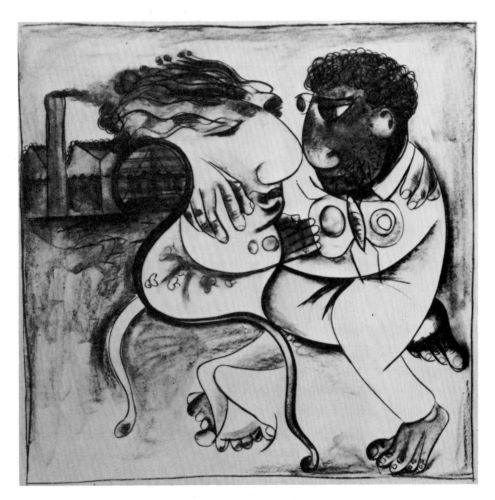

Embracing figures on a bench

series begun in 1957, first shown in Australia in 1958 and continued and shown in London from 1960 to 1961. The full name of the series is *Love, Marriage and Death of a Half-Caste* and I believe it to be catalytic within Boyd's *oeuvre* and his career, since it manifestly led to his most important exhibition up to that time, a retrospective show at

the Whitechapel Art Gallery in London in 1962. This gallery was then in its heyday under the inspired guidance of Bryan Robertson and at that time a show there was for a living artist an accolade second only to a retrospective at the Tate.

The series brought Boyd instant recognition beyond the borders of Australia, much as the Burke and Wills and Ned Kelly paintings did for Sidney Nolan – who later became Boyd's brother-in-law when he married Mary Boyd Perceval. Significantly, they were the most obviously 'Australian' of Boyd's paintings; dealing with Aborigines, they had to be. Ironically, while a painter like Russell Drysdale had painted the Aborigines to considerable effect in an entirely conventional manner, which had brought him great fame and fortune in Australia but little outside it, the far more exotic, striking, yet utterly indigenous images depicted by Boyd had an almost instantly universal appeal in the Anglo-Saxon world.

Boyd had been profoundly affected by his observation of the Aborigines and attendant half-castes of Central Australia. Entirely eschewing any 'noble savage' nonsense, for all the elements of fantasy he brought to the paintings he saw them plain.

We don't see here the sturdy figures of great physical strength painted and drawn by Drysdale, nor the jolly painted chaps holding a corroboree and playing didgeridoos. Instead we see the sad hunted and haunted figures we could visualize from Randolph Stow's remarkable novel *To The Islands*. The characters inhabit a world of tin shacks, ragged clothes, desperate love haunted by death and fear. They are oppressed and their relationships are doomed because the outside world gives them only hostility at worst and, at best, apathy. If all this sounds like a social commentary, it is not meant to. Boyd is too subtle and sophisticated an artist to sermonize.

He simply shows the predicament of, say, the bride in *Mourning Bride I* as she tries to join her lover/husband in the coffin, his jet black skin white in death, as his blue-skinned friend (or is it his formerly living self?) watches both impassively and sadly. Guns are pointed, bridegrooms are frightened, a pale-faced half-caste child clings to a rock-solid Aborigine whose blackness illuminates the painting as much as her scarlet dress.

Thus in the Bride series Boyd's brand of fantasy becomes more firmly grounded in reality, paradoxically in a group of paintings peopled not by figures from the Bible but by unnamed, half-observed, half-invented Aborigines and half-castes. In other words, Boyd has created his quasi-mythical figures not out of the known, European

Doris Boyd, with hand over mouth

religious models of the Renaissance but out of the native Australians whom he could himself observe in the flesh. Not, of course, that there is any attempt in Boyd's Aborigines at anything approaching conventional realism. Inevitably Boyd has tried to dig beneath the conventional surface. If the black-skinned Aborigines were Negroes, one would say he was expressing their Negritude. There is a kind of racial understanding in these pictures, a wholly unpatronizing, unsentimental comprehension of their plight. In Drysdale's paintings one is made brilliantly aware of their physique and their external appearance. In Boyd's one becomes aware of their minds and spirits. Although the trees, the scrub and, particularly, the birds which so frequently recur in Boyd's work are all redolent of Australia, it is the Aborigines in the Bride series which constitute the most strongly Australian element in his *oeuvre*. In a painting like *Half-Caste Child* (1957) we find an almost archetypal Boydian situation and setting. The trees spring from rocky land, the sky contains a hundred subtle colours, the ubiquitous black bird looks on and the human figures are clothed in reds and blues of a

startling vividness. The child clings, seeking protection, to a truly primitive figure: his massive, neckless head is attached to a huge, stiff, strong but curiously vulnerable body and the great staring, startled eyes are at once fierce and haunted, cruel and pitiful. In other paintings in this series the element of fantasy is very strong, but it is a fantasy founded in terror, filled with images of hidden watchers and hostile pursuit, of death and mourning.

These are tragic images, painted with both passion and compassion, but they do not simply make one angry in a knee-jerk-reflexive liberal, intellectual way, for they are not a crass political 'message'. The imagery is too exotic for that. The gun-pointer has a white beetle on his

Yvonne Boyd (Yvonne Lennie) lying on couch with book and clarinet case

black cheek, the persecuted lover a gorgeous bouquet of flowers stuck in his ear. The paintings themselves burst with sumptuous colour. They pulse with painterly life. Each one is a glowing icon, not of social anthropology but of high art. The Bride series constitutes, together with Nolan's two series on Burke and Wills and Ned Kelly, the most powerful visual images to emerge from Australian painting, as opposed to painting in Australia, in this century. Boyd ceases to be precocious and achieves both absolute originality and complete maturity; these paintings are, I believe, the watershed of his art and without them he could not have done some of the notable later series.

Boyd's arrival in London in 1960 is also a turning point in his work. The accessibility of Europe's vast collections made a profound impression on him and his eclecticism became more extreme, as the

sometimes wild imagery of the Bride series spilled over into his first London work.

In the paintings Boyd did in London in the early sixties (he moved to England with his family in 1959) there are several noticeable developments. In many pictures the fantasy has a basis in metamorphosis, as in *Nude Turning into Dragonfly* or *Bride Turning into a Windmill*. In others Boyd displays his endearing habit of eclectic borrowing – for example, the fruitful left breast from Tintoretto's *Origin of the Milky Way* or the mournful, seated dog from Piero di Cosimo's picture of a satyr mourning a dead girl. But in all the paintings of this period Boyd shows a much more sophisticated handling of paint than previously. The relative flatness of the paint gives way to a heavier, more impasto style, with fairly thick streaks of paint carefully worked with knife or brush-handle. This technique is much in evidence in the series of portraits he did at about this time and is exploited to enhance the physical immediacy of these works in that most difficult of genres.

Perhaps the most singular paintings that Boyd has done so far are those on the theme of Nebuchadnezzar and Daniel's prophecy of his fate: 'Thou shalt be driven from men, and thy dwelling shall be with the beast of the field; thou shalt be made to eat grass as oxen.' Boyd shows us Nebuchadnezzar 'wet with the dew of heaven, till his hair was grown like eagles' feathers, and his nails like birds' claws.' He shows us the king afflicted, like Job, with boils; above all, he shows him consumed by a terrifying madness. Boyd's imagery here is highly complex, mingling that of the Bible with that of his own imagination and simultaneously toying with Freudian ideas. (In one picture Nebuchadnezzar is on fire, squatting simultaneously on gold and his own excreta.)

The most exciting of these pictures is probably *Red Nebuchadnezzar with crows* in which a terrified, crouching king, covered in boils, stretches out huge, splayed, suppliant hands set on fire and outlined in yellow flames, and cowers before the attack of two black, red-eyed dive-bombing crows. (One is reminded of Van Gogh's crows in a cornfield, and, since one of the crows is going beak-first into Nebuchadnezzar's mouth, of Freud's interpretation of Leonardo's dream. But the menacing bird in Leonardo's dream was a kite and it was its tail that entered the dreamer's mouth, so that perhaps Freudian interpreters of Boyd's work should not be over-zealous, particularly as the Nebuchadnezzar paintings present them with an all too easy field-day.) The whole painting, in its colouring, in the fierceness of the working of the paint surfaces, in its feeling of whirlwind and

simultaneously of shackled (because fruitless) motion, is filled with a kind of cathartic terror. The force of both its imagery and its execution make it linger in the mind long after one has seen it.

This peculiar force is found also in *Nebuchadnezzar and the crying lion*, where the thick yellow impasto of the lion, with its paint surface worked up almost into a facsimile of the lion's curly mane, utterly dominates the haunted shadowy figure of the king. Boyd's representation of the lion is a *tour de force* in communicating the essence of the beast, with its startling forward projection and the power of that great, muscular, tapering torso.

In this series of paintings there are many other memorable images: the king walking, multi-legged, like a Muybridge photographic sequence; the king tufted with eagles' feathers, walking blindly through a purple, starry night or striding through the fields like Van Gogh on the way to Tarascon. In one very moving work he is on his hands and feet, naked, eating grass, the knobs of his backbone standing up and echoed by the peaks of the hills behind him, the beloved Boyd dog perched on his back.

Boyd is sometimes open to the inevitable criticism that his work is illustrative and over-thematic. That it is illustrative is, since he has deliberately eschewed abstraction and any specific 'school' or movement, perfectly natural.

Until what we call 'modern art' began, all painting was illustrative and it is only in a world and at a time when a pile of bricks can be bought with public money and displayed in a national museum that 'illustrative' could be thought a pejorative word. Leonardo was, after all, illustrative. As for the thematic nature of Boyd's work, as so dazzlingly demonstrated by the Nebuchadnezzar series, this seems to me the natural concomitant of his amazing energy. If the Renaissance and classical painters were happy with one version of an allegorical subject or if one patron requested a St Jerome, then that was fine; but once let Boyd get an idea for a subject, be it biblical, allegorical or mythological, and he's away.

In 1972 I thought it would be interesting to put Arthur Boyd and Peter Porter together to see if there was a theme that would stimulate them both. When Jonah emerged from our joint talks, Peter Porter wrote a substantial volume of verse and prose at what seemed to me remarkable speed. Arthur Boyd, however, almost rendered the publication of a mere book impossible. So far as Porter's words were concerned, I remember suggesting a possible change of order here and there and an omission or two; but Boyd simply flooded my office with

hundreds of drawings in line and wash. We almost drowned in this cornucopia and it took months to fine down to the selection that eventually appeared in the book.

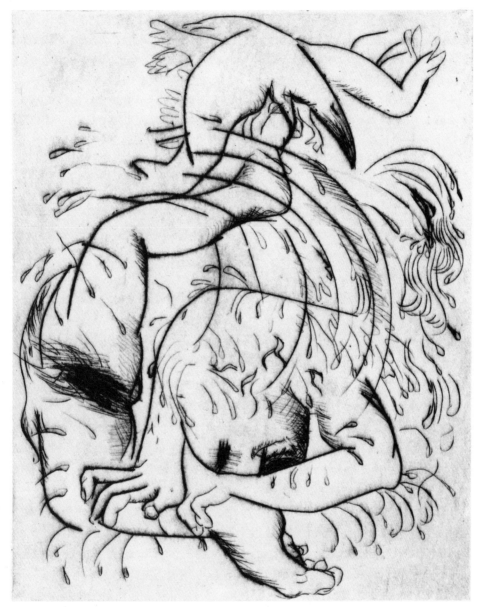

Jonah's contract with the Whale

Since there is a certain solemnity about both art and literature and particularly in writing about them, it is worth quoting and illustrating from Jonah as both Porter and Boyd have a lively sense of humour.

> SATURDAY I have this day experienced the wonder of the whale's farting. Such turbulence of digestive juices, so many deplorable vapours, I have encountered, but considered later that it must prevail with whales as it does with men, that it is better such gasses be out than in, and that no man, nor whale either, is ever embarrassed by the smell of his own farts.

JONAH'S CONTRACT WITH THE WHALE

... that the party of the first part, hereinafter known as *The Whale*, shall undertake to deliver the party of the second part, hereinafter known as *Jonah*, by means of vomiting, expelling or otherwise voiding the said *Jonah* on to a beach, promontory or any secluded part of the adjacent coast at the earliest opportunity before the New Moon, always allowing for local impediments and hindrances offered by tide, weather or any other natural hazard.

... that the said *Jonah* will, if required, assist *The Whale* in carrying out this undertaking by journeying to the screen of membranes at its throat and tickling or titillating these parts to hasten the epiglottal reflex: *Jonah* also agreeing to follow *The Whale's* instructions at all times and, while remaining in its belly, to abjure fire and trenching implements, and also to undertake not to gather material such as ambergris or sea-kale which might be offered for sale on his return to the outside world.

Boyd's collaboration with Porter has been a fruitful one. *Jonah* was followed by *The Lady and the Unicorn* in 1975 and *Narcissus* in 1984. These two later books each contain a series of black and white engravings of considerable virtuosity. No conventional printed book can do justice to the deep velvety black that surrounds the etchings, which are, as one might expect, inventive, full of fantasy, highly charged with eroticism and at the same time lyrical in tone. The Unicorn may be a fabulous beast but it is also often a sad one; while Narcissus doubtless loved himself too much, he had no one else he *could* love. As always, Boyd's fantastic, at time phantasmagoric, vision is a compassionate one. The central characters of his major graphic series, including the often delicious and hilariously sexy *Lysistrata*, are more sinned against than sinning.

The visual games that Boyd plays in his graphic work as a whole, full of sly innuendo, erotic charm and sheer *joie de vivre*, are equalled in terms of technical skill by very few twentieth century artists. For comparable virtuosity and single-minded exploration of a theme, one really has to go back to Picasso's *Minotauromaquia*, an appropriate parallel not least because Boyd has always shown, throughout his graphic work, an absolute genius for metamorphosis. It is particularly visible in the St Francis pastels and engravings, where the saint becomes inseparable from his beloved animals.

This passion for changing forms, while accentuated in the graphic works because of their subject matter, is of course highly visible also in the paintings. Given the fluidity of paint as a medium, as opposed to the necessary rigour and rigidity of copper plate, the metamorphoses are, if not more inventive, more like a magician's tricks when carried

out with brush rather than needle. Sometimes they are almost breathtaking in their boldness, as in *Bride with Lover* (1960), which Boyd subtitles as *Bride Turning into a Windmill*, or *Nude Turning into a Dragonfly* (1961). The *Bride Turning into a Windmill* is a *tour de force* of the imagination as, against a sumptuous background of vegetation, sky and inevitable black bird, the Bride is a mere head. Instead of a body, there is just an elongated pillar of white wedding-dress, while her

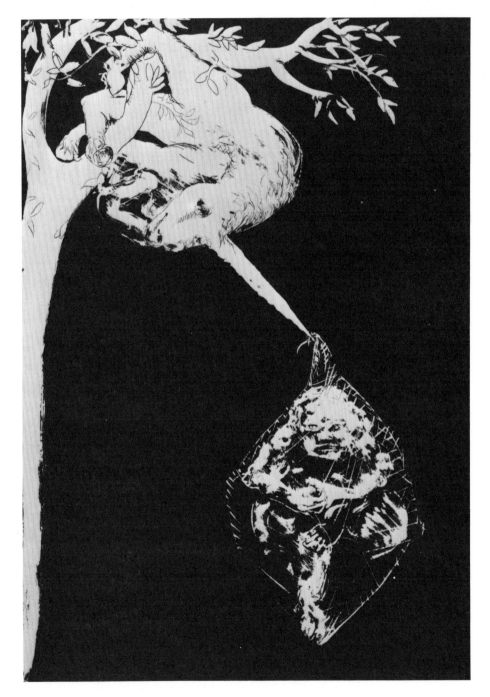

The Lady and the Unicorn XV

bridal veil stands on end and becomes the windmill's sails, as she serenely levitates in a horizontal position. It is a breathtaking image, once seen never to be forgotten.

Much has been made of Boyd's 'Australianness', as if he were a Johnsonian woman preacher. As a critical label it is about as valuable as Hardy's being a Wessex novelist or D. H. Lawrence's intimate knowledge of Nottinghamshire life. Yet without Wessex there would have been no Hardy, and Boyd's Australian heritage is inseparable from, and highly relevant to, his art in that it is the foundation upon which he has built the pillars of his artistic talent. Indeed in the early and the most recent work Boyd's native country is indispensable to his art and our understanding of it. What one must be aware of is the use of the national adjective as a limiting factor. This is easy enough to avoid if one takes into account the decades of the sixties and seventies, which owe relatively little to his Antipodean roots.

During that period he experienced the influence of English and European topography and aesthetics, and also engaged upon the many themes and iconographies mentioned above, none of which is in any sense local. Indeed, they are universal.

Boyd has a house in Tuscany and it is therefore hardly surprising that he so wholeheartedly entered the world of St Francis and the Wolf of Gubbio. He spent a lot of time in Portugal creating and supervising a series of sumptuous tapestries and thus joins a tiny handful of modern European artists who have mastered this difficult medium.

He also has a house in Suffolk, only a few miles from Constable's Flatford Mill, and, in that rural seclusion, has done some of his finest graphic work as well as becoming a highly accomplished painter of landscapes which are truly English in spirit and not some kind of reverse transportation from Botany Bay.

But in the last few years, without in any way severing his ties with England and Europe, he has made a deeply committed return to Australia – not to his native Victoria but to New South Wales, where a formidable family estate has been established on the banks of the Shoalhaven river.

Not all art books genuinely illuminate their subject matter, so it is a rare pleasure to recommend as an essential tool in the understanding of Boyd's recent life and work an extraordinary and obsessively detailed study by Sandra McGrath entitled *The Artist and the River: Arthur Boyd and the Shoalhaven*. The study of Boyd's relationship to the area is so exhaustive that it even includes some of his instructions to his architect, as well as some useful, sharp comments on individual works.

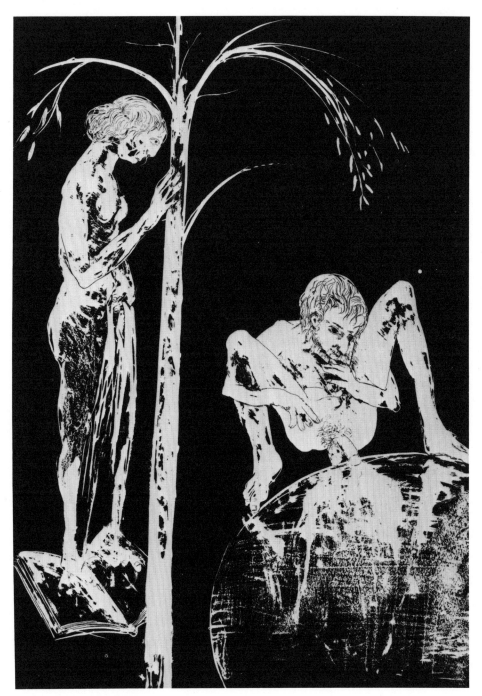

Narcissus XX

Boyd's output over the last few years, beginning in 1975 and still going strong in 1985, provides a sample of his *oeuvre* in both microcosm and macrocosm. The relationship with nature is there in the endless and successful attempts to come to terms with a landscape so dramatic that one finds it hard to credit until one sees the accompanying photographs. There are the usual animals, the live ones flying, running or watching, the dead ones as clean-picked carcasses or

bloated corpses floating down the river in flood, all done with the extreme tenderness that fills so much of his art. Nude female figures, not a million miles from his wife Yvonne, are set in an unmistakable Australian bush and are charged with the same intense love Rembrandt devoted to his Saskia.

There is also the genuine grand design of his topographical sense. He has always, in large-scale landscape paintings, been able to show the earth's skeleton beneath the skin and flesh surface of the most elaborate and tangled Boydian vegetation.

There is, too, the inescapable mythology. Narcissus is himself observed on the banks of the river. There is the freely admitted eroticism, even in the landscapes. As Boyd himself said of his *Broken Cliff-face and Moon* of 1974–6, 'the cleft shape has obvious sexual connotations, but any division in a rock face – even a waterfall – can be seen that way.'

But any idea that Boyd, now in his sixties and very much rooted in his relatively new Australian renaissance, might have 'settled down' is happily dispelled by the continuing, even burgeoning, vividness of his imagination.

The prodigal son is welcomed back into a cave in a bank of the Shoalhaven, a slightly sly passing angel rubbing its hands in smug satisfaction. A man on a sandbank drives a jinker, drawn by black swans. In what is to me the most striking work of the period, *Shoalhaven River with Rose, Burning Book and Aeroplane* of 1976, we get a conventional but daring view of the river as seen from a high rock, with the water curving and meandering for miles into the distance. On the rock rests a fragile, toy-like aeroplane next to a fiercely burning book. The burning book is surely one of the most horrific images of the twentieth century. In this essentially peaceful landscape the plane is an image of military war, the book a potent reminder of prudish and repressed women with hatpins for excising genitalia and of Nazis eradicating uncomfortable free ideas by burning books in Frankfurt.

As if that were not enough, above it all, against the lightly clouded blue sky, like a descending parachute, there is a huge, gorgeously painted rose. If this all sounds symbolic, then Boyd clearly means it to be; he has himself commented that 'The rose represents the desperate attempts of the Europeans to impose their civilization and culture on an essentially primitive landscape. It always floats because it cannot take root. If it does, it destroys like Lantana.'

The above analysis of book and plane is of course my own, based on my instinctively European stance towards Boyd's work and my

understanding of his own absorption of the horrors of the history of this century. It is cautionary, therefore, to go back to his own stated interpretation of this canvas: 'The burning book represents Aboriginal wisdom, which has also suffered from the encroachment of white civilization. If the white settlers had taken a page out of the Aboriginal "book" they might not have ruined the landscape. The aeroplane is a reminder of the harshness of the land – they were used that year to rescue people when the Shoalhaven flooded. They actually used helicopters but I felt a bi-plane had close connections – grasshoppers and dragonflies for instance.'

Well, it is Boyd's painting and he is entitled to know what he put into it and what he means. But I do not think my own view of it is entirely fanciful. As always, once a painter has finished a work its content becomes common property. Unless it's downright dull and empty, its ideas are transformed by the eye of the beholder. Nevertheless, this undoubtedly major work is a perfect fusion of Boyd's 'Australianism' and the solid leavening of his European experience.

That Boyd is, in his versatility, a kind of Renaissance man is a truism. I began this essay with a crude piece of free association, but as one creates a retrospective of his work in that other museum without walls, one's own head, with its crowded, unerasable memories of everything one has seen and recorded there, the mind's eye must select, as inevitably Ursula Hoff's study of the artist, which follows, so scrupulously does.

One remembers the unique vision of the terrain, recalling Randolph Stow's lines from 'Landscapes' in his collection *Outrider*:

> A crow cries: and the world unrolls like a blanket;
> like a warm bush blanket, charred at the horizons.
> But the butcherbird draws all in; that voice is a builder
> of roofless cathedrals and claustrophobic forests
> – and one need not notice walls, so huge is the sky.

One recalls the poignant images of Adam and Eve, the Aborigine and his elusive bride, of tormented Nebuchadnezzar and lovelorn Narcissus, the gentleness of St Francis, of the Unicorn trapped by hunters, of humans metamorphosing into animals and phantasmogorical creatures, all depicted with brush or needle or palette knife or even fingers, in an ever richer, yet evermore controlled and defined blaze of original colour.

From the smooth 'Old Masterish' texture of the early work to the later heavy impasto, from the early sparse drypoints to the full-blown heavy black plates, Boyd's art is a majestic progression from teenage

precosity to a mature grandeur of conception and execution. He is, I am convinced, a twentieth century artist who will live for and in posterity. And, for that other kind of posterity, students of the family tree might wish to know that Arthur Boyd's son Jamie is already an

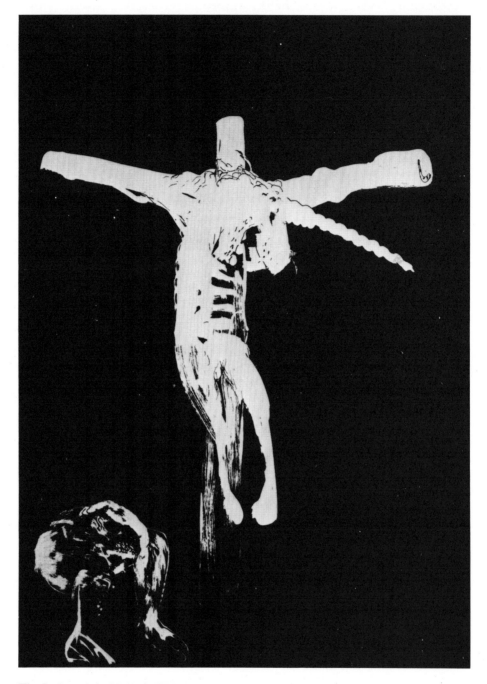

The Lady and the Unicorn IV

independent and successful painter, so that the fourth generation of artistic Boyds is beginning to flourish . . .

THE ART OF
ARTHUR BOYD

by Ursula Hoff

PART I
1920–1959

Arthur Boyd was born in 1920 at Murrumbeena in Victoria into a family which had come to Australia from Great Britain in the early nineteenth century. Arthur's maternal great-great-grandfather, Sir William à Beckett, had been the first Chief Justice of Victoria. His grand-daughter Emma Minnie married Arthur Merric Boyd, son of the military secretary to an early Governor of Victoria. Both were painters [2, 22]. With them began a succession of artists, writers and musicians which now extends into the fourth generation.

The remarkable family and their restless migration from town to country, from Australia to England and back, form the subject matter of several novels by Arthur's uncle Martin Boyd. In *The Cardboard Crown*, *An Outbreak of Love* and *A Difficult Young Man* his characters in summer often occupy a house he calls 'Westhill'. Its real name was The Grange, once owned by the à Becketts at Harkaway. Built in a belated Georgian style, it overlooked the Berwick countryside from the window of the room portrayed in *Interior with Figures* [22] by Martin's mother, Emma Minnie, when she was fifteen years of age. Much later The Grange was to play a decisive part in the life of Arthur Boyd.

In 1908 Arthur's father, Merric, acquired an old orchard in Murrumbeena; in it he built a house which he named Open Country after the unspoilt land around [1]. He married the painter and potter Doris Gough, who assisted him in setting up a pottery. After a period of war service in England and France Merric took instruction in the design of machinery and ceramic techniques at the Wedgwood Potteries in Stoke-on-Trent, which enabled him to improve his facilities at Open Country. He became the first well-known studio potter in Australia. With ornament based on native plants and animals, his ceramics [3, 4, 5] were stylistically allied to the Art Nouveau which he found in the early numbers of *The Studio*. His wife Doris, who had been a pupil of Frederick McCubbin at the National Gallery Art School, decorated many of her husband's pots with designs of great delicacy. She also painted in watercolours and handled oil paint with surprising forcefulness. Both Doris and Merric held strong religious convictions, and the household at Open Country was dedicated to art and religion in a spirit well described by Franz Philipp as 'Blakian'.

Open Country was the setting of the first three decades of Arthur Boyd's life. In later interviews, drawings and paintings he has paid tribute to the orchard, the houses embedded among the old pear and mulberry trees, and the 'Brown Room' [*1a*] where family and friends forgathered in close community, which often included his uncle Penleigh and the latter's two sons Pat and Robin. Boyd received his first training in the family circle. From his earliest years he modelled in clay, drew and painted; encouraged by the family circle he never doubted that art was his vocation. His formal training at the National Gallery Art School and at private drawing classes was short and of little avail.

Leaving school during the Depression Boyd went to work in his uncle's paint factory in Fitzroy, but was relieved from such drudgery when his paternal grandfather after the death of his wife moved to a cottage in Rosebud on the Mornington Peninsula, Port Phillip Bay, and invited the boy to stay with him. In 1939 both returned to Open Country.

At Rosebud Boyd was able to paint full-time. The brilliance of light in *The Jetty, Rosebud* [*23*] is reminiscent of paintings by Conder and Streeton, but the open impasto strokes announce his conversion to Expressionism. Together with his cousins Pat and Robin he explored forms of art felt to be more avant-garde than those of his elders. Years later he could still remember in every detail a postcard of a painting by Van Gogh which he saw at that time in Robin Boyd's room. The regular brush and palette knife strokes of *Sheoke Reflected in Tidal Creek* [*24*] give a firm structure to the composition and lift the act of painting out of the service of illusionism. Boldness of attack distinguishes Arthur's Mornington Peninsula landscapes from the minutely detailed views painted by his grandfather. Boyd dispensed with scenic wings, with the contrast between near and far, and with the picturesque motif; instead open skies, rolling hills and bare fields alternating with gnarled, windswept trees form his subjects.

On rainy days he painted portraits and interiors [*7*]. As early as 1934, when he was still at Murrumbeena, he had made an impressively organized painting of his mother [*25*]. In his self-portrait [*26*] painted at Rosebud the contrast of light eyes and sunburnt skin and the marked texture of the brushwork are used to convey the creative excitement of the moment. This painting indicates a shift of manner similar to that in his landscapes. Before going to Rosebud he had made a picture of the main sitting room at Open Country; in the tonal manner of Max

Meldrum, it achieved a light-suffused but impersonal image [8]. The room could have been anywhere in the Melbourne art of the thirties. During the war he turned again to that same room, which he now filled with figures whose expressionist rendering concentrates our attention on the faces [9]. The features of his brother David, absorbed in playing, the shrunken and withdrawn image of Merric Boyd on the sofa, the Charles Rennie Mackintosh-type chair (made by Penleigh Boyd) and the glimpse of his grandmother's house through the window conjure up the quintessential and unique aspects of the Brown Room.

Among the circle that had formed itself around the Boyds was Max Nicholson, then an English Honours student at Melbourne University [57]. He had known the Boyds since 1934 and often brought friends to the house. Since World War I the Boyds had been close to an Austrian emigré analytical chemist, Victor Rathausky, who was also an enthusiastic amateur photographer [1]. The Rathausky children came to play in the orchard with the Boyd children. During World War II refugees introduced by Max Nicholson were made welcome at Murrumbeena, among them the Polish student of painting, Yosl Bergner, and the philosophy student of German origin, Peter Herbst. Max Nicholson came every week to read aloud. The books which made the profoundest impression on Arthur were Dostoievski's novels *The Brothers Karamazov* and *The Insulted and Injured*, early short stories by Franz Kafka and poems by Dylan Thomas and T. S. Eliot. Bergner, who had started painting in Warsaw and had seen reproductions of German Expressionist works in his father's library, had been dismissive of Arthur's Peninsula landscapes and portraits. In the light of what was known of the Nationalist Socialist regime of terror such subjects seemed irrelevant. Boyd's new paintings do indeed differ markedly from those done at Rosebud, both in mood and in style. In *Three Heads* [10] the Boyd brothers impersonate Alyosha, Dimitri and Ivan Karamazov. Their expressions range from the withdrawn to the possessed; and unnaturalistic colours with sharp contrasts of bright green and red remind one of the 'green faces' which Arthur saw on his first visit to Bergner's studio.

Dostoievski's descriptions of invalids and epileptics and his accounts of extreme emotions extending from murderous hate to saintly love deeply fascinated Arthur. Illness became a new subject of painting. Barbara Hockey [11] while a student at Melbourne University had been confined to bed with tuberculosis. With its emaciated eye sockets, feverish, haggard look and swift impasto brushstrokes, the

portrait is the most powerful of those Arthur painted during the late thirties.

After joining the army in 1941 Boyd was eventually stationed in the cartographic warehouse in South Melbourne, a poor industrial area on the bay where he came face to face with human misery of a kind he had not met before. People too old or too infirm or disabled for war service assembled on the beach and on the esplanade. Their image joined in his mind with the memory of the corpse of his grandfather who had died in 1940, of the cataleptic form of his father who suffered from epilepsy and of acquaintances in wheelchairs and on crutches who had been crippled by the prevalent epidemic of poliomyelitis. The political and social radicalism of Yosl Bergner and of the members of the Contemporary Art Society, of which Boyd had become a founder member, spurred him on to new forms of expression. He was encouraged in this by Bergner, who had studied with the painter Altman in Warsaw and had immersed himself in books in his father's library which reproduced pictures by Schiele, Daumier, Van Gogh and Corinth. Though haunted by *The Insulted and Injured*, Boyd rarely painted actual incidents in the social realist manner. His panel *Progression* (1941) as well as drawings of soldiers in hospital, soldiers and prostitutes, of a horse and cart endangered by an oncoming locomotive and of a woman walker with a lame dog are based on observation. The drawing *Soldier and Prostitute with Galleon* [*14*] makes a play on words: like a sailing ship the woman is in full rig. For the greater part, however, Boyd's art was to be many-layered; his realism was to serve symbolism. In *Kite Flyer* [*15*] houses and people are lifelike, but the whole has another meaning. The old woman sitting on the doorstep is tied to the domestic round. The girl before her throws up her arms in lament. The girl in front flies a kite, hoping for a reaction, but the kite is inscribed with a crucifix and casts an ominous shadow over the scene. Like a hooked fish, the Kite [*27*] floats on a line; though airborne, it cannot escape the hold of the dwarfish creature below.

A drawing [*16*] commemorates a feeble-minded man who offers flowers to passers-by in the hope of a kind word. The image centres on the loneliness of a totally self-absorbed person. Purely imaginary is the butterfly man [*17*] whose transformation from man into insect evokes Kafka's story *Metamorphosis*. In *The Fountain* [*28*] the apple tree of Paradise carries the head of Adam, while the temptress, Eve, arises from a fountain – a cup, a loving-cup, a poison cup, the stem of which is supported by Boyd's symbol for 'bestial' sex. The crescent moon and

the flowering and fruit-bearing tree present the ever recurring round of day and night, spring, summer, autumn and winter. From the same year dates *The Baths* [*29*]. A triton aims to deprive the woman of her dog and points to her eye, around which he is drawing a black circle. The crown of flowers worn by the woman, so Boyd has said, had its origin in the coloured hair-curlers worn by the women in dressing gowns that he saw in Fitzroy when as a boy he went early to work in the paint factory. This mundane memory grew into the poetic image of a crown of flowers which elevates the wearer into an illuminated being. (The writer is reminded of Prokosch's description of the German author Thomas Mann: 'The words he was uttering spread from his skull like antlers'.) Implied is a play on words. The triton is a sea creature, he wants to make the woman 'see' that he wishes to take the dog back to 'the sea'. Many years later this elusive scene was to inspire one of Boyd's most magical works.

Close in style and colour to *The Fountain* is *The Cemetery II* [*30*]. It combines allusions to the Melbourne General Cemetery, opposite which Max Nicholson had his flat, and to South Melbourne terrace houses with their Victorian ironwork and their link with the memory of his dead grandfather and his epileptic father. The tree of life grows out of the corpse; the crescent moon, forever waxing and waning, lies above the scene. In *The Seasons* [*31*] the tree of life, flowering on the right and bearing fruit on the left, shelters embracing adults. In the distance the young engage in a carefree dance with the beast. The recumbent man in front represents old age and death. The cycle of youth, maturity, old age and death is the theme. One is reminded of Picasso's Blue Period allegory *La Vie* [*18*], reproductions of which were available in Melbourne at the time. The sorrowing figure squatting in the foreground, also found in a drawing executed in the same year [*19*], compares with the huddled, despairing image on the two canvases in the background of *La Vie*. The tree in *The Seasons*, like the tree in *The Cemetery II*, is the descendent of the decorations on Merric Boyd's pottery, its bare branches resembling the streaky incisions in wet clay [*3*].

The features of the cripple in *The Gargoyles* [*32*] are similar to those of Boyd's brother-in-law John Perceval, who had been a polio sufferer in his youth. Again the imagery is symbolic. The cripple longs to escape, but is as trapped as the huge gargoyles on the roof which cannot leave their moorings. Seen in another way, the fearsome creatures stand for the inescapable environment of the old, run-down, impoverished suburbs.

All the South Melbourne paintings are small. They are rarely many-figured, a few actors occupying a stage space bordered by terrace houses or factories, often with a view out to the bay. The disproportionate heads and bodies of the figures recall cartoons. Red and green against brown predominate, put down with a deliberate artlessness and avoiding the order and subtle gradations Boyd had achieved earlier. His brushwork, freer than seen in his Peninsula Van Gogh manner, owed some of its immediacy to the Cossack painter Danila Vassilieff, who had settled in Melbourne in 1937, where he became a member of the Contemporary Art Society and introduced the theme of street life in Fitzroy, painted in a vivid, spontaneous and expressionist manner. Subjects such as lovers in a boat or floating in hammocks remind us of Boyd's admiration for Kokoschka's *The Tempest* [20], an image which fascinated him for many years.

The South Melbourne paintings join together such heterogenous images as coffins and trees, trees and human figures, heads and fountains, hair and seaweed in a way resembling the method of Dylan Thomas, whose poetry was read aloud at Open Country:

> Hairs on your head, then said the hollow agents
> Are but the roots of nettles and of feathers
> Over these groundworks thrusting through a pavement
> And hemlock-headed in the wood of weathers.
> <div align="right">(from 'Altarwise by Owl-Light')</div>

Despite army service Boyd was able to resume a certain amount of outdoor painting during periods of leave. Quite at variance with the scenes popularized by the Heidelberg School he recorded scrubby eucalypts resembling grown-out cauliflowers, whose tufty tops spread to the horizon in the featureless monotony of an untouched wilderness [21]. After one of these painting trips Boyd came across a watercolour by Louis Buvelot [49] in the National Gallery of Victoria, in which he recognized eucalypts similar to his own. The sombre tones of the dark scene suited his mood and he repainted a landscape he had in hand [50], allowing the straggly eucalypt, fallen trunks and rotting wood in the left foreground to contrast with a view into light-filled distance, the way Buvelot had done.

A wartime incident is set into this kind of bush in a drawing where a group of soldiers come upon a deserter who has died [51]. In the Hunter series [33, 52] the theme of the dark dangerous bush is developed, mythical primitives taking the place of the soldiers. Boyd's grandfather had kept his bush scenes in a muted tonality [2]; Penleigh Boyd's *Winter Triumphant* [6] opposed the gold and blue of Streeton's

summer with a harsh and sombre Australian winter. In *The Shepherd* [*33*] Boyd's bush is not only dark but self-destroying and self-regenerating – trees fall and die, new saplings take their place. The hunter gets lost and dies; the stockman can only tend his flock if he destroys the bush; harsh conditions lead to impossible dreams of flight and escape. Barely distinguishable from the dead wood, a dead man lies among the prostrate trees. In *Figures by a Creek* [*52*] despairing humans fill the foreground; lovers seek solace in sex. In *The Lovers* [*34*] some of the symbolism of the Hunter series continues, but the mood is lighter. Again, as previously, he draws on Picasso's *La Vie* for the lovers, on his father's pottery decorations for the tree [*3, 4*]. The near view opens to a light-filled distance in the manner of Buvelot [*49*].

After Boyd left the army various factors led to an inner crisis. The bitter antagonisms between the factions inside the Contemporary Art Society put him out of sympathy with his colleagues. The inward-looking nature of his own 'poems' began to pall; he later told the older painter and gallery director Hal Missingham that had he gone on with his South Melbourne themes, he would have ended painting nothing. Through Peter Herbst he had come into contact with philosophers at Melbourne University but felt overawed by the verbal performances which carried over from seminars into social gatherings, and which to Boyd were 'removed from the sort of thing painters were taking an interest in'.

Moral upheaval increased when news from the war front revealed the fate of the Jewish population in Europe. One of the most hallucinatory of the South Melbourne pictures, in which a crucified figure emerges like smoke from a factory chimney, suggests that rumours about the gas ovens of the extermination camps may have begun to circulate.* By May and July 1944 the papers carried descriptions of such camps at the Polish city of Lublin discovered by the advancing Soviet troops. Peter Herbst remembers talk at Open Country on the problem of evil: 'If God is good, why does he allow such suffering?' The religious dedication of the elder Boyds and the intense emotional engagement of Arthur's Jewish friends with

*NOTE
At the end of May 1945 newsreels taken at the concentration camps of Buchenwald and Belsen were simultaneously released at all newsreel theatres in Melbourne (*The Argus*, 24 May 1945). In a much later drawing (Tadgell 1776) *Beast devouring figure before Nazi soldier and smoking chimney*, out of which comes a human head, Boyd directly associated the smoking chimney with National Socialism and the holocaust.

European events led to a decisive turning point in the painter's development. He told Missingham that until this time Bruegel and Rembrandt had not meant much to him. Then in Bruegel's allegories of the sinful world he found the form for *The Mockers* [53]. Instead of the narrow foreground stage with its three or four actors used in the South Melbourne paintings he learned to use deep space, extending across the whole canvas. He understood how to distribute innumerable figures in violent motion seen from a bird's eye view and thus to create an image of a world possessed, raving under the eyes of an indifferent barbarian deity sitting in a tree, who turns his back on the Crucifixion, which has taken place in the distance. A penetrating analysis of *The Mockers* and its companion piece *The Mourners* occurs in the book *Arthur Boyd* by Franz Philipp, a refugee from Vienna, members of whose family had perished in a concentration camp. Boyd's imagination was undoubtedly affected by the emotions and thoughts of his Jewish friends. If Bruegel's narrative scenes lent him the image of a 'world upside down', Rembrandt [54] inspired him to the use of the single figure and to expressive gestures and compassionate mood. In the young David [55], soothing the melancholic king with his harp, memories of paintings by Rembrandt mingle with those of Boyd's father sitting in his armchair with Doris Boyd by his side. Rembrandt's example led Boyd towards subtle light-dark effects, broken colours and open brushwork. Rembrandt also taught him new ways of painting folds and wrinkled or smooth skin, and how to instill tenderness into the gestures of hands. Although he only knew them through colour reproductions, the perusal of Bruegel's paintings roused Boyd's interest in new techniques. In Max Doerner's *The Materials of the Artist* he found recipes for tempera used by Bruegel. Traditionally, tempera (powder colour mixed with egg yolk thinned with water, which dries almost instantly in a lighter tone than while wet) had been used to paint the whole picture, only finishing touches being applied in oil. Painters also reversed the process, or mixed tempera and oil for better drying of the latter. This concern with Bruegel helped to widen his compositional devices and to refine his brushwork. The irregular impasto strokes of the thirties and the heavy, grainy, tonally undifferentiated brushstrokes of the South Melbourne 'poems' made way for a style in which areas of uniform tone are overlaid by linear motifs. The range from sombre foreground to the explosion of light in the middle distance of *Melbourne Burning* [35] differs strikingly from *The Mockers*, in which the scene has been articulated not by light and tone but by a pattern of strong colours [53].

Melbourne Burning (1946–7) is the last of the 'Bruegel paintings' and topically the most relevant. The explosion in the centre recalls the atomic bomb at Hiroshima (1945), yet is given immediacy by the presence of Princes Bridge, the South Melbourne Brickworks, Flinders Street Station and other Melbourne landmarks in the background. Apocalyptic visions are evoked by an angel blowing the trumpet, by the dead rising from their graves and the witness figure of St John sitting in the foreground.

The Expulsion [*36*], 1947–8, is painted with techniques similar to that of *Melbourne Burning*, but achieves a more uniform tonal effect. It translates certain Italian ideas into an Australian idiom: the biblical scene is set in an indigenous Australian wilderness among rocky boulders overgrown by a delicate network of scrub and grass. The figures are variations on Masaccio's and Michelangelo's treatment of the theme; as in Masaccio's painting Adam hides his head in his hands, but Eve adopts the defensive pose given by Michelangelo to Adam. The white and soft nakedness of the expelled and the disproportionate Jack-in-the-Box rage of the angel, who bursts through the bush like the last rays of the setting sun, introduce a note of irony which is even more vividly present in the companion piece, *Angel Spying on Adam and Eve* [*37*]. The embracing couple is spied upon not, as in Rembrandt's etching, by a dragon-snake but by a grim-faced watcher, the first of many such figures in Boyd's *oeuvre*.

The Art Room of the Public Library of Victoria (now the State Library), where readers could use the shelves of an excellent stock of art books, has always been a fund of information for Melbourne artists. While the circle around John Reed – Sidney Nolan, Albert Tucker and others – concentrated on Picasso, the School of Paris or the German Expressionists, Boyd included Old Masters. He also looked long and often at the self-portrait by Rembrandt in the National Gallery of Victoria, and may have seen the Dante illustrations by Blake which were put on show there for the first time in the early 1940s. He felt that his concern with the past was 'as avant-garde as what was done at Heide', the meeting place of the Reed circle.

After leaving the army Boyd needed to earn a living, and he did so in a way for which family tradition had equipped him. With the help of John Perceval and Peter Herbst he set up a pottery which from 1944 until the end of the war turned out utility ware, but soon after became a studio pottery making highly original decorated work. Despite the fact

that this was as far away from established taste as were his paintings, he found a 'connoisseur's market' which enabled the two newly married partners to support their young families.

Geoffrey Edwards, who in 1982 gave the 'Painter as Potter' exhibition at the National Gallery of Victoria, commented in the catalogue on the role which pottery decoration had played in the work of the School of Paris artists Picasso, Miro, Chagall and Gauguin. The style of the AMB pottery stood on its own at the time. It differed as well from that of Merric Boyd. While the older potter had often squeezed his pots after throwing, moulded them into shape and modelled and carved their edges and handles in imitation of trees and branches, keeping his pots in gentle hues of yellow, grey-green and powder blue, the young AMB pottery turned out simple shapes painted in strong colours, with motifs drawn from people, flora and fauna. In the bowl with an angel's face [*38*] the round features of the head echo the shape of the bowl and provide the eye with a resting place, while the 'beast' motif moves the eye around the inner rim. The lively head is a portrait of Betty Burstall of Eltham, then a neighbour of the artists' community at Montsalvat founded in the thirties by the painter Justus Jorgensen.

Boyd's preoccupation with the AMB pottery came to an end with the arrival in Australia of his uncle, the novelist Martin Boyd. The writer bought The Grange, the former family house at Harkaway, near Berwick, and invited Arthur, Yvonne and infant Polly to stay with him while the painter was engaged on murals around the dining room. Since destroyed, these decorations are fully described by Philipp. Two of the most mature and accomplished figure compositions yet created by Boyd formed part of the scheme. At first sight *The Prodigal Son* [*40*] is a puzzling picture. The theme has become lodged in one's memory in the form given it in Rembrandt's painting, where the father embraces the returned prodigal in the doorway of his mansion. In Boyd's picture the scene takes place in the open. The trees and meadows reveal his preoccupation with Tintoretto, but the preparations for the feast in honour of the returned son is handled in a manner reminiscent of Bruegel. The preparations begin in the distance with the rounding up of the calf for slaughter. Passing over the inbetween stages, the artist shows it next, lying in the right foreground, ready dressed for the barbecue. The father's figure in the chair reminds us of many portrayals of Merric Boyd in Arthur's early drawings and paintings. The prodigal and the mother behind the chair recall Rembrandt, to whom Boyd is indebted for the absorbed, dedicated

manner in which each figure acts out its allotted role. Philipp has written about the warm, truly Venetian splendour of the colours.

The rendering of the Susannah theme [*41*] is also unusual. Rembrandt made various versions in which Susannah is physically attacked by the Elders, and always afraid and apprehensive. In contrast, Tintoretto's beautiful crouching nude is unaware that she is being spied on. Boyd adopts the spying Elder from the Venetian master, but Susannah – clearly based on Rembrandt's *A Woman Bathing in a Stream* [*58*] in the National Gallery, London – is exchanging a conspiratorial glance with the spy. This theme of woman and observer was to remain with the artist and find particularly frequent expression in the London additions to the Bride series.

A note of affectionate irony is visible in Boyd's relation to the art of the past. It is as if he felt that the emotional intensity of Rembrandt and the Venetian opulence and drama of Tintoretto were no longer apposite; they are emulated in a spirit of gentle self-mockery. His admiration for the great painters has remained with him ever since and became of particular importance during his time in London, but over the years the use he has made of them has changed. In the Grange murals the desire to vie with the past led to a complexity which greatly exceeds the deliberately artless brushwork and simple staging of the South Melbourne pictures. He demonstrates his mastery of composition in depth, tonal subtlety, linear calligraphy and the ability to cover large walls with landscape and figures. To work on a large scale, here realized for the first time, would remain a goal in later year.

The religious paintings of the forties were accompanied by a great many compositional drawings. Boyd had always been a prolific draughtsman. Tadgell lists thirty drawings between 1934 and 1940, consisting mostly of studies of family and friends. The National Gallery Art School, still teaching stump drawing from plastercasts, had held little attraction. He had attended private drawing classes in a studio in Dudley Buildings, Collins Street, but few model drawings remain. He changes from chalk to pen drawing and the war years see fantasy compositions leading to the South Melbourne 'poems', reflecting here and there his interest in Picasso. Open air landscape drawings precede the Hunter series, when chalk comes back into use. Drawings of Yvonne, of the infant Polly, of friends and domestic scenes proliferate. In media ranging from chalk to pen or pen and wash he moved to the study of profiles, hands, fold motifs, elbows, umbrellas. While he was living at The Grange Boyd made a large

number of studies of everyday life in town and country as well as of bush, paddock and fields.

The fantasy drawings preceding or accompanying the religious paintings of the late forties are often pen and wash and of great resourcefulness. Among the preparatory drawings for ceramics the study of Picasso's Vollard Suite becomes obvious, not only in the poses but in the great concern with the nude in complicated positions and the use of pure line drawing.

After the family returned from The Grange to Murrumbeena Arthur invented a new type of ceramic which combined translucency of colour with the format and figurative content of oil paintings. He made tiles of about 24×24 inches (61×61 cms) and, mixing various coloured oxides with clay to the consistency of oil paint, covered them with compositions. They were then sprinkled with lead glaze and fired in a slow kiln. The imagery revived some of his religious scenes in more compressed and vehement forms. New themes appeared. The crumpled pose of *Icarus Fallen on a Field* [59] has its ancestry in Picasso's broken-down Minotaurs of the Vollard Suite. The image has no precedent in art history that I know of. Icarus is more often shown falling through the air, his wings on fire. Boyd's inclination to think himself into texts and select episodes congenial to him led to some of his most celebrated works of later years, such as the St Francis, Nebuchadnezzar, and Narcissus series. *Jonah Swallowed by the Whale* and *Cripple and Factory Chimney* [60, 61] mark the use of Picasso's curvilinear Cubism of the early thirties, and attain the rich effects of mediaeval glass. In *Tobit and the Goat* [42] with the sharp recession from Tobit in the foreground to the diminutive Anna in the distance Boyd returns to devices of the South Melbourne forties, enhanced by the beauty of the deep lustrous colours. As related in the Apocrypha, blind Tobit suspecting that his wife had stolen the kid commands her to return it. The statuette-like goat, fingered suspiciously by the blind man, suggests that in Tobit's imagination the goat figures as the Golden Calf. One of the most important of these early ceramic paintings, which exists in several versions, is *Temptation of St Anthony* [43], where the traditional temptress is reduced to half a head repeating the shape of the rock boulders that surround the saint. Young viewers are often struck by the prophetic similarity of Boyd's work to the paintings of Chia, Paladino, Clemente and other Neo-Expressionists.

Taking his exploration of ceramic technique a step further, Boyd

built a very large kiln for firing sculpture. His father had made small figurines and full-scale heads of a traditional kind. His son has described the acute pleasure he derived from seeing his own large pieces coming out of the kiln, 'complete, uncracked and with a terrific glaze'. *The Kiss of Judas* [*62*] and *The Thirty Pieces of Silver* [*44*] both formed part of Boyd's first exhibition of ceramic sculptures at the Peter Bray Gallery run by the painter Helen Ogilvie, the former being acquired by the National Gallery of Victoria, the latter by John Reed. In the gallery bulletin Philipp wrote: 'Entering the exhibition room . . . one felt like walking in a strange forest of gnomed beings, a world magically convincing yet imaginatively separate from ours', and stressed the means of 'heightened expressive emphasis' that distinguished the new work. It is unusual for the High Priest to be shown with the hand in which he accepts the thirty pieces of silver from Judas held behind his back. A similar hand occurs in Rodin's *Burghers of Calais*. To compare Boyd's group of gnomes with Rodin's life size bronzes is to experience once more the artist's ironical stance towards himself and the masters.

A clearer relationship exists between *The Kiss of Judas* and Picasso's Boisgeloup heads, which provided part of the inspiration for the huge noses. The disproportionate relation between the heads and the bodies continues Boyd's practice of the forties [*9, 16*] which focuses our attention on the expressive faces. The Olympic Pylon, commissioned in 1954 and standing thirty-five feet high, is Boyd's largest ceramic sculpture; an elongated version of it, called *The Sisters*, is in the Adelaide Gallery. Its motif derives from Picasso's art, but the main influence came from Picasso's personality. The Spaniard's versatility, his technical brilliance, imaginative depth and creative vitality had a mesmerizing effect on many Melbourne painters of Boyd's generation.

In between preoccupation with the Grange murals Boyd found landscape subjects in the surroundings of the house, which, standing on a hill, offered a wide view over the countryside. His Berwick landscapes still pay homage to Bruegel. The interlocking zones in the middle distance of à Beckett Road [*63*] and the framing copse on the right, through the spindly trunks of which the track disappears from sight, form a framework learnt from the Flemish painter. But the ghostly, white, claw-like skeleton trees, the sheds in the centre and the cart equipped for the safe transport of wood are uniquely local.

When in the summer of 1948–9 and again in the following year the Boyds made prolonged stays in the country bordering on the

Wimmera River in North West Victoria, the large flat expanses of wheat and pasture suggested yet another image of nature, more typically Australian than the smallholdings of the fertile Berwick district.

The early Wimmera landscapes painted in oil are heavily textured, though the palette knife has not been used with the vertical order evident in the Peninsula landscapes. The later paintings – for example, *Cornfield, Berwick* [45] and *Burnt Wheat Stubble* [64] – are often in tempera, delicately and thinly painted in the pale yellow and brown tones of high summer. They are enlivened by such detail as thistles and grasses in the foreground or a watermill, a dam, a bull or a distant shed [46]. In the painting named *Santa Gertrudis Bull* after the mythically enlarged black creature in the centre, the scene, in itself uneventful, consists of an open space which, like the sea, gives one a feeling of immensity and infinity. Boyd also made excursions into the Grampian Hills which border on the Wimmera plains to the west, where bush and rock offer opportunity for a delicate calligraphy [65]. The wilderness here does not inspire him to the fierceness he had put into his Hunter series. A Grampians waterfall [66] is held in such restrained and objective key that it conjures up memories of early landscapes by Von Guérard or Chevalier, then perhaps unknown to him. Though there is an earlier waterfall drawing (Tadgell 519), the locality of which has remained unspecified, such a subject does not enter Boyd's work again until the seventies.

The earliest depictions of Aborigines date from before 1800, from the first years of the settlement of Port Jackson. As Bernard Smith has shown, the concept of the noble savage which inspired so many portrayals soon gave way to the 'comic savage' bearing 'the marks of degeneration consequent on contact with Europeans'. Illustrators depicted the tribal rites of the Aborigine, his food gathering and hunting, his weapons, dogs and humpies, or his usefulness as a native guide. Rarely is he endowed with human feelings. Few Australian painters of the early twentieth century took black people as their subject. Gauguin's residence in Tahiti, however, and the new approaches to ethnic art – which, as ethnograph James Clifford has shown, resemble the methods of Surrealism – renewed artists' interest in native peoples.

In the forties Yosl Bergner and other social realist painters depicted the wretchedly poor Aboriginal families who lived at the edges of town. Aborigines appear in Russell Drysdale's *Station Blacks, Cape*

York 1953, dressed in cast-offs, with army-disposal digger hats, members of a doomed race. Later, in a mood of mysticism, Drysdale presented the Aborigine against the background of vast empty outback scenery as the holder of the mysteries of the Stone Age. Arthur Boyd in his sketches noted down the realities of Aboriginal life in Alice Springs [*67, 68*]. The paintings which ultimately resulted from them were of an entirely unprecedented nature.

He had taken the train from Port Augusta to Alice Springs equipped with sketchbook, pencil and pen. From the window he drew passing sights, huts, animals, snakes and people [*69*]. In Alice Springs and Arltunga he recorded blacks and half-castes living in squalor in shanty towns, whorlies and dry riverbeds, and noted their total isolation from the white population. To him the blacks he saw were neither 'noble' nor 'comic' but tragically suspended between two worlds. His deep concern with the deprivations he witnessed led him to imagine what a half-caste Aborigine might feel, what dreams and fantasies might result from his inability to bridge the gulf between himself and black as well as white society. In following his hero into the channels of the subconscious Boyd adopts a similar course to Patrick White in his treatment of the black boy, Jackie, in *Voss*, written in the same years in which Boyd was contemplating his Bride series [*47, 70–74*].

Five years elapsed during which the dark memories of Alice Springs, the symbolic images created in the forties, the colours and shapes of his ceramic tile painting and of Chagall's fantasy world all combined together to yield the most important group of works of his Melbourne years. Philipp found features from Chagall in the early forerunner of the series, *The Half-Caste Wedding* of 1955. The Russian painter's levitating couples initiated the idea of making marriage the test of the half-caste's relation to his world. The white bride, the bouquet and flowering trees, even the green jacket and dark trousers of the bridegroom, occur in Chagall's work – but the Russian master's pictures are celebrations, affirmations of life, nostalgic fantasies of happiness. For Boyd the bride motif brought back a memory of an open truck at Alice Springs which carried a number of Aboriginal women to church, their white bridal finery contrasting with a method of transport more fitting for cattle. Boyd's leading theme is frustration. His interest in the stage could have contributed to his choice of a narrative form; he was at the time drawing costumes for Peter O'Shaughnessy's staging of *King Lear* at the Arrow Theatre, Melbourne. It must also be remembered that Sidney Nolan's Ned Kelly series was painted earlier, in 1946–7. Boyd's pictures vary in size

and do not tell a coherent story, but his friend Tim Burstall was able to use many of them for his ballad-like film entitled *Love, Marriage and Death of a Half-Caste*.

Some of the earliest paintings are based on sketches he had made in 1951. The corrugated iron shed and the bird sitting on its roof in *Half-Caste Child* closely follow drawings. *Aborigines Playing Cards outside Whorlie* [67] is transformed into the allegory of *Shearers Playing for a Bride* [70]. The shearers are illuminated by love, symbolized by a hurricane lamp around which fluttering moths court disaster. The bride, offering a bouquet, is beset by 'beastly sex'. Here, as in the following scenes, the Aborigine is clad in an old-fashioned green uniform with brass buttons. His skin colour is blue, like that of the gods in Indian painting. The Frightened Bridegroom [71] reminds us of Polyphemus, one of the race of Cyclopes who once worked as smiths for Zeus but lost their 'employment' and who, according to Homer, lived 'sullenly apart from one another in caverns hollowed from the rocky hills'. The painting is set in the wilderness of Boyd's early bush landscapes. Forebodingly, a dead sapling has fallen from its fellows in the bush. The bride and bridegroom are outcasts from society, both black and white. The citified black in European clothing tears the bride's veil and shoots the groom [72]. A funeral bouquet grows out of the groom's ear. Like an incubus the dead man lies on the bride's veil, as with an age old gesture of lament she turns towards the only other human face present, the reflection of her own [73]. In this painting, originally called *Neglected Bridegroom*, the bride plays the role of Narcissus who, obsessed by his reflection, became insensible to all around him – a theme to become one of Boyd's leading preoccupations in the seventies [148, 163–4, 186]. The figures of this series are larger than any painted earlier by the artist. They occupy the front of the stage, rarely move and often have a background of wilderness symbolic of their lost state. As the series grew, a more linear and flatter style began to prevail, which put Philipp in mind of Boyd's friendship with John Brack, Robert Dickerson and Charles Blackman. The strong colour fields bear resemblance to his ceramic paintings. Elwyn Lynn was reminded of Gauguin and wrote: 'Boyd, like Picasso, employs a tradition to comment ironically on it and on his own work'.

Certain motifs in this series recall Boyd's paintings of the forties. The flowers growing from the head, the recumbent lovers [72], the lamenting bride [73], the man vainly stretching out his hands towards the disk of the sun, the hanging crescent moons, the Aborigine in a coffin, the watching black bird, show that the vocabulary formed at

South Melbourne served as a fount of inspiration throughout his life.

In one of the last pictures of the series, *Bridegroom and Gargoyles* [47], the bridegroom is one-legged; the sun is setting in a fiery glow and all around and above the Aborigine are the fierce heads of the gargoyles and their shadows. Bridegroom, cripple, soldier and Aborigine combine to form an image of the victim in an inescapable trap.

In this series Boyd has created symbols of Aboriginal mentality which are similar to later comments by the Australian anthropologist W. E. Stanner: 'homelessness, powerlessness . . . produced . . . inertia, the non-responsiveness, the withdrawal, the taking with no return, and the general anomy that . . . characterizes Aboriginal life during their association with us'.

Arthur Boyd, David Boyd, John Brack, Robert Dickerson, Charles Blackman, John Perceval and others were strongly committed to figurative art at a time when the taste for abstraction was taking an increasing hold on younger Australian painters. The art historian Bernard Smith formulated a manifesto which asserted the cardinal importance of the image in painting. Arthur took no active part in the statement, though he contributed to the exhibition called 'The Antipodeans' held in August 1959. He was already totally absorbed in preparations for his first European journey.

PART II
1959–1971

Arthur Boyd had long wished to see Europe and in 1959 he went abroad with his family for what he believed would be a period of a few months. In Australia, he was now regarded as a leading artist, his paintings were bought by collectors and he had been taken on by a Melbourne dealer, Thomas Purves, who guaranteed him some financial support for the journey. Not only did Boyd want to see original paintings by the masters but longed to test his own paintings on the London market and before a new set of critics.

He arrived in England at an opportune moment. By the late fifties Australian painting had become sufficiently well known in London for the British Council to sponsor a visit to Australia in 1960 by the Director of the Whitechapel Art Gallery, Bryan Robertson, who selected from dealers and studios the examples which made such a vivid impact when they went on display in his gallery in 1961. Boyd obtained a one man showing at the Zwemmer Gallery in July and August of 1960 and was offered a retrospective at the Whitechapel Art Gallery in 1962, for which he painted more than sixty new paintings. The six months' stay lengthened into twelve years.

The high spirits induced by his acceptance in London are well illustrated by the following incident. Soon after moving into his Victorian house in Highgate the artist prepared the selection of works for his retrospective at the Whitechapel Art Gallery. In the large downstairs room, which extended from the street front of the building to the garden front, the former owner had left a pair of huge red velvet curtains. Boyd pulled the curtains across the whole width of the street window and directed a strong studio-light on them. Several hundred paintings were stacked on either side along the walls. When Bryan Robertson came, he found a chair and a table with a whisky bottle at the far end of the room. One painting after another was put against the red curtains – at such a rate that Robertson pleaded repeatedly, 'Not so fast!' and finally stopped the seemingly endless flow of works with the words, 'Remember this is *an* Arthur Boyd retrospective, not *the* Arthur Boyd retrospective.' When the show opened in June 1962 visitors saw paintings from all periods of Boyd's development as well as sixty-three new works made in London.

Boyd continued to paint subjects from the Bride series. *Lovers by a*

Creek [*74*] is a variation on earlier scenes, but the imagery has become simpler and the loose, open brushwork and ordered composition suggests a new concern with picture making and paint texture. The Aboriginal motif is gradually abandoned; by 1961 the nude has replaced the bride. One should not leave out of account the example of Nolan's Leda series of 1958 exhibited in London in 1960, in which a pale Leda floats before a dark ground, as well as the impact of the Old Masters in the London National Gallery. Boyd was inspired first of all by Piero di Cosimo's naked nymph [*102*], which became a favourite painting. Recumbent and then floating nudes appear in his work in 1961 [*103*]. He had not been able to find a nude among the collection of Old Masters at the Melbourne gallery. Unlike some other nudes in the London National Gallery, Piero's figure is not an allegory nor has it been possible to ascribe a mythological significance to it. The dead nymph with the small wound in her neck is part of the life of nature – a faun delicately tests her forehead for warmth, a dog grieves; flowers and plants surround them. Piero modifies the normative poses of Quattrocento art and depicts his animals and the estuary setting with a rare acuteness of observation. Unlike Bruegel and Rembrandt, who had caught Boyd's attention earlier, or Titian, who was soon to occupy him, Piero di Cosimo was not one of the most acclaimed masters of his time, but he was its *unicum*. 'He loved to see everything wild,' wrote Vasari. Piero's most memorable works are a series of pictures showing the development of man from an animal state to an early form of primitive civilization. Consciously or unconsciously Boyd felt the attraction of this streak of primitivism, the slightly macabre association of eroticism and death in Piero's painting. Neither realistic nor classically proportioned, the keynotes of Boyd's nudes are sensual and romantic. The resting nude undergoes variations, turns into a dragonfly, or in an insect-like pose washes in or drinks from a creek [*104*]. By 1962 the nude represented by leg and head only is 'unveiled' by the dog, or turned into a double nude, or, in comic variation on Picasso's Minotaur, has been captured by the bull [*105*]. The floating nude, leaning across a dark pond like a silvery trunk of a dead gumtree, bears a resemblance to Merric Boyd's pottery design [*106, 5*]. A group of paintings pays homage to Titian's *The Death of Actaeon* [*107*], which at this time was on loan to the National Gallery. In *Lovers with a Bluebird* [*48*] the canvas is unified yet detailed; on the red ground, which reaches to the upper margin and eliminates the sky, tempera inscribes a delicate tracery of slender saplings and grasses. The open brushstrokes of the highlights are reminiscent of the late manner of

Titian's *The Death of Actaeon*. The lovers basically derive from Boyd's early adaptations of Picasso's *La Vie* but later work by the same artist suggested the cubist merging of heads, to which the bodies, armless and reduced in scale, are subordinated. Woven into the group is the memory of Correggio's *Io*, which the painter had seen on his visit to Vienna in 1960 and which suggested the confrontation of faces; the cloud arm of Zeus seems reflected in the dark snake-like limb of Boyd's lover. The bluebird of happiness pays homage to Conder's water-colour of that title in the Melbourne gallery.

We find a closer response to Titian in the pictures referred to as *Nude with Beast*, of which we reproduce the third version [*108*]. It must be remembered that Titian's subject was the chaste goddess Diana casting a spell on the hunter Actaeon, who had accidentally seen her naked. As a result Actaeon was transformed into a stag and torn apart by his own dogs. Boyd's upright nude recalls the diagonal stance of Titian's Diana; she is shown combating a two-legged monster which, Philipp thinks, is the transformed Actaeon who haunts Diana in her dreams. The female figure in this series is for the most part represented with eyes shut. From a triumphant victor, then, Boyd has turned Diana into a victim, so bringing the theme into line with his early images of sex and beast [*75*]. Another viewpoint comes from Brian O'Shaughnessy: 'The sensuality which we meet in these paintings . . . is the true sensuality of the flesh and is enshrined in the irridescence and luminosity and calm of autumn and sunset, those times of peace and fruition and harvest.'

Among the attractions that kept Boyd in London long beyond the six months he had originally intended to stay were commissions that took him into new fields. One of the most momentous of these was the opportunity given him in 1963 by Robert Helpmann, the actor, dancer, producer and choreographer, who asked him to design the sets for his ballet *Electra*. The sets originated in a series of etchings, the first independent venture into this medium on which Boyd engaged after a visit to a Goya retrospective at the Musée Jacquemart André in Paris in December 1961. He may also have seen etchings at the great Picasso retrospective at the Tate Gallery in the summer of 1960. His technique consisting of fine line work and deep shadows recalls Goya and Rembrandt but the imagery continues the line of thought of the *Nude with Beast* paintings of the same years, in ever new combinations to which such early motifs as the gargoyle heads, the horned beast, and the double-ended figure lend a note of violence and fantasy. These

prints, vastly enlarged and transferred onto huge canvases, became two backcloths and two permanent screens boxing in the set, black on white and white on black [*109–11*]. The red floor symbolized the blood of the murders that took place in the house of Atreus. The costumes were purple with an all-over design of winking eyes, gargoyles and snakes [*112*]. The Erinyes were made up with three faces, so that they seem to look at the spectator rather than at Electra in the throwing scene [*113, 114*], which rises to a pitch of violence unprecedented in ballet. Neither the sets nor the costumes have survived.

Richard Buckle, organizer of the Shakespeare exhibition held to commemorate the four hundredth anniversary of the poet's birth, had been much impressed by the *Electra* backdrops as well as by some Shakespearean scenes among the ceramic paintings Boyd had shown at the Zwemmer Gallery in 1963. He asked the painter to contribute to this event and allocated *Romeo and Juliet* to him, as most suited to his style. In a detailed analysis of the polyptych [*76–8*] Philipp stressed that Boyd does not illustrate narrative episodes; his images arise from Shakespeare's poetic metaphors and from the moral concerns which underlie all of Boyd's art. Romeo and Juliet are seen as victims – they are outsiders, though different from the distressed people the artist watched on the Port Melbourne waterfront or, later, among the Aborigines at Alice Springs. Having acted against the will of their society, the lovers, more by default than design, die tragically. Boyd was particularly touched by the element of chance in the course of events that led to their death.

The most important image, that of the centre panel, [*76*] variations of which occur several times in the polyptych, calls up the lines in Act V, scene 3:

> What's here? A cup clos'd in my true love's hand?
> Poison, I see, has been his timeless end.

Boyd's imagery with its overtones of Wagner's *Liebestod*, goes back to one of his most memorable compositions of the forties, *The Fountain* [*28*]. In both, the reclining monster forming the foot of the cup symbolizes the passions and a tree growing from the beast carries heads, here blossom-like and weeping. As Juliet, intertwined with the tree (of Life, of Paradise?), drinks the poison, her lips touch a mirage of Romeo's lips recalling the lines of Act V, scene 3:

> I will kiss thy lips;
> Haply, some poison yet doth hang on them,
> To make me die with a restorative.

The delicate shimmering colours and the glistening glaze transfigure the imagery so that it inhabits a realm not quite of this world in a manner akin to mediaeval enamel.

Of the same period as the Shakespeare Memorial, *Two-ended Figure with Bouquet* [79] has been described by Philipp as a 'literal construct of a hermaphrodite'. Does the laurel-wreathed head of a poet emerge from the dreams of the sensual man? The free, delicate and painterly effect obtained from the ceramic medium has a beguiling quality.

Soon after the physically and mentally exhausting work on the Shakespeare Memorial polyptych had been finished Boyd changed to a hitherto untried and totally different technique. In 1965 Hal Missingham, then Director of the Art Gallery of New South Wales, asked him in an interview about his method of working. Boyd's answer throws an interesting light on the reasons for such a change: 'I find that I work very intensely for a period of say three or four months at a time, usually with a gap of a month, preparing the way for this . . . more intense work; . . . the preliminary work done between these bouts of work would be such as drawing or putting down ideas in a fairly crude way, and also changing medium to either relieve myself from getting too bogged down in the one thing . . . or of giving relief in some way.' The way in which he obtained relief after the very exacting and complicated process of the tile paintings was to take up pastel.

In this medium he returns once more to the imagery of the forties such as the kite, the lovers in a boat and others. Even the manner of working with short, regularly spaced strokes of pastel recalls the ordered strokes of the palette knife in the Peninsula landscapes.

More easily transported than the requisites of oil paint, panel or canvas, pastel sticks accompanied him on the annual holiday which he and Yvonne spent in Umbria in 1964. In Gubbio and Assisi the story of St Francis began to engage his imagination – the red dog of previous paintings turned into the Wolf of Gubbio.

The interest in St Francis may owe something to the mediaevalist T. S. R. Boase, then President of Magdalen College, Oxford. Earlier in 1964 Boase, who had met Boyd on his visit to Australia in 1956, had written a foreword to the catalogue of the Arthur Boyd Exhibition at the Bear Lane Gallery in Oxford. In 1934 Boase had published an edition of a life of St Francis, the greater part of which was destroyed by enemy action during the war. After Boyd returned from Italy he read Boase's book and the *Fioretti of St Francis* and continued a series of pastels which were eventually turned into black and white lithographs used to illustrate a new edition of the book. Covering the

surface of the paper with short parallel marks predominantly of yellow and red, the pastel strokes impart to the scenes a sense of light which not only divests them of any merely narrative and mundane significance but conveys a feeling of spiritual grace appropriate to the subject. Boyd mostly avoided incidents occurring in the great Italian painting cycles. Such familiar scenes as St Francis' sermon to the birds, are not used. Instead, the saint's relation to his followers yielded most of the subject matter. In his *Turning of Brother Masseo* [*80*] the repeated profiles of hands and feet make a pattern both striking and whimsical which would have been unlikely before the days of Cubism and Muybridge's slow-motion photographs. In *Dreaming of a hunchback* [*81*] Boyd turns St Francis' elegant garment into a patchwork coat reminiscent of the 'coat of many colours' of the young Joseph. *St Francis cleansing the leper* [*82*], by throwing water over him, is a particularly fine example of the open transparent strokes of the crayon and of the restrained colour scheme. Reduced to essentials, silhouetted against plain backgrounds and more differentiated in gestures and attitudes than at any earlier time in Boyd's *oeuvre*, these figures have a family resemblance to the Trecento frescoes which the artist saw in the churches in Tuscany.

Another outcome of his friendship with T. S. R. Boase was a book reproducing paintings and drawings by Boyd on the theme of Nebuchadnezzar for which the writer had compiled the biblical and historical sources on the history of the king.

According to the Book of Daniel, Nebuchadnezzar, King of Babylon, was 'driven from men, and did eat grass as oxen, and his body was wet with the dew of heaven till his hairs were grown like eagles' feathers and his nails like birds' claws. "And at the end of the days I Nebuchadnezzar lifted up mine eyes unto heaven and mine understanding returned unto me and I blessed the most High" and he was re-established in his kingdom.'

No painter had ever devoted himself to imagining the experiences of Nebuchadnezzar in the wilderness. Dutch seventeenth century painters concerned with the mercy God extends to the unworthy had shown the king humbled and regenerated as he returned from his exile. William Blake was the first to show the king as half human, half animal, with 'hairs like eagles' feathers' and 'nails like birds' claws'. Arthur Boyd had a free field.

In thirty-four canvases Boyd shows us the punishments of the king. The cycle begins with the Jewish legend which told that Nebuchad-

nezzar made a cloud [*83*] to hide him from human eyes so that he would be like God. Boyd lets the cloud rise from the king's recumbent body; in the cloud shines the face of God, who rebukes the king for his presumption. The 'great tree' [*84*] of the king's dream which was to be cut down by order of a holy man, also rises from his body. Daniel interprets it: the tree is the image of the king and the cutting down a prophecy of his madness.

Nebuchadnezzar had aimed too high: 'Pride goeth before destruction and a haughty spirit before a fall' (Proverbs). Boyd was reminded of Icarus, who, flying too close to the rays of the sun, fell to the earth in flames. He portrayed Nebuchadnezzar as a meteor heading down towards a waterfall in the Australian bush. He lies crumpled on the ground [*85*]. The punishments that follow fit his crimes. He committed acts of cruelty such as ordering Shadrach, Meshach and Abednego to be put into the fiery furnace: many of the king's trials consist of burning. He is sometimes credited with imprisoning Daniel in the lions' den [*86*]; a wild lion with open jaws roars at the king in the wilderness [*87*]. Boyd also shows him tormented by water, with his head rolling in the surf on a pebbly beach [*88*]. Various legends suggest aberrant sexual tastes, which may account for the testicles, often red hot, with which Boyd endows him, echoing verbal images such as 'inflamed by lust', or Blake's 'O Flames of furious Desire' (Urizen) or 'burning with shame, with pride'. Not only pride, cruelty and concupiscence but an inordinate obsession with gold made the king culpable. In another painting he lies head foremost in total foreshortening, like the dead in classical Roman battle reliefs, faceless and diminished by his total preoccupation with money, which, as gold coins, lies all around him. In [*89*] he is bent double around a heap of coins.

A fate not directly related to the biblical text but one which is obviously feared by painters is blindness [*90*]; in no less than three plates Nebuchadnezzar is shown sightlessly groping his way through darkness. In these as in some other images flowering plants grow on his back, their stems sticking in his flesh like the feathered arrows in the body of St Sebastian.

He is tormented by a longing to escape. Immersed in sand [*91*] up to the neck, he desperately struggles to climb a steep hillside. In fulfilment of Daniel's prophecy he has become like a beast of the fields, a ram; only hands and testicles remain of his human shape. The lion [*92*] which has been pursuing him has turned into the peaceful white image of Daniel's den [*86*]; Nebuchadnezzar, half-transformed into a

tree raises his eyes towards a rainbow, the token of the covenant God made between himself and Noah. In the last painting of the cycle [*93*] Nebuchadnezzar, burning with remorse, is accompanied by Daniel, whose prayer effects the king's return to reason and the world of men.

The mesmerizing imagery of this series is a tribute to Boyd's artistic culture, to his awareness of the art that surrounded him both in Australia and in the Old World, and to the heights to which he aspires. Though there is no narrative sequence, the whole cycle gives the impression of a pilgrimage such as Dante's through the Inferno; Dante's *Divine Comedy*, as illustrated by William Blake, can be seen in over thirty watercolours in the Melbourne Gallery and was much publicized in Boyd's youth. The tree growing out of Nebuchadnezzar's body has an analogy in Dostoievski's *The Brothers Karamazov*, which made such an impression on the young Arthur Boyd that he has frequently referred to it in interviews. In the famous dialogue between Ivan Karamazov and the Devil, the latter says, 'I will plant a small seed in you, from which will grow an oak – and such an oak, that you with this tree in your chest, will want to join the hermits and unblemished maidens, because, secretly you long for that, in fact greatly. You will eat grasshoppers and drag yourself into the desert.' Some of the imagery was adapted from previous work of his own. *Nebuchadnezzar fallen in a forest with black birds* [*85*] reflects his own tile painting of *Icarus Fallen on a Field* of 1951–2 [*59*]. The Blind Nebuchadnezzar [*90*] has an affinity with Picasso's blind Minotaur in the Vollard Suite. The precedent for *Nebuchadnezzar buried in sand* [*91*] is the mysterious, unique and unforgettable image of a dog by Goya in the Prado.

If these considerations appear far from the concerns of life and art of the 1960s, one must remember that Boyd is dedicated to the use of allegory. The psychology of cruel, dictatorial rulers is not irrelevant in the twentieth century. *Nebuchadnezzar in flames* [*93*] brings to mind Vietnamese children set on fire by napalm bombs. Some of the Nebuchadnezzar images are transferred to the conflict-ridden painter, Boyd's subject in the seventies. One should also remember Sidney Nolan's nine *Inferno* panels of 1966 which recall, according to Hal Missingham, 'the remarkable Hiroshima panels widely exhibited after the last war'.

Whilst the compositional principles of the series do not vary greatly from those used in the early sixties, the actual handling of paint and colour has undergone great changes. The pictures glow in a veritably Babylonian opulence of colour. The white king is set against the pinks

and yellows of the fiery bush; delicate nuances of gold and blue penetrate the image of the cloud; the tawny lion contrasts with the luminous blue of the night. Often the texture of the brushwork is so open and light as to resemble drawing and points to a very fast working pace. The dark tonality of the *Nude with Beast* paintings has given way to light and colour; as in the St Francis series, figures and backgrounds form a pattern on the picture plane against sloping and undulating horizon lines or the parallel verticals of gum saplings, reminiscent of clumps of trees drawn in the 1940s by the painter's father, Merric, which form a near abstract pattern of blue and purple verticals on a light ground. The figures of the Nebuchadnezzar series are often close to the baseline. Yet occasionally, as in *Nebuchadnezzar's head in a wave* [*88*], the diagonal recession into space usual for landscape painting re-emerges.

In the book *Nebuchadnezzar* by Arthur Boyd and T. S. R. Boase the illustrations are interspersed with pages of drawings in which certain Nebuchadnezzar themes are elaborated but which also resurrect older motifs and bring in new ones now centring on the theme of 'the potter'. The latter had already made an unexpected appearance in one of the paintings – *Seated Nebuchadnezzar and crying lion* [*94*] – in which the king, in uniform, holds a pot between his hands, while the seated lion sheds tears like the Wolf of Gubbio in the St Francis series. In addition the king has the features of the Austrian painter Oskar Kokoschka, whom Boyd had met during these years.

If the Nebuchadnezzar series was heroic and historical, the Potter paintings which followed were intimate and autobiographical. They are poetic evocations of the early life of Merric and Doris Boyd, the artist's parents. Both had died: Merric in 1959, shortly before Arthur and his family left Melbourne, Doris a year later. Their deaths and the dissolution of the home at Murrumbeena prompted works of a more private nature than any undertaken since the forties. By 1964 Boyd had experimented in several compositions, but the theme is not consistently pursued until after early 1966 when the Nebuchadnezzar theme had been exhausted. From the next two years dates a large output of drawings, etchings and paintings on this theme [*95–101, 116–20, 127–33*]. Tadgell records thirty-nine drawings between 1966 and 1968 and fifteen between 1968 and 1970; in addition Boyd made about sixteen etchings and two series of paintings.

Some of the paintings are childhood memories: Boyd's mother walking in the orchard of Open Country near the house [*95*] or sitting

in an armchair among the spring foliage [*96*], and his father resting, his long legs stretched out on the ground, drawing a seagull on the beach or a cow in the bush near where the never-completed circular railway passed Open Country [*97, 98*]. At dusk or dawn the mother drives the jinker home from the beach [*99*]. The potter's wife decorating a pot [*100*], with the potter's dark, Van Gogh-like face looming up next to her red hair, is a half-figure composition of the kind Boyd had used for Saul and David [*55*]. The figures on the beach at 'Arthur's Seat' [*101*] participate in the gentle morning tonality of the jinker scene [*99*] but its truly Australian character is complicated by the subtlety of the mist-laden atmosphere the pictorial inspiration of which owes less to nature (the artist not having visited the spot for nearly ten years) than to Turner's *Evening Star* in the London National Gallery. James Gleeson wrote of the painting in 1969: 'He could not have painted so fair and radiant a dusk if he had not stood before his canvas on a beach by Arthur's Seat ... and yet they were painted in London.' The figures evoke the honeymoon of Boyd's parents spent at Rosebud; by their close similarity to Adam and Eve [*37*] they also refer to 'our first parents'. Such intermingling of memories and associations resulting in many-layered meanings increases as the series develops. The woman in *Figure in a Wave* [*127*] may be the potter's wife, but she has seaweed hair and recalls early drawings and *The Baths* [*29*] and compares closely with *Nebuchadnezzar's head in a wave* [*88*]. Father sitting on the ground surrounded by pots from the empty kiln [*128*] seems close to memory, but has poignant overtones of fantasy. The 'dislocated' pose of his right arm reminds us of his falling-sickness; at the side in the wintry bush looms a vision of the wife as Venus or Eve; in the distance of this sombre scene a fruit tree begins to bloom. Intimations of inescapable suffering, so strong in the South Melbourne paintings [*30*], is the theme of the highly expressionist *Potter Falling over a Decorated Pot* [*129*]. The complex composition, recalling Picasso's etching *Female Matador I*, opposes the upside down head of the potter with the large white features of his wife. His huge head with dishevelled hair conjures up images of Christ crowned with thorns. The figures surround a large green pot decorated with the cow of the potter's drawings, whose large and colourful udder symbolizes obsessional fixations. The consoling role of the potter's wife reaches its climax in *Pottery Destroyed by Fire* [*130*], a tragic event of the year 1926 which deprived the family of its livelihood.

The paintings discussed so far formed part of an exhibition held in

Brisbane's Brian Johnstone Gallery in August 1969. In October of the same year others, larger and stronger in colour, were shown at Arthur Tooth's gallery in London. In the beginning light brown harmonies had prevailed; later, at Tooth's, red-blue or blue-green contrasts became frequent. Some of the Johnstone exhibition subjects recur in London in more vivid colours [*131*]. *Early Morning – Potter and his Wife on the Beach* [*132*] evokes a new range of poetic associations. We are reminded of *Nebuchadnezzar's dream of the tree* [*84*] with overtones from *Nebuchadnezzar's head in a wave* [*88*]. The potter, who, in the likeness of Blake's figure of Dante in one of Melbourne's watercolours, makes a 'marginal' appearance, has a vision of his wife as the progenitor of the family tree. Picasso's *Sculptor in his Studio* from the Vollard Suite is echoed in *Potter Holding Plaster Head* [*133*]. Merric Boyd not only conceived of the throwing and moulding of pots as a form of sculpture, but also modelled figurines and bust portraits. The triangular composition, the strict profile attitudes and the ideal nudity are neo-classical, but the total impression is quite unclassical as well as unrealistic. The nudes are reduced to rudimentary forms; the *grisaille*-type painting is held in tones of blue modulating into green with white highlights, the whole pointed up by the one accent of contrasting red in the hair of the woman. Equally removed from reality is *Potter looking at Chardin Print* [*119*], with the potter's blue face and the red and white skate which has been given the shape of the kites of the 1940s. Boyd's homage to his parents includes not only childhood memories and allegorical dramatization but also nostalgic fantasies. Having been successful during his London years, Arthur had travelled and seen Europe's great art collections including the Louvre in Paris; his father had known France only from the battlefields. Would he have loved Chardin's skate as much as Arthur did? James Gleeson suggests that Boyd in the Potter series created his own *Songs of Innocence and Experience.*

In March 1971 Boyd finished *Lysistrata I* and *II* [*134*], large murals which had been commissioned for the St Helier's Hospital at Carshalton in Surrey with funds made available by the Royal Academy. When the building was to be demolished, the two murals were acquired by the Art Gallery of New South Wales. The lamp of love illuminates Pan's cave, as it had illuminated the shed in which the shearers play for a bride [*70*] and the grotto of Romeo's tomb in the Shakespeare Memorial. Of the many scenes from Aristophanes' *Lysistrata* Boyd chose the moment when some of the women who had

barricaded themselves in the treasury of the Acropolis desert their companions and let themselves down to the Cave of Pan. One finds her soldier husband waiting for her (on the right) but Pan and Dog and Black Beast are watching. In the distance is another escapee and a windmill. The imagery crosses with another passage from Aristophanes' play where the Chorus refers to Melanion, who to avoid marriage 'ran off to the hills and in a special grot raised a dog and spent his days hunting rabbits.' Whoever the inhabitant is of the cave, its golden light, contrasting with the blue green of the bush landscape surrounding it, is the pivot of the painting. A number of depictions of other *Lysistrata* themes on canvas are in the Australian National Gallery. Earlier, Bernard Baer of the Ganymed Press had commissioned a portfolio of etchings, published in 1970, in which the technique used by Goya and Picasso of white figures on a black aquatint ground was employed in contrast to black line on a white ground as in the illustrations by Aubrey Beardsley (1896) and Norman Lindsay (1925) of the same text. Boyd's deliberately unsophisticated style stresses comic rather than erotic implications. The men carrying firebrands to smoke out the women from the Acropolis remind us of gnomes [*122*].

During the sixties Boyd painted portraits of a number of friends who were visiting London. The linear handling of Cameron Jackson [*135*] enhances the effect of his expressionistically enlarged eyes. Like stills from a film, the four poses of Joseph Brown [*136*] with their expressive emphases and anti-naturalistic colours vividly catch the characteristics of the sitter's forceful personality. The fragile grace of very young girls – Cathy and Rosalind – is magically conjured up within the regular grid of widely spaced pastel strokes [*137*].

PART III
1971–1983

In October 1971 Arthur Boyd was welcomed in Canberra as Creative Arts Fellow of the Australian National University. His presence was the occasion of a major retrospective exhibition which covered the whole extent of his *oeuvre*, many pieces having been specially brought back from London. In January 1972 he drove over to Bundanon, near Nowra, to visit his Sydney dealer, Frank McDonald, who owned a house close to the Shoalhaven River. Here, on a day over 100° in the shade, Boyd sat in the open in the sunlight to paint one of the first outdoor sketches he had made in over ten years [*123*]. The intense heat recalled to him Jonah outside the city of Nineveh, the subject of one of his tiles of the 1950s: 'God prepared a sultry Eastwind and the sun beat upon the head of Jonah, that he fainted . . . he said, it is better for me to die than to live.' Boyd lived, and the experience became a major turning point in his career. After coming back to Canberra he persisted in working in the open, in the bush easily reached from Garran, where he and Yvonne had a house. He began a group of large nudes which had no precedent in his *oeuvre* and which were continued later in England. Patrick McCaughey, writer on art and gallery director, describes them as 'making the most traditional use of the nude as a neutrally regarded artist's model'. The poses suggest, however, that Boyd was not merely concerned with mastering a new skill. *Figure by a Creek* [*124*] brings to mind Rembrandt's *Susannah Surprised by the Elders* [*125*]; the direct look together with the surprised gesture of the hand suggests an intruder. In this and other versions the association of the nude with forest, rock and running water recalls Courbet's nude entitled *La Source*. Another of these studies [*126*] makes oblique reference to Manet's *Déjeuner sur l'herbe*; we see the nude model from the point of view of the male figure on the far right of Manet's picture. In the last of the group [*138*] Boyd painted the landscape from the copse behind his cottage in Suffolk and, taking the wet canvas inside, added the model, chair and all. The figure sits removed from 'life', like a posed model. Yet it is homely and relaxed, not unlike John Brack's nudes in domestic interiors. Boyd did to Manet what Manet had done to Raphael and Giorgione. Manet took the pose of his classical and ideal nude from Raphael but gave it the face and body of his model, Victorine, thus creating a witty send-up of

academic conventions as well as expressing his respect for the Renaissance masters. By making *Déjeuner sur l'herbe* into a 'dinner on the grass – Australian style' (the artist's own words) Boyd allied himself with the great European tradition.

In the sixties, living in London, Boyd had little opportunity to paint in the countryside. On his return from Australia in 1972 he moved to a cottage in a rural area and responded at once to its surroundings. *Suffolk Landscape with Gate* [*139*] reminds us that it is painted in Constable country. The hedged fields, the tree-lined horizon, the framing spruce reveal the ordered, long-established nature of the district; the Deben river bank provides the natural habitat of the white swan [*153*]. His earlier preoccupation with the sun-bleached scenes of the Wimmera may have attracted him to the pallid colourless light of winter. He commented on his impressions in an interview: 'The Suffolk paintings are in a fairly high key but when you think ... of Conder's *Yarding Sheep*, a slight marvellous painting which has one single tree and sheep in a very dusty landscape in a tonal range reminding one of Debussy, ... the key of the English landscape drops down about twenty tones. The flatness of the land gives a marvellous light because there is no interruption. The shadows are not strong in England but there are less of them, because the strength of the light is dispersed. The stronger the light the more intense the shadow. If you get a flat landscape with an evenly spread light you get the feeling that it penetrates.' (Quoted with alterations and contractions.)

In Australia Boyd had found some of his landscape themes in the bush, others in open plains. In London in the sixties he sometimes still painted bush interiors, but combined the sparse grey foliage of the gumtrees with the lively green of English leafage. In Suffolk his studio window opened on to a copse of spruce, larch and other trees, the prolonged study of which culminated in the large canvas *Suffolk Copse, Figure and Book* [*140*] in which the mild English light is reflected from the white pages of a book, the pinkish-grey bark of the spruce and the green undergrowth. The colours are intensified by contrast with the white of the book and the image of the painter sketched in on the right. The grasses and bushes rendered in delicate linear detail, the even intervals between the trees, the dimming of light and diminishing sharpness of focus at the sides impose a harmonious order which foreshadows the Riverbank canvases of later years.

The contented mood reflected in *Suffolk Copse* gives way to its opposite in the companion piece, *Painting in the Studio* [*141*]. Against the grey wall of a dimly lit interior leans a canvas on which a painter is

propelled along by a woman, much like the woman with the lame dog in a drawing of the forties [*14*]. The painter is half beast, half man; his face reminds us of the young farouche Rembrandt. Antlers grow from his head, his legs are formless and end in claws; like Actaeon he is changing into a beast. He holds brushes in one hand and gold in the other. A fury-like muse supports, pushes and ravishes him. The figures are set in a gloomy desert landscape. To the right of this canvas the studio wall opens on a view of white hot sand and trees seen through a wire mesh, a motif Boyd associates with laboratory cages for experimental animals. One may infer from the subject that the painter's calling is felt to go 'against the grain', that he is shut off from nature, driven by uncontrollable forces of fantasy and worried lest he appears engaged in his art for material gain.

The theme of the 'caged painter' continues to occupy Boyd in the years from 1972–3. In *Chained Figure and Bent Tree* [*154*] the wire cage encloses the painter's head. The beasts in the distance, the trees to which he is chained hark back to *The Lovers* [*34*]. If in the early pictures the lovers were often shown as the victims of a jealous, vindictive society, the painter in the seventies is the victim of a world which expects him to perform for reward; he is also at the mercy of his own hyperactivity, of an excess of fantasy. Like Nebuchadnezzar he inhabits the wilderness [*87, 89*]; he is watched by the potter who, in uniform and crowned with flowers, stands behind an easel; the painter himself, 'dogged' by a muzzled cur, is vainly chasing his model-muse who escapes from the canvas on the right [*142*]. Rainbow and rain recall the last of the Nebuchadnezzar scenes [*92, 93*]. In another picture [*143*], with bony spines and Asian features crouching among the Chinese reeds, he resembles Nebuchadnezzar buried in sand [*91*]. Wistfully he watches the small birds which so effortlessly overcome the unscalable heights – now covered with Suffolk spruce. In further variations on the theme of what McCaughey called 'the artist *in extremis*' the dog has expired; the painter paints the shadow of a windmill on the shifting sand; or he 'paints a tree', literally, by applying his brushes to a sapling, while the muzzled dog is 'in his hair'. He runs, but is at the same time narrowly confined by a wire-mesh cage.

In contrast to the enclosing forest behind the contented painter [*140*] these ironic send-ups of the painter *in extremis* are often set against the blinding light of a vast desert, which has its forerunners in Boyd's flat arid Wimmera paddocks and in the pallid winterlight of the Suffolk fields but is now recreated in the image of the lower

Shoalhaven estuary [*64*]. The meticulous execution of the Suffolk wood has been replaced by sketchy handling, carrying the marks of great speed and of rapid movements of hand and brush. Boyd brings into being a relation of figure and space new in his *oeuvre*. In the forties he had sometimes shown deep vistas but his figures rarely left empty large areas of the canvas. After the high horizon and crowds of small figures in the manner of Bruegel [*35*] he still uses Bruegel's space in his Berwick landscapes – tilted foreground with only a narrow strip of sky [*45*]; when painting in the Wimmera he returned to the traditional landscape format of two-thirds ground, one-third sky. In the Bride series various relations exist between the large figures and the background. In the early pictures deep space recedes behind the figures to a low horizon; in some late examples space is omitted for a flat ground. Often, however, the ground consists of dense bush filling the canvas to the exclusion of the sky. In the sixties also figures are successfully embedded in the skyless undergrowth of the woodland. He abandoned this formula on his return to Australia and after some trial and error arrived at the vast flat distances which remind us of some of the forties pictures but are now more specifically used to convey a feeling of isolation.

By placing his distracted painter in an eroded land Boyd reinforced the eerie mood of these scenes. He also expressed his growing concern with conservation and his fear for the landscape which had been one of the main inspirations of his art. His arid scenery brings to mind the premonitions of an Australian writer of the last century, Barnard Eldershaw: 'Soil erosion and dessication of the country, the march of the desert [will get us in the end]. . . . We cut down the trees and clear the scrub, grass grows, we bring the sheep and the rabbits and they eat the grass. In a dry spell they dig out the roots of the grass and ringbark the trees that are left. The rains come and channel the naked earth, scar it with crevices. The heat dries the earth to powder, the wind carries it away. No exhalation rises to refill the clouds. The wind and the dust scarify the country. The seed reserve is exhausted, dried out, blown away. The future dies.' Eventually Boyd's painter is reduced to a caveman; he has ceased to be able to communicate; his book is on fire, his brushes are useless since there is no more canvas; the muzzled dog, his alter ego, can neither feed nor howl; the devastated slope offers no shelter [*155*]. In several paintings of the following years the mushroom shape of the atomic explosion foreshadows the termination of life on earth. The pessimism expressed in these paintings matches Boyd's statements made in an interview with Peter Porter in 1977 in which he

referred to a vision of the future – 'of environment being destroyed and everything being overwhelmed by Technology . . .' – and described himself and Peter Porter as being 'in the unnecessary business of entertainment'.

The questioning mood of the early seventies extended to his attitude to the Old Masters. In *Painter, Dog and Model* [*144*] Boyd comments on Rembrandt, Velazquez and Picasso. The painter, a self-portrait, recalls the aging Rembrandt; he sees himself in a mirror. His father, sitting in the wicker armchair of an earlier painting [*120*], is the model; 'so in a way I am trying to push him out of the way and put myself in'. The mirror and the dog lying in front allude to Velazquez' *Las Meninas*. As before, the dog is muzzled, the brushes are not in use. Picasso's variations on *Las Meninas*, which Boyd saw in London in 1960, prey on his mind: 'Would he have liked to be like Velazquez?' he asks. An answer is given in *Figures, Money and Laughing Cripple* [*156*], where the face of the crippled painter recalls the Karamazov heads of his youth but also reminds us of the grinning self-portrait by Rembrandt in Cologne [*157*]. Wearing a fool's ruff, he has taken over his father's brushes and, literally, stands on his father's bones; behind him is a parody of Leonardo's cartoon of St Ann and the Virgin and Child, which resembles Boyd's own early variations of Picasso's *La Vie* [*18*] and shows St Ann sitting on a heap of gold. The Leonardo cartoon is one of the most valuable pictures in the world, not only as art but in terms of money. The publicity which accompanied its sale by the Royal Academy to the National Gallery in 1962 was one of Boyd's earliest experiences in London. The ominously laughing heads, green and red as in the forties, imply that art at any time is made for gain, but that the painter who now emulates the achievements of the masters may turn out to be a fool.

During the early seventies Boyd's friend the publisher T. G. Rosenthal suggested that the poet Peter Porter and Boyd collaborate on a biblical text; the story of Jonah was chosen and the book, consisting of poems by Porter accompanied by etchings and drawings by Boyd, was published in 1973. Both poems and illustrations are playfully satirical. Boyd's drawings match in spirit the ironic images of the despairing painter. Porter's God says:

> Jonah, I don't like what's happening in Nineveh,
> it used to be a military state where everyone
> did his time in the army; now it's all parks
> and permissiveness and lying about.

Boyd's drawing [*158*] of a double-headed monster above a digger's hat which covers a fallen cripple revives ideas of his South Melbourne period. The informal freedom of line is adequate to the grotesqueness of the imagery.

Poet and painter invent Jonah's adventures during his imprisonment inside the whale, a subject as new to art as the trials of Nebuchadnezzar in the wilderness. W. H. Auden described the story of Jonah as 'the story of a voyage undertaken for the wrong reasons, of learning repentance through suffering and a final acceptance of duty.' In Boyd's and Porter's interpretation monstrous images and disillusioned comment prevail. When Jonah has repented and been returned to dry land he gives the Nineveh sermons in which he conveys to the city God's intention to destroy it. Boyd's incisive sparseness, reminiscent of Chinese art, matches the sharp rhythms of Porter's lines:

> Destruction shall spit you out like pips
> Time like a tap be left turned on –
> the maps are lost, this is eclipse,
> You die while the bullfinch starts his song.

Sometimes Boyd's images are like footnotes to Porter's words. Jonah feels let down by God. Despite his sermon Nineveh has not repented, yet God has not destroyed it. 'Not a hair has twitched in a nostril.' Hurt in his pride, Jonah wishes to die. In Boyd's etching [*159*] God is playing with Jonah as the cat plays with the mouse; he holds up the mirror to show Jonah his tear-stained face. The delicacy of Boyd's etched lines, which harmonizes well with Porter's lightness of style, stands in marked contrast to the harsher linework of the etchings and drypoint of the late sixties.

The subject of Jonah inspired Boyd to a great number of drawings and etchings, but to one painting only, *Jonah Outside the City* [*160*], where the prophet had gone to watch God destroying the unreformed Nineveh. Boyd's composite image consists partly of the gourd, which God killed to deprive Jonah of its shade, and partly of the beast of man's sinful nature; expired, it lies on its back, its open belly filled with gold. Nineveh in the distance has the shape often given to cities in mediaeval miniatures. Over the horizon looms the mushroom cloud that threatens the Ninevehs of the twentieth century.

Arthur Boyd and Peter Porter co-operated once more on a book of poems and illustrations, which was published by Secker & Warburg

under the title *The Lady and the Unicorn*. The theme seems to have been suggested by Boyd's Australian friend Georges Mora, who loved the unicorn tapestries in the Musée de Cluny in Paris. Mora's Tolarno Galleries in Melbourne became a subscriber to the book.

According to myth the unicorn is an emblem of purity; it is trapped and betrayed by the woman it loves and made over to the hunters. Porter and Boyd transport it into the fallen world, where it becomes the touchstone of vulgarity, pride, possessiveness, lust, and treachery. Boyd sometimes comes close to, sometimes strays from Porter's themes. He lets the emperor who is hunting the unicorn observe the most seductive embrace that has yet figured in Boyd's work; the unicorn is caught in the lady's long tresses and the bouquet of flowers we remember from the Bride series sprouts in her hand. Since the unicorn dies for love it is likened to Christ; it is hunted by the King's hunters who try to trap it:

> When framed at last in total sun
> The Unicorn with such a cry
> As Christ divulged on Calvary
> Galloped away from grass and wood.

Boyd's unicorn leaps across the disk of the sun; the hunters have fallen like the soldiers who guarded Christ's tomb at the resurrection [*161*]. Boyd derived his imagery from Dante's souls in the Stygian Lake, as illustrated by William Blake [*162*]. Betrayed and imprisoned, the unicorn appears to both artist and poet as a creature crucified. Boyd draws on the most monstrous inventions, the gargoyle-shark heads, the skulls and the images of his beast, which here stand in the services of the pain of martyrdom. Other scenes draw on the ironic contrast between ordinary life and the ideal. Betraying the whereabouts of the unicorn to the soldiers, the lady justifies herself:

> His skin's
> like the sun, but a girl can have
> enough of gods and godliness.

Boyd places her in front of one of those groups of trees so enchantingly reminiscent of Gothic tapestries, putting an Australian billy can (for tea) and two mugs on the ground as evidence of the lady's last assignation with the fabulous creature. Another down-to-earth touch occurs when the lady cradles the unicorn on her lap; in front of her naked feet lies a single unlaced, low-heeled shoe. Porter's poem effects a sudden change of tone; the ecstatic praise of the lady's godlike nature

is followed by:

> she touched the ground
> and wore strong shoes.

The white figures incised with delicately etched detail are set off by the deeply black, richly textured aquatint ground, which ebbs and flows in tone, sometimes flushed by hues of pink, yellow or green. Boyd's imagery and technique recall his *Lysistrata* prints but greatly excel them in rich effect and subtle irony. The contrast between the idyllic scenes of the unicorn in the woodland and the stark and grotesque images of the unicorn betrayed, imprisoned and crucified are the core of Boyd's finest graphic series to that date.

The Lady and the Unicorn was published in 1975. Soon after 1977, when he exhibited the Narcissus paintings in London, Boyd visited the Port Jackson Press at Appledore in Devon; here David Rankin printed a series of etchings for him on the theme of Narcissus. Later, after Boyd returned to the Shoalhaven in 1978, Rankin and his partner, Max Miller, moved to Sydney. Max Miller brought materials for etching to the Shoalhaven and aquatinted some plates on which Boyd, with brush and stopping-out varnish, painted designs in the soft tones characteristic of this medium. Many of the subjects were skulls and painters' faces reminiscent of the laughing heads of 1972–3 [*156*].

In October 1974 Arthur and Yvonne moved to the Shoalhaven River and by May 1975 were able to occupy their new home, Riversdale, the picturesque view from which reminded the visiting Peter Porter of the background of Piero di Cosimo's *Mythological Subject* [*102*]. They remained for a year and returned for another year-long stay in 1978. The 1973 paintings had suggested a personal crisis similar to the one Boyd experienced in 1945. This time the way out to new creations was the Shoalhaven River – the return to painting from nature. Just as Bruegel and Rembrandt had shown him the way in 1945, now Tom Roberts, von Guérard and Piguénit became his spiritual mentors. His concern is not with general impressions but with combining the order of his large *Suffolk Copse* [*140*] with geological and botanical features of the region: 'Suffolk has dense woods of silver birch, spruce, larch and other types of pines, sycamores and they have a vertical quality like the bush at the back of Riversdale or Bundanon. The tonal values are completely different.... The shapes are very much the same.' In *Riverbank* (1972) his first reaction to the Shoalhaven had been broadly impressionistic [*123*]. Similar views in the 1974–7 period are strictly

organized and comparatively linear. Often dividing the panel into two or, more rarely, three zones, rocks and trees run parallel to the picture plane. All detail, whether high or low, is kept at the same distance from the eye 'as with a zoom lens'. His meticulous detailing may remind us of von Guérard, but the flat pattern he evolves is distinctly of the twentieth century. The straight tree trunks and small tufts of branches and leaves record the peculiar type of eucalypt indigenous to the region which holds on to very shallow earth over rocky surfaces; fallen and upright trees combine to form a tightly ordered pattern. Painted in a new technique on small copper plates with the finest of brushes these landscapes are studio paintings, recollections cast in a classical form new in Boyd's work [145–7].

Several large canvases of the middle seventies show the high, tree-covered riverbank of the Shoalhaven; they pay homage to bush scenes by Tom Roberts such as *In a Corner on the McIntire*, where huge pale boulders and dark clefts reflect themselves in the still water, or the bush background to *Bailed Up*, with its rising ground and finely delineated tree trunks filling the whole upper part of the canvas to the exclusion of the sky.

Boyd told Sandra McGrath, author of *The Artist and the River*, that 'the stillness of the river and the echoes of the valley originally triggered the idea of Narcissus'. Painters of the turn of the century had equipped the Australian bush with pastoral idylls in the classical tradition. In Sydney Long's *Spirit of the Plains* a nymph painted from a nude model leads a row of cranes which dance to the music of her shawm. When Boyd takes up the Ovidian half-god he does not attempt to evoke an Arcadian dream world. To Boyd Narcissus, of whom it was prophesied that he would live long if he did not come to know himself, personifies the artist's self-knowledge which threatens to turn into impotent self-love and self-destruction. Seeing his face in a pool, the myth tells us, Narcissus falls in love with his own beauty; he despairs, pines away and at his death is transformed into a flower. Following a visit to the Shoalhaven Peter Porter wrote poems in which the native rock orchid takes the place of the narcissus plant and becomes a striking symbol of self-sufficiency: 'battening on its own dead limbs ... the orchid rears its dozen necks on a cushion of self.' Boyd effects a double transformation: both the orchid and the dead tree spell Narcissus. The heavy floods of 1974 had thrown up driftwood on the riverbank [163]; its shapes inspired the shapes reminiscent of the Muse propelling the painter towards his canvas [164]; as in the Bride

series [*71*], the cave symbolizes isolation. While the classical myth here barely modifies the riverbank scenery of the Shoalhaven, it impinges much more forcefully on our attention in *Reflected Figure and Cave* [*148*], in which a number of themes familiar from earlier paintings assemble into a new context, more grotesque and more romantic than in *Narcissus with Cave and Rock Orchid* [*164*]. We are familiar with the ominous black crow from Boyd's paintings of the forties; the gold coins, alias excrement, remind us of Nebuchadnezzar. The rocky cave, prefigured in *Frightened Bridegroom I* [*71*] stands out sharply against the hot, sandy plain which filled the window-view of *Painting in the Studio* [*141*]. Most striking is the elaboration of the reflection in the water, which now does not concentrate on the features of the onlooker as in *Bride Reflected in a Waterhole* [*73*] but opposes the harsh contrasts of reality in the upper part of the canvas with a Turnerian image of dreamlike beauty. Thus the classical Narcissus does not remain a stranger on the Shoalhaven but, entering Boyd's family of forms, becomes a strand in the web of his art which leads to the Colonial poet [*185*] and re-emerges in the eighties in the splendid aquatint series accompanying the Narcissus poems by Peter Porter [*173–8*].

Narcissus watched his reflection in the mirror of the calm Shoalhaven, but Boyd witnessed the river at other and more dramatic moments; the completion of his house at Riversdale was held up for months by heavy floods and several times he heard the roar of the torrents carrying driftwood and dead animals towards the estuary and experienced the sudden stillness following the subsidence of the water. *Jinker on a Sandbank* [*149*] is based on such a moment. The composition converts the poetic imagery of his *Potter's Wife, Horse and Trap* [*99*] into a symbol of imminent disaster such as had been the subject of an early drawing [*12*]. Instead of the poetic, Turnerian haze of the potter picture, cold sombre tones of imminent nightfall strike an ominous note; it is as if nature was holding its breath. The black horse stumbles uncertainly towards the water; fear has turned the driver into a hare; the crows of death prepare to descend. While *Jinker on a Sandbank* evokes the deadly forces of nature, *Flood Receding in Winter Evening* [*150*] is an elegy on the destructiveness of man. During the flood a valuable stud bull, marooned on a high patch of ground, was forced to swim by means of a helicopter; it made the crossing but perished from panic soon afterwards. In the grotesque carcass floating past Boyd laments the destruction of a noble work of nature by modern

technology. The mirror-like expanses of water and the colourful afterglow in the last two paintings pay homage to two Australian painters of the last century, Eugen von Guérard (1811–1901) and W. C. Piguénit (1836–1914. Boyd's interest in von Guérard [*165*] may have been aroused by his friends the art dealers Joseph Brown and Frank MacDonald. They had done much to revive recognition of this painter who had absorbed the practices of German *Biedermeier*, a modest form of naturalistic rendering held in a lyrical mood. Piguénit's romanticism is of a later and grander kind [*166*]. Both artists travelled extensively in search of wide panoramic views and notable sights. While Boyd was attracted by the beauty of their effects of dawn and dusk, he did not pursue the views into deep space, framing devices and divisions of scenery into foreground, middle distance and far distance employed by the nineteenth century painters, nor did he travel in search of imposing motifs. Instead, he explored the neighbourhood of his Shoalhaven home. Like his figure compositions, his landscapes always contain an element of autobiography.

Traditionally fish in art belong to still life, to paintings of food for low or high living; fish figure in the *vanitas* still lifes by such Dutch seventeenth century painters as Pieter Claesz where herrings, together with bread and beer, signify frugal fare; the most famous skate in art dominates Chardin's Lenten still life in the Louvre, alluded to by Boyd in *Potter Looking at Chardin Print* [*119*]. In Boyd's paintings the skate is hung up prepared for sale in a Suffolk fish shop, as Rembrandt's slaughtered ox hangs in the butcher's cellar. Brilliantly subtle and rich passages of paint render the delicate, slippery, vulnerable underside of the fish, which in life rests on the seabed, its dark dappled upperside protecting it from its enemies [*151*]. Boyd's skate is exposed, lacerated, pinned up, an emblem of victimization; breathing holes give the head a speaking countenance which seems to mock the spectator. In another picture the fish appears to talk, mesmerized by the ventriloquist [*167*]. In *Skate in Merric Boyd Pot* [*152*] the shimmering delicate surface of the skate is compared to ceramic glaze in a tribute to Merric Boyd, whose tree pattern [*4*] decorates the pot. Chardin was not the only inspiration for Boyd's skates. Memories from his boyhood and scenes from paintings by Turner coalesce with the French painting; the stingray, an Australian fish related to the skate, could be found dying in the sun on the beaches near Rosebud, thrown out from the net by fishermen. Similarly, discarded skate lie on the sand near the fisherwomen in Turner's *The*

Sun Rising through Vapour in the National Gallery, London, a picture often visited by Boyd. Other fish such as the trout or the mackerel [*168*] join the skate as symbols of man's destructiveness. As Elwyn Lynn wrote in 1981, 'the symmetrical mackerel, lustrous in life and death, has been hooked. . . .' Oddly enough, Lynn continues, 'there is a buoyancy, almost an optimism, in the quality and style of the work; there is a subtle assertion that art will triumph. . . .' Splendour strangely triumphs over death and age in *Trout in Dish and Pointing Figure* [*179*]. Early drawings of mythical fishermen and women [*169*] and *The Baths* [*29*] anticipated the theme of this work of the late seventies. An etching accompanying poems by Peter Stark in *Tomorrow's Ghosts* (1971) introduces a further variation: the old woman from the sea trying to catch a fleeing youth [*170*] oddly reverses the imagery of *The Baths*.

When the motif returns in the late seventies [*179*], the woman has grown older and is wearing glasses; instead of a dog she holds a dish with a trout and points with a black hand towards the distance – perhaps to the sea whence the fish came. The contrast of the sea-green glaze of the dish with the silvery trout and the rose colour of the hand and flowers against the dark ground, together with the larger-than-life size of the whole, endow this work with a powerful sense of mystery.

During his stay on the river in 1978 the artist explored new regions of the neighbourhood. In open air sketches, like *Budgong Creek Rocks* [*180*] and *A Pond for Narcissus with Lilly-Pilly Trees* [*181*], secluded spots in the undergrowth amongst the rocks contrast with the open river views of the previous years. Painted on board, a softer surface than the copper plates, they presage a loosening of the rigid discipline he had imposed on himself during his first encounter with the new scenery and combine visual truth with vernal freshness. The planar and linear conception of the earlier copper plate riverbanks enabled him to solve to perfection the problem presented by a tapestry commission received from the Feilman Foundation in Perth. Originally he intended to use for it *The Prodigal Son* of the Grange murals, but eventually provided a new version [*182*]. The strict horizontality of the rockface overlaid by the transparent screen of saplings and formalized shadows made a perfect pattern for the weavers. The scene has been transferred from the 'ideal' landscape in the mural at The Grange [*40*] to the surroundings of Boyd's present home on the Shoalhaven. The cave this time has psychological rather than mythological overtones. It stands for forgiveness and shelter. The group of

father and son pay homage to the greatest representation of this theme, Rembrandt's *Prodigal Son* in Leningrad. Boyd adds a touch of humour: the son has arrived in a boat, which is carefully tethered on the right, and a golden seraph blesses the encounter and throws a black, bird-like shadow on the rock.

A commission for lithographic illustrations to a translation of stories by Pushkin resulted in a painting in which the Shoalhaven region is made to stand for the 'Kingdom of the East' where the beautiful but treacherous Princess of Shamakhan steps from a tent 'shimmering with beauty like the dawn' to entrance the hapless king, the leading figure in the story of 'The Golden Cockerel' [*183*]. The Princess and her tent resemble the second of the *Lysistrata* murals, while the river winding through the hills, as in *Picture on the Wall, Shoalhaven* [*184*], shows an imaginary view stylized in memory of Baldovinetti's *Madonna and Child* in the Louvre, thus connecting the past with the present and associating Boyd's Australian home with his summer holidays in Tuscany. All these imaginary views have pessimistic overtones; the Princess is but an apparition which will cause the king's death; in *Picture on the Wall* the atomic cloud is rising in the distance. In other Shoalhaven River paintings a rose, a burning book and an aeroplane are emblems presaging disaster. Stylistically these canvases show great richness of tonal range and a fluency of brushwork, which increase in the landscapes of the eighties.

A group of paintings is devoted to the 'Colonial poet' [*185*], to whom Boyd transfers Narcissus's preoccupation with the self. Dressed in tight early nineteenth century clothing, so unsuitable for the Australian climate, the poet sits under an orange-tree, like himself of 'foreign' origin. Absorbed in his book and unaware of his surroundings, he has the cloven hoof of the false Jehovah in Blake's Book of Job; his alter ego, the beast, stares at its reflection in the water. Across the empty stretch of white-hot sand sits the log cutter, from Streeton's *Whelan on the Log*, responsible for the denuding of the land. The complex references found a simplified form in *Skull-headed Creature over Black Creek* [*186*]. Boyd had started the composition with the figure of the poet, but painted it out and combined man and beast into a fantasy creature; like the poet, it has one cloven hoof and one human leg; it has stared for so long at its image in the black river of the underworld that its head has turned into a brainless skull. In the sandy, shadow- and waterless distance Cain kills Abel. Boyd's Colonial poets are indifferent to the violent activities of Europeans, and to their

importations that have brought destruction to the native people, plants and animals of Australia.

The skull which makes its appearance in the Narcissus-Colonial poet paintings has its model in a couple of animal skulls which came into Boyd's possession during one of his stays at the Shoalhaven. They touched on a long forgotten memory: during his journey to Central Australia he had noted in his sketchbook the skull, ribs, spinal cord and hide of an animal [69]. *Horse's Skull, Blanket and Starry Sky* [*187*] translates the drawing into a romantic allegory. On a cold night following a hot summer's day mists rise over the distant river; above, the stars glitter in the clear sky. On the hot ground lies the steaming skull and bones of a pony called Flame which had died in a barbed wire entanglement. As the butterflies (of resurrection) flutter around the horse-blanket which covers the pony's remains, the skull emits a celebratory flame. Later, in Suffolk, a stoat, still lissom in death, was commemorated by the painter in a lifesize oil [*188*].

It is of interest to note that in 1980, together with his fish series, Boyd exhibited at Fischer Fine Art in London some sketchbooks of his father's containing several watercolours of about 1950 in which the potter elaborated on paper a motif from his early pots [*4*]. Clumps of parallel tree trunks, stylized along the lines of Art Nouveau designs, stand white on purple or green ground, sometimes outlined in blue and merging into the red shade cast by the foliage. Several of the clumps are of straight limbs, others bend in regular curves. These water-colours inspired Arthur's four large paintings called Trees I–IV [*189*] which formed the nucleus and focus of the exhibition. Like the skates they pay homage to his father and to the memory of his early days at Murrumbeena. The four panels arranged themselves in pairs; in one pair the trunks run in straight parallel lines, in the other they bend in curves. The last variation on this theme comes close to an abstract of concentric circles.

When in 1981 Boyd returned for the third time to live on the Shoalhaven he had overcome the sense of strangeness which initially assailed him and provoked the discipline he imposed on himself in the copper plate paintings [*146*, *147*]. A freer, more painterly handling and more subtle conditions of light, varying with the passing of the seasons and the changing light of day, characterize his new landscapes. *Shoalhaven Riverbank and Rocks* [*190*] of 1978 still bears resemblance to the meticulous linear copper plate scenes, despite its large scale and

the weight and massiveness of its forms. *Shoalhaven Riverbank and Large Stones* [*191*], in which the bush opens to reveal the clay surface of the bank, is bleached by the noontide light of high summer; higher up, the bush colours are dulled by the smoke of burning. *Reflected Rock and Riverbank* [*192*] has the low light and deep shadows of winter; unlike the spindly stalks in the previous picture, a denser growth sprouts along the riverbank. The almost imperceptible differences of season, so unlike the striking contrasts of summer and winter in Europe, had not often entered Boyd's landscape art of earlier times. Yet, despite such attention to observation, his pictures reconstruct rather than simulate nature. He combines what he knows with what he sees. Comparison with photographs of the riverbank reproduced by McGrath, in which the bank is obscured by foliage, makes it vividly apparent that Boyd's paintings are comments on rather than copies of scenery.

This becomes even more evident in *Waterfall in the Shoalhaven Valley* [*193*], inspired by the Fitzroy Falls which cannot be observed front on; the composition is developed from the small rivulets in some of the copper plates [*146*] and from a side view of the much larger Fitzroy Falls, rendered with emphasis on the foaming progress of the waters towards invisible depths.

The high riverbanks of the Shoalhaven opposite Bundanon culminate in a stony excrescence whose shape has suggested its name, Pulpit Rock. Rising above a sharp bend in the river its silhouette is visible from many sides. Like the potter, Narcissus and the skate, the rock has become a member of Boyd's 'cast'; it is his Rigi, his Mount Fuji, his Mont Saint Victoire. Set against the colourless brightness before sunrise, its outline dominates the view. After sunrise a warm glow suffuses the surface; rocks near the water's edge and their reflections are clearer than before. By midday the colour has faded from the mountain, the blue of the sky is intense but begins to be dimmed by mist; the reflections in the water are less clear than before. It is possible to identify individual trees and to follow the course of the river on the right. After sundown Pulpit Rock sinks back into shadow; the blue has left the sky; the rock is more distant and begins to merge into the surrounding range; a black swan has come out to feed; the painter is on his way home. Subtle changes of position and emphatic contrasts of colour weld *Four Times of Day* into one continuous movement of rise and fall. In these paintings of Pulpit Rock [*194–197*], set between sky and water in an ambience of luminous space, Boyd restates the theme of the cyclic element in nature that had occupied him in the forties.

Four Times of Day has reminded some viewers of Monet's series of haystacks or cathedrals. Boyd's conception is distinct from these in that two of the four paintings are devoted to near-night effects. For him light remains an interval between periods of chill darkness. Even full daylight is tinged with melancholy, in eloquent contrast to the 'blue and gold' of Arthur Streeton, who wrote so enthusiastically about his plans for 'large canvases all glowing and moving in the happy light'. The high silhouette of Pulpit Rock shuts out the 'golden plains' of prosperity. Straggly bush covers the rockface; solitude and loneliness prevail. As in all Boyd's work, evidence of twentieth century technology is shunned; power lines, high roads, overpasses and bridges, though not far away from the Shoalhaven valley, do not enter the painter's repertoire. It is eminently telling that the pony whose death is so movingly commemorated [*187*] was destroyed by contact with the invention of barbed wire, calling up the barricades of World War I remembered by Boyd's father. Arthur Boyd's landscapes are contemplations of the 'inevitable and the unceasing in nature, of cold and heat, and summer and winter, and day and night'.

As we have seen, the primordial and the savage hold a conspicuous place in Boyd's imagination. His landscapes are frequently taken from unpopulated, lonely places, areas where man's presence has left few marks. Skulls, dead animals and victims of natural disasters follow the dead trees, black scavenger crows and primitive men of the forties and fifties. Among the Old Masters Boyd felt particularly drawn to the atavistic, obsessed Piero di Cosimo and the magically expressionist aged Rembrandt. In his drawings of the sixties Boyd recasts the desolate themes of the South Melbourne period which merge into a steady stream of imagery redolent of primitive passions, obsessive sex and themes of violent death, several of which centre on the Ancient Mariner killing the albatross. Not only in content do these drawings recall the taste for the macabre prevalent at the turn of the last century; in their delicately interweaving lines and spiralling shapes unrelated to the rectangles of the paper the principles of Art Nouveau continue. The elemental is reflected in Boyd's 'variation' [*198*] on Rembrandt's one-eyed Julius Civilis [*172*], who dominates *The Conspiracy of the Batavians* which the Amsterdam Town Council commissioned for its palatial new Town Hall. The painting was to illustrate an incident from the early history of the Batavians (the Dutch of the first century AD). One of their nobles, now only known by his latinized name of Julius Civilis, assembled a band of guerillas with whom he temporarily

freed his country from Roman occupation, an episode which reminded the seventeenth century Amsterdam burghers of their recent release from Spanish overlordship. Rembrandt's depiction differs strikingly from the conventions of history painting of his day. Rubens, for example, had cast his early Flemings in the same heroic mould as his Romans. Rembrandt's Batavians are prehistoric figures, rough, uncouth, barbaric inhabitants of the forests. The uncanny image of Civilis is enhanced by the fairytale splendour of his head dress, which Rembrandt based on one of Pisanello's Gonzaga medals. By placing a dead cock around Civilis' neck Boyd, surrealistically combining incompatibles, reminds us that his hero was doomed; like the Ancient Mariner, Civilis loses his followers. If the cock appears instead of the albatross, it may be because it hung in the local butcher's shop in Suffolk together with other fowl Boyd used for still lifes at the time. The green and red colours which lend such vivid presence to the ugly features of the barbaric leader recall Boyd's early heads of the brothers Karamazov [10]. The London exhibition in which Boyd's Julius Civilis hung also displayed his illustrations to Peter Porter's Narcissus poems. The striking effect of these aquatints evokes drawings by Aubrey Beardsley. Boyd's imagination often fastens onto single words and poetic similes in Porter's text. The illustration accompanying the introduction [*173*] is subtitled 'rage of revolution'. Boyd's composition shows torn-off limbs and a head among wild beasts in a dynamically revolving pattern. *Narcissus Loses His Love* [*174*] conveys the central theme of the myth, namely Narcissus' absorption in the reflection of himself in water – an absorption so complete that he wastes away and dies. Boyd's imagery is here based on his earlier *Horse's Skull, Blanket and Starry Sky* [*187*]. The skull and book echo his *Colonial Poet under Orange-Tree* [*185*]. Not only poets but painters tend towards narcissism. Little Andrea [*175*] is as absorbed in the image of the sheep he draws as is Narcissus in the reflection of himself. Dressed in Quattrocento costume he is under the protection of a Medici, whose hand dispenses gold. Narcissus's head spins [*176*] on hearing anthropologists' theories about himself – theories which emerge, like 'His Master's Voice' from an old-fashioned gramophone speaker. Like Boyd's father sitting on the beach drawing a seagull [*98*], a painter standing in a boat paints a bird spearing a fish on his canvas, supervised by a huge pelican [*177*]. Rock and figure echo in the reflections, while a goat – the evil spirit of the Colonial poet – looks on [*178*].

In his early years Arthur Boyd had adopted the traditional size of

easel paintings meant to hang in the quiet of the private home. In England several commissions came his way which secured a wider public. These included stage design, book illustration and a large mural for a public institution. In the wake of contemporary trends he increased the size of his canvases and used new motifs and startling, unexpected juxtapositions to achieve greatest intensity of effect. During his return to Australia the vast plains, the open skies, the unpopulated distances seemed to demand an ever increasing scale. Yet the link with his early manner is never broken. The sensitive hand, the individual, idiosyncratic mark of the brush, the opposition to conventional finish and the pull which both idyllic and sombre sides of life exert on him remain constant all his life.

Boyd's most recent public commission is the maquette for the huge tapestry to be woven by the Victorian Tapestry Workshop for the new Parliament House to be opened in Canberra in 1988 [*199*]. A bush scene in Boyd's most lyrical vein, it is, in Elwyn Lynn's words 'a lovely, shifting wall of fluctuating, nuanced hues'.

The excitement roused by the sheer size of the commission carried over into a number of Shoalhaven canvases of new magnitude [*200*]. *Shepherd by Black Creek* recalls motifs used in the Hunter series and in the mythological landscapes of the sixties, transferred into the rich bush setting of the Shoalhaven. Harmonies of blue and white are thrown into focus by the pink of the lovers. Boyd's interest in bathers, which had not occupied him since the early fifties, was revived by Cézanne's *Bathers* in the London National Gallery. The idyllic and secluded beach, far from the city, which Conder and Streeton had made popular, is replaced by the beach in the technological age [*201*]. Cars and speedboats, raucous cries of a hedonistic mob break the calm of nature. What Boyd owes to Cézanne is the considered build-up of the figures into a frieze composition. The stunning effect of the huge painting rests on the contrast between hot tints, ugly masks and monstrous forms of a crowd and the beauty of the natural world. Above the garish human turmoil rises the impressive, timeless riverbank. Luminous cumulus clouds scud across the deep blue sky. Never before in Boyd's work have nature and man stood in such striking juxtaposition. To quote Elwyn Lynn, 'the work is the epitome of the creative continuity of Arthur Boyd's art.'

EPILOGUE

An outstanding feature of Arthur Boyd's *oeuvre* is its great variety. Landscapes, impressionist or expressionist, alternate with or combine with figure scenes; erotic or fantastic subjects occur alongside biblical or mythological scenes. Many of the latter are set into a bush wilderness; figures turn into animals; themes which occupied him in his youth reappear over the years in drawings, etchings, ceramic paintings; they undergo variations and sometimes reappear forty years later in a painting. He can work simultaneously in different pictorial modes, from lyrical landscapes to allegory, or both combined. The secret of Boyd's fecundity of invention is his sense of kinship with the whole world of art; past and present merge in his imagination. More than most Australian painters he is constantly aware of the Old Masters. Yet his work retains the unmistakable imprint of his own hand – set down, as it is, *alla prima*, swiftly, with seemingly little premeditation. He often makes version after version, until the original impulse is exhausted. An unceasing flow of rapid drawings forms a *continuo* accompaniment to the painted *oeuvre*.

The most unusual element in Boyd's performance is the persistence with which he returns to his origins; the way in which both the art of his father and his own youthful work became a reserve from which he draws new ideas and to which he returns in between explorations of new ground. In the middle sixties he repeated a large number of drawings from his South Melbourne period, the imagery of which is again transfigured in even later works. The bush, conceived as primeval wilderness in the war years, provides the background for many of the Bride paintings of the fifties as well as for the *Nude with Beast* and Nebuchadnezzar series in the sixties. His tree forms were often related to the swaying lines of his father's pottery designs. His father's drawings of clumps of tree trunks as well as the Sherbroke Forest interior by Tom Roberts in the Art Gallery of New South Wales were points of departure for the vertical forest scenes of the seventies.

The roots of Boyd's figure compositions also reach back to family tradition, though not to paintings. Biblical stories read to him by his maternal grandmother filled his imagination with parables which have continued in his memory throughout his life. Paintings of Susannah

[*41*] and of the Prodigal Son [*40*] recur at intervals. Each time they take on a new form. The early *The Return of the Prodigal Son* of 1946–7 [*171*] is a small panel and the figures are undifferentiated in age, as if the three Boyd brothers wrapped in sheets had acted the scene in the Murrumbeena orchard. In the late forties the Grange mural [*40*] displays the whole range of Boyd's artistic know-how on a larger scale, the gestures are self-explanatory, the father has a patriarchal air and the elaborately orchestrated space recedes far into distance. When the theme is taken up again in the seventies it participates in the flat, ordered conception of space of the Shoalhaven copper plates. As shown earlier, father and son are linked in an embrace inspired by Rembrandt's painting in Leningrad. Though the composition of *The Return of the Prodigal Son* [*182*] is new, a link remains with the earlier painting: the arch which encloses the figures of the 1946–7 panel is the prototype for the half-round cave in the riverbank in which the 1980 figures are enshrined. The strong primary colours of their garments recall the ceramic paintings of the fifties.

When Boyd became acquainted with the theories and practices of Modernism he was made aware of methods of working radically different from those pursued by his family or prescribed by the National Gallery Art School. His early years coincided with the influx into Australia of Surrealism and Expressionism. He made friends not only with the Expressionist Yosl Bergner, but with the painter and sculptor Danila Vassilieff who advocated rapid execution unhampered by premeditation. International acceptance as evidenced in Thoene's book on modern German art and the writings of Herbert Read lent Modernism authority in the eyes of local followers. Whilst Boyd soon abandoned his own surrealist phase, he remembered the value of automatism, of spontaneous, unplanned invention. Though he often looked to Old Masters for subject and construction, he returned throughout his life to periods of unhampered rapid execution and to invention free from the control of logic. The varied imagery of the Nebuchadnezzar and the Potter paintings, so close to each other in time and so different in kind, is a testimony to the richness of the springs of imagination thus tapped.

From the war years onward Boyd repeatedly assembled apparently disconnected motifs to obtain new images. In the South Melbourne paintings a tree is half tree, half man; a human head is attached to the body of a dragonfly, a tree grows out of a corpse, a head out of a cup. The free flow of ideas tempers the constraints imposed by reality and convention. Particularly striking examples are the drawings of the

sixties on the subject of the potter. An armchair develops an arm that moulds a pot on a wheel; the same chair is the repository for a huge head, which kisses the beast as it emerges from an upright coffin. A large number of erotic configurations are grouped and regrouped in ever varying combinations. Hardly any of these fantasy images enter the paintings on the subject of the potter.

Boyd's rare power of associative thinking is particularly evident in the Nebuchadnezzar series. Nebuchadnezzar is like an actor putting on a one man show; he is alone on stage for the whole of the performance until he is joined by Daniel. To have sustained a sequence of over seventy permutations on a theme for which there is no precedent in literature or art is a remarkable achievement in itself. Other series (St Francis, Jonah, the Unicorn and Narcissus) retain contact with a text, of which, often, they are associations rather than illustrations.

Expressionism continues the tradition of figurative art in which a significant idea is inextricably interwoven with aesthetic form. Whereas since the Renaissance artists either followed an ideal of beauty or stayed close to observable fact, twentieth century Expressionists cultivate a subjective and experimental approach; their themes are often fantastic and filled with private symbols. The manner of execution conveys states of feeling; distortion, illogical spatial relations and idiosyncratic handling serve to convey the intense involvement of the painter with his theme. Boyd shared the Expressionists' conviction that the purpose of art lies in the combination of significant content with a form that immortalizes it.

One may ask to what extent such a belief finds expression in landscape painting. It would be misleading to describe Boyd's work as alternating between two modes of working; to divide it into realistic renderings of nature and imaginative compositions, or to oppose *plein air* and studio painting. Even his landscapes go beyond mere resemblance to reality. In many of the early figureless scenes, obtrusively handled dead trees, skeletal forms and black crows evoke intimations of death. The arid open air settings of the painter *in extremis* have symbolic significance. The harmoniously composed and gently illuminated *Suffolk Copse* [*140*] equates nature with poetry, a book of which lies open on the ground. In *Painting in the Studio* [*141*] the painter is shut away from nature, but in a third picture [*142*] in that sequence the wilderness of the bush adopts a meaning similar to the desert of the painter *in extremis*; the accumulation of bush, rain, light and rainbow is irrational; the painter is haunted by his potter-father

and vainly reaches out after the escaping model-muse. Bush scenes painted in the Shoalhaven region seem meticulously 'real' compared with earlier bush scenes in Boyd's *oeuvre*; it was the relatively untouched nature of the area that had attracted the artist to it. The portrayal of its riverbanks no longer romanticizes the bush, but neither are the paintings literal transcripts of a given spot.

He gives a diagrammatic account of its formation and a graphic image of the precarious hold on the ground of the fragile eucalyptus of that region. The element of destruction in nature itself, the struggle of each live organism against chaos as well as the threat posed to nature by man's activities are present in the Shoalhaven landscapes, just as they had been present in a different form in earlier landscapes. Boyd now looks at the scenery with the objective eye of the naturalist as well as with the anxious care of the conservationist. The subjectivity of the expressionist trend has given way to a new classicism.

Boyd is the only Australian painter I know of who has explicitly used his art to justify or question the artist's calling. The distracted scenes of the early seventies are unprecedented even in his own *oeuvre*. One is reminded of Picasso's illustrations to Balzac's *Chef d'oeuvre inconnu* which deal with the painter's increasing estrangement from reason and reality, and of Picasso's drawings of the painter and his model. Both series arose from the Spanish artist's fear of aging and of losing his inspiration. They are personal and humorously resigned. Boyd's thoughts tend towards a transcendental despair inspired by the times in which we live.

Throughout its varied and manifold imagery Arthur Boyd's art remains fundamentally consistent and coherent in its aim. The spirit of Art Nouveau which inspired Merric Boyd's decorations and drawings and the *fin de siècle* mood inherent in the novels of Martin Boyd have sustained Boyd's art in all its phases.

THE ART OF
ARTHUR BOYD

Plates

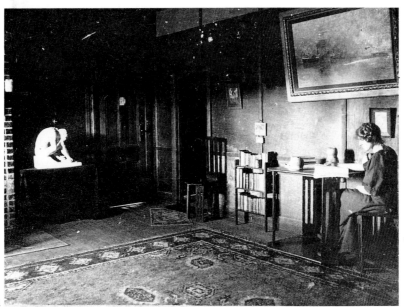

1a

1b

1c

1 Victor Rathausky
 (a) The Brown Room (b) The house (c) Arthur's studio

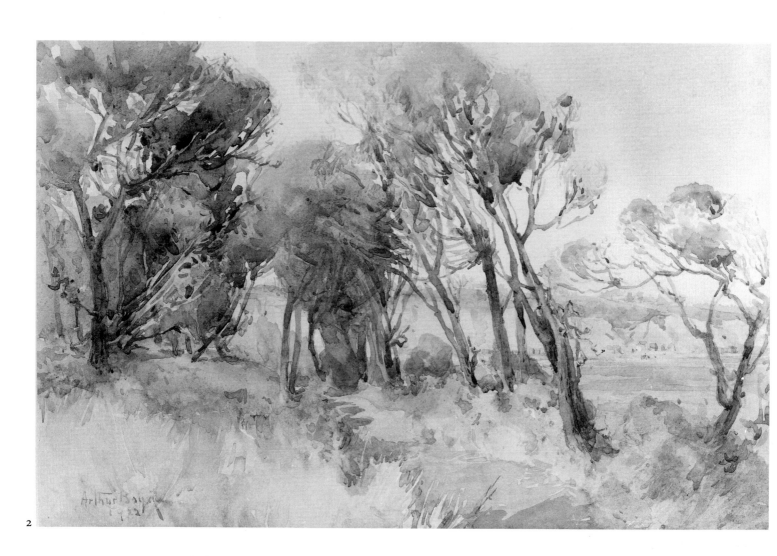

2

2 Arthur Merric Boyd (1862–1940)
 Landscape 1922

3 Merric Boyd (1888–1959)
 Jug with handle in tree form 1930

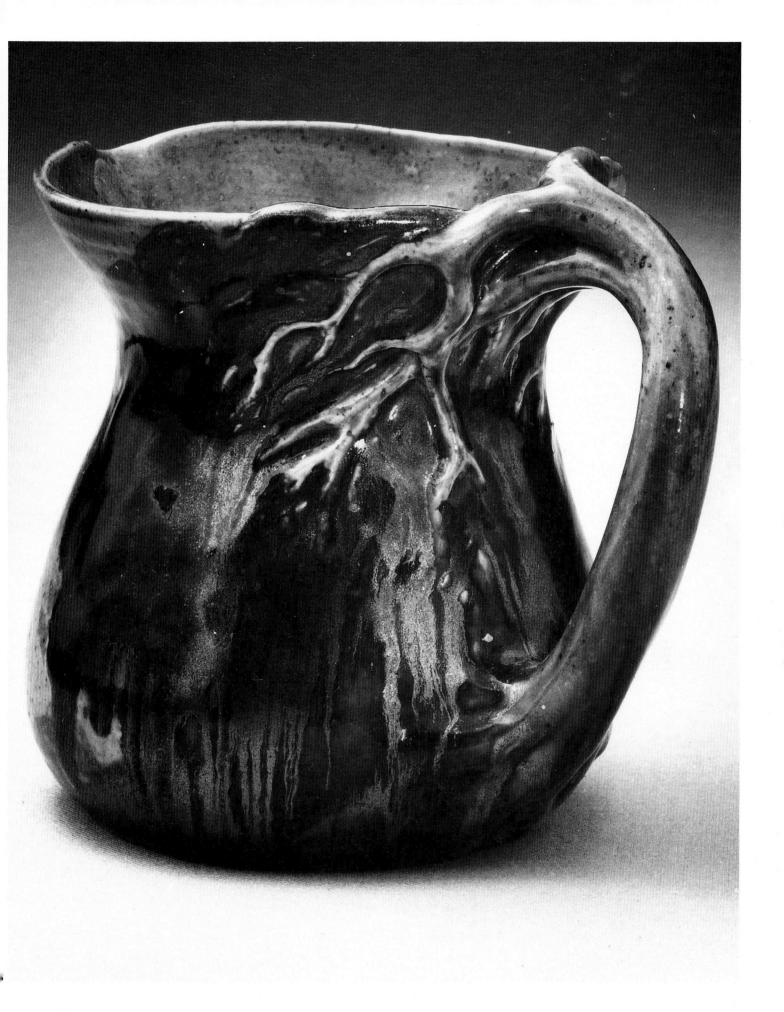

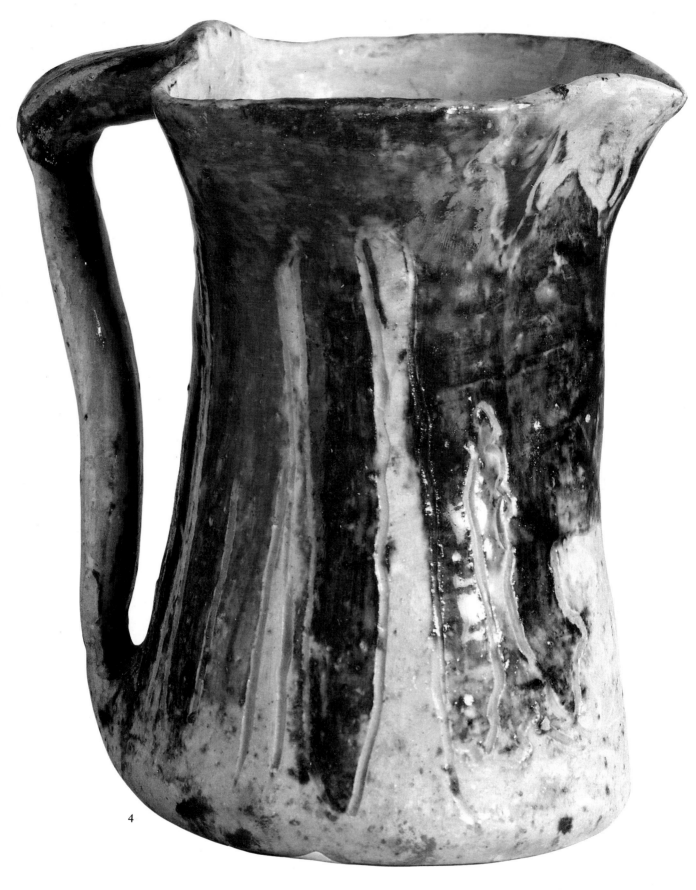

4

4 Merric Boyd (1888–1959)
 Jug with tree trunk pattern 1912

5 Merric Boyd (1888–1959)
 Pot with leaning tree trunks 1912

6 Penleigh Boyd (1890–1923)
 Winter triumphant 1920

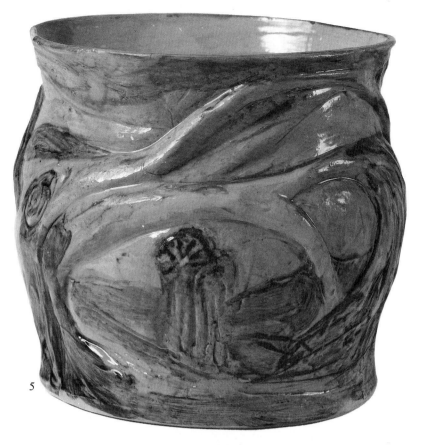

5

6

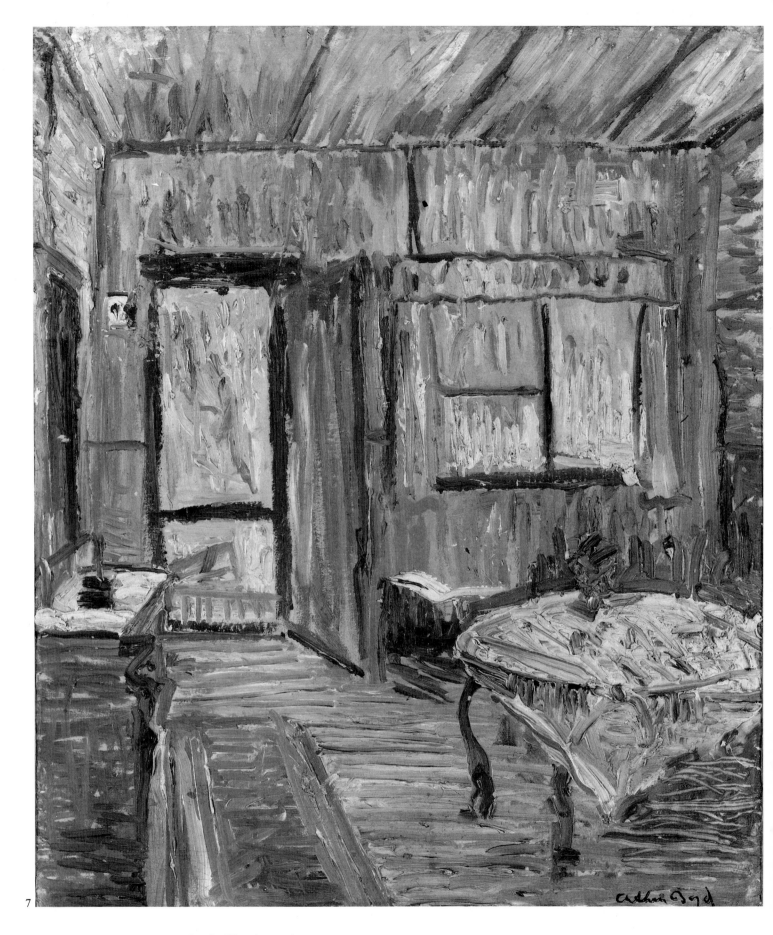

7

7 *Rosebud Interior* 1936
8 *The Brown Room* 1935

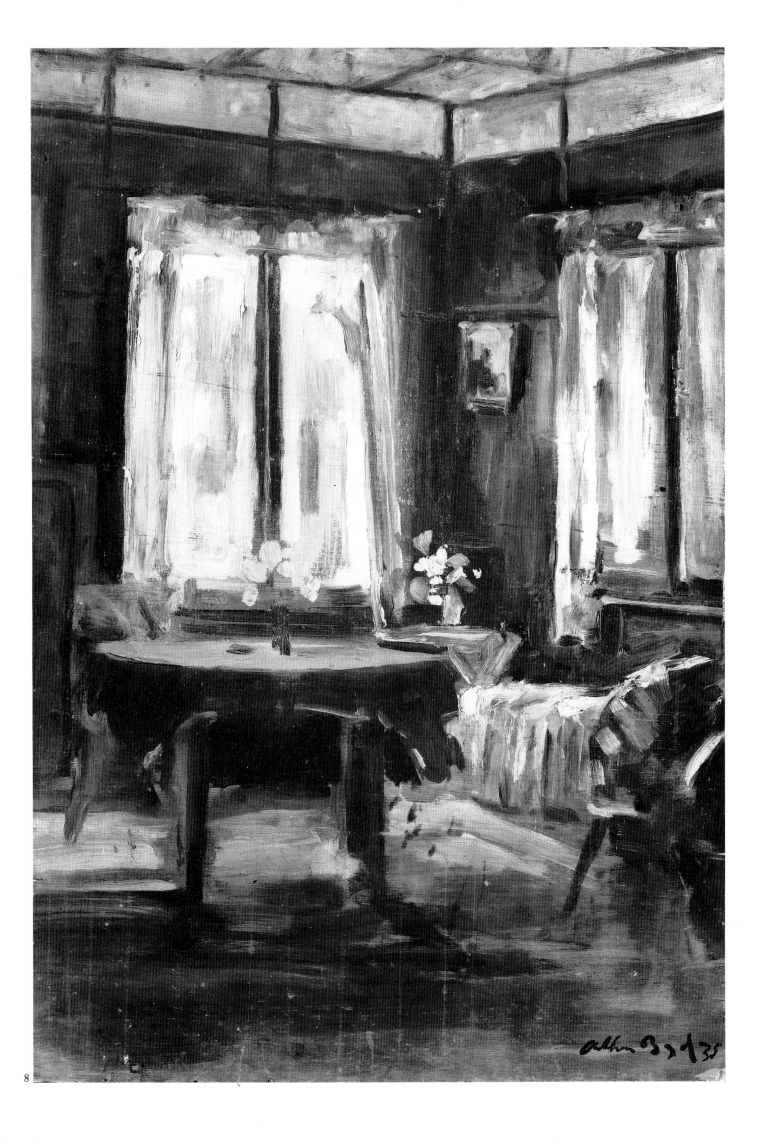

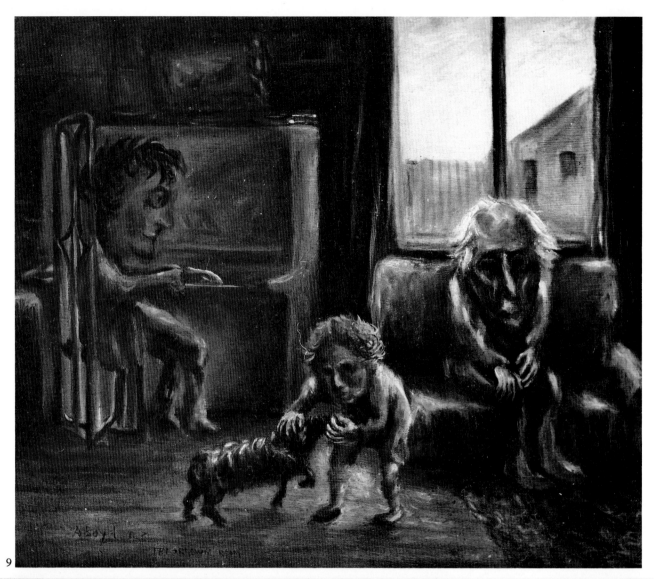

9

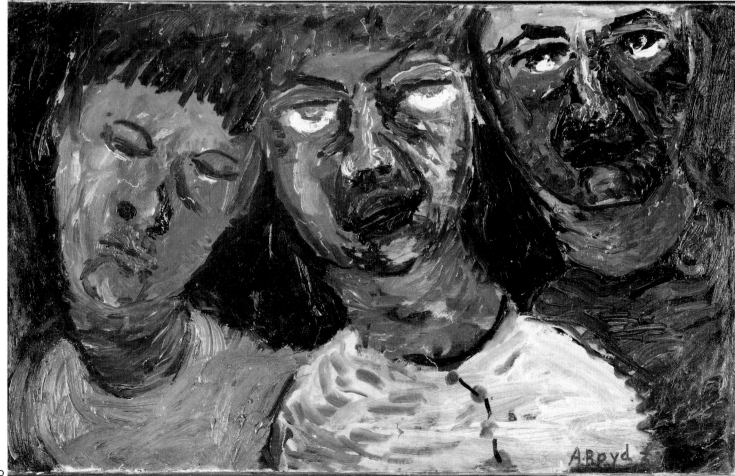

10

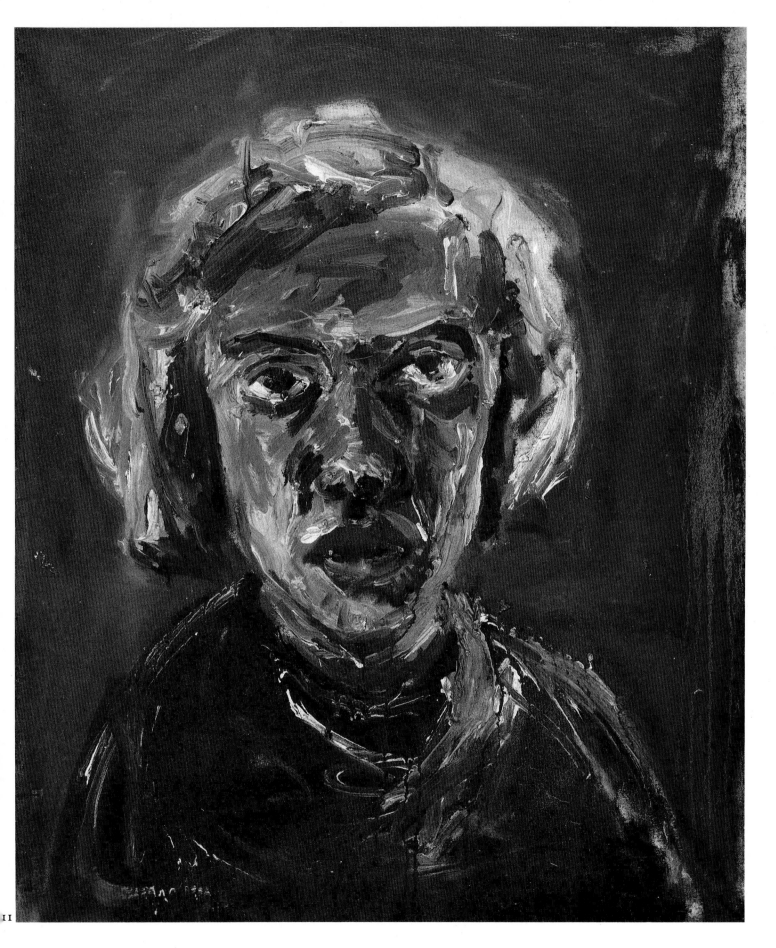

11

12

13

4

12 *Horse, Cart and Locomotive* 1941–3

13 *A South Melbourne Woman Exercising a Lame Dog* c.1941–3

14 *Soldier and Prostitute with Galleon* 1943

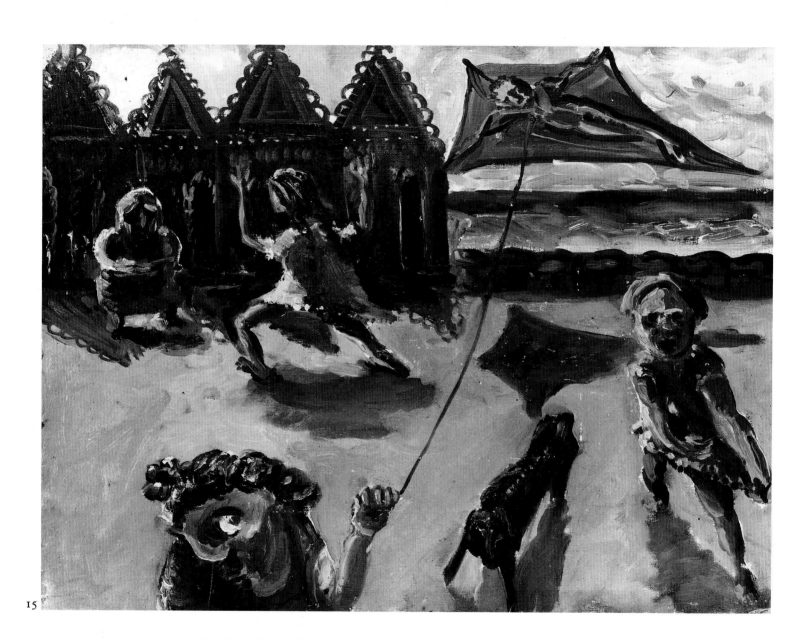

15

15 *Kite Flyer, South Melbourne* 1943
16 Study for *Man with Sunflower* 1943
17 Study for *Butterfly Man* 1943

16

A. Boyd 43

17

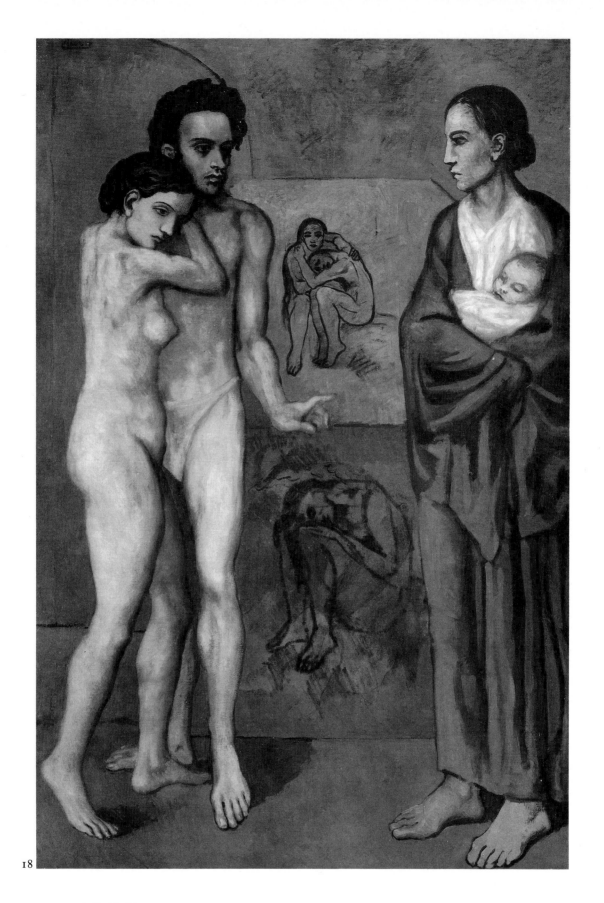

18

18 Pablo Picasso (1881–1973)
 La Vie 1903

19 *Figure with Crutches, Fallen Figure, Dog, and Figure on Bench* 1944

20 Oskar Kokoschka (1886–1980)
 The Tempest 1914

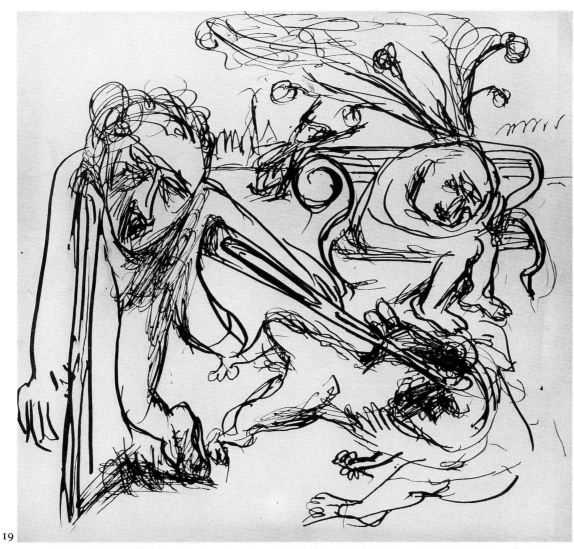

19

20

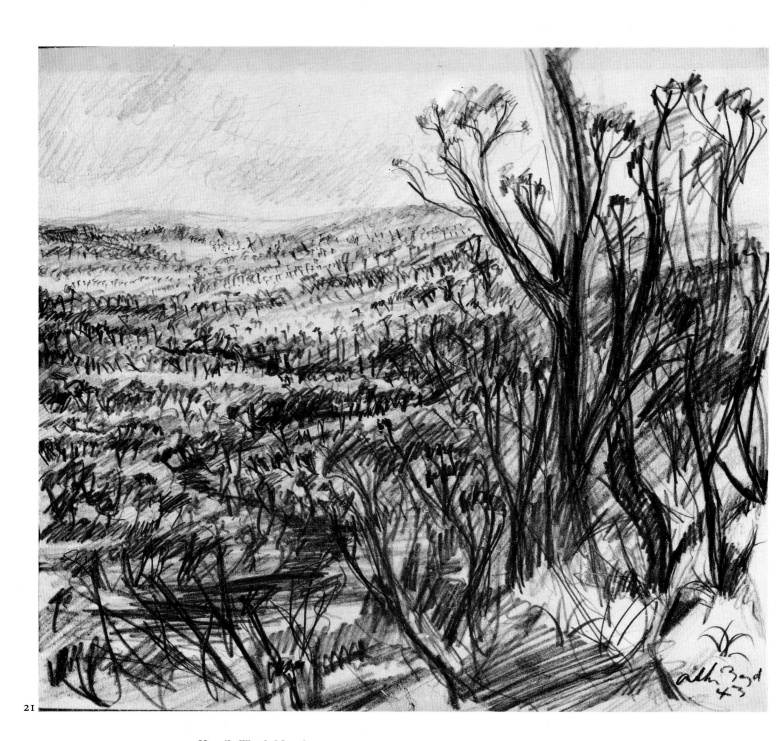

21

21 *Heavily Wooded Landscape* 1943

22 Emma Minnie Boyd (1856–1936)
 Interior with Figures, The Grange 1875

23 *The Jetty, Rosebud* 1934

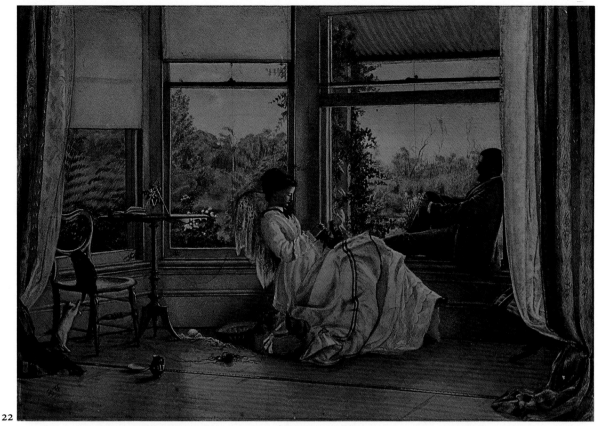

22

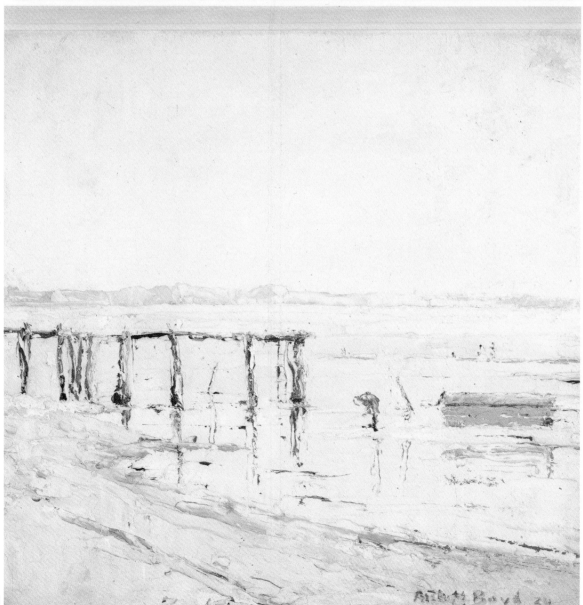

23

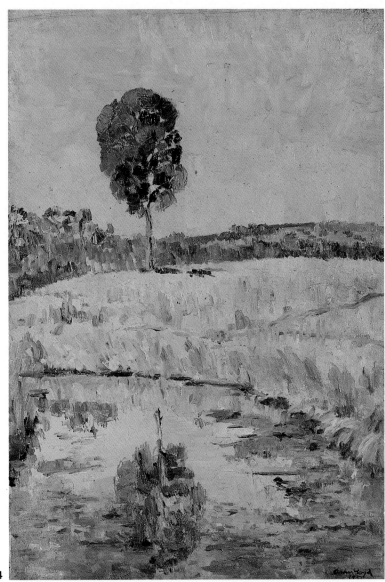

24

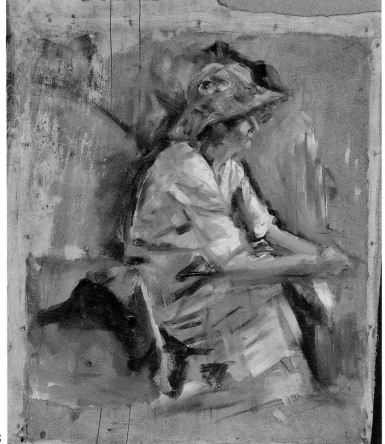

25

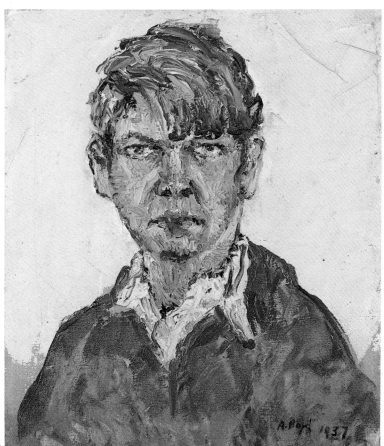

26

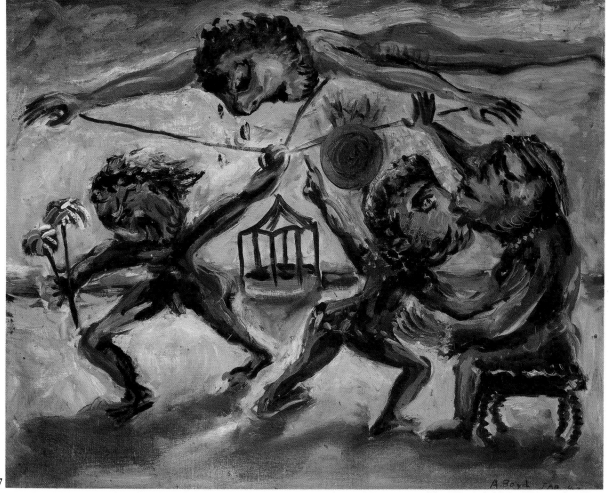

27

24 *Sheoke Reflected in Tidal Creek* 1937

25 *Doris Boyd in Blue Hat* 1934

26 *Self-Portrait in Red Shirt* 1937

27 *The Kite* 1943

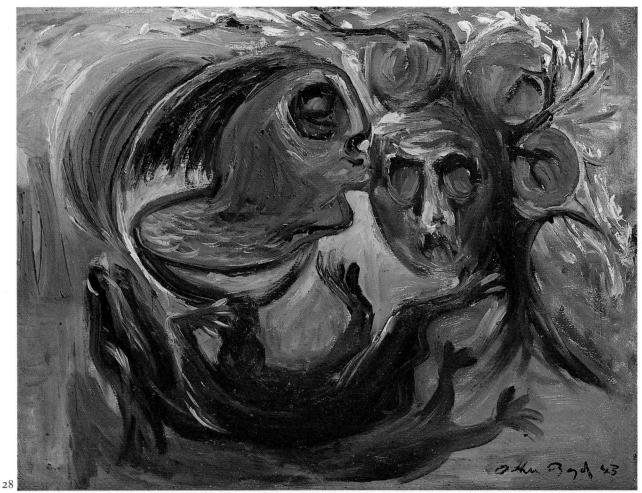

28

29

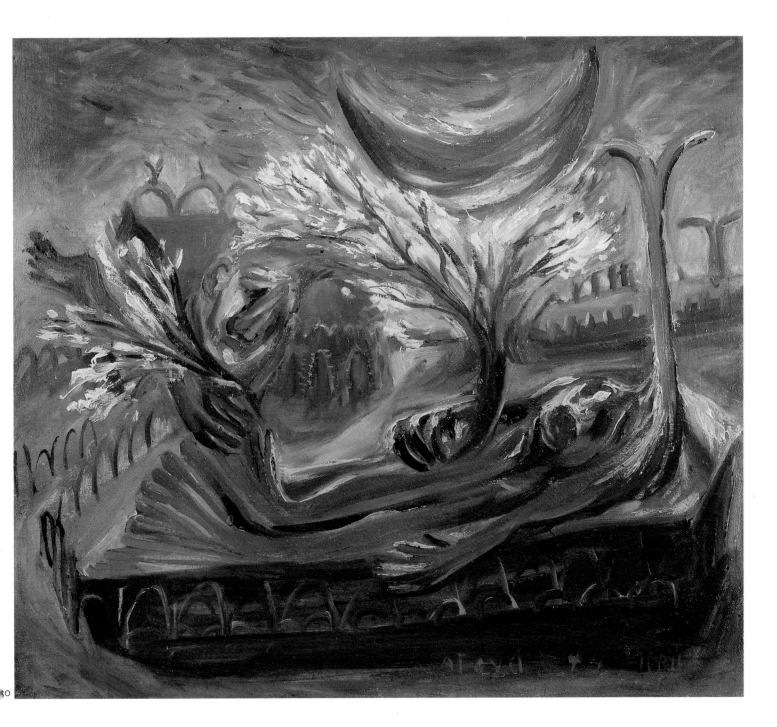

28 *The Fountain* 1943
29 *The Baths, South Melbourne* 1943
30 *The Cemetery II* 1944

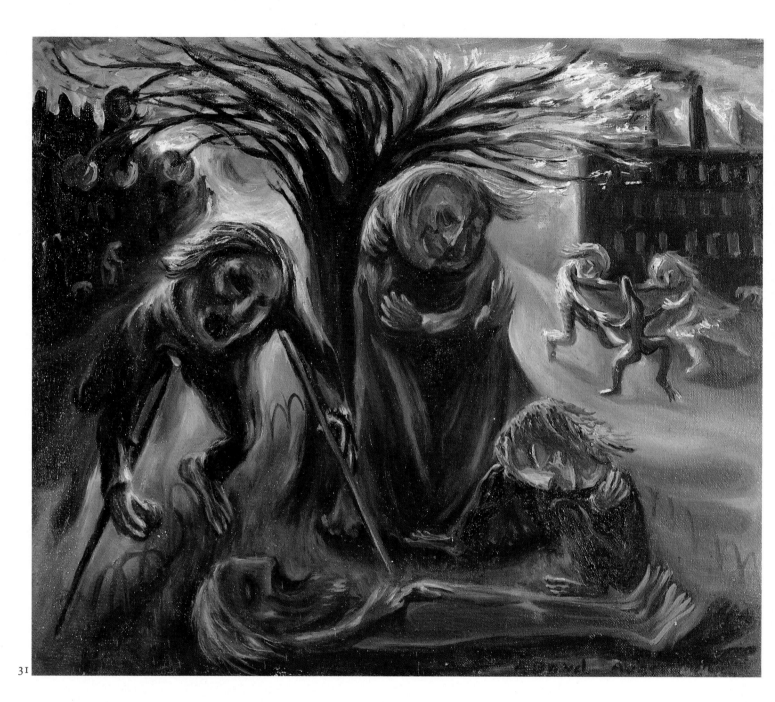

31

31 *The Seasons* 1944
32 *The Gargoyles* 1944
33 *The Shepherd* 1944

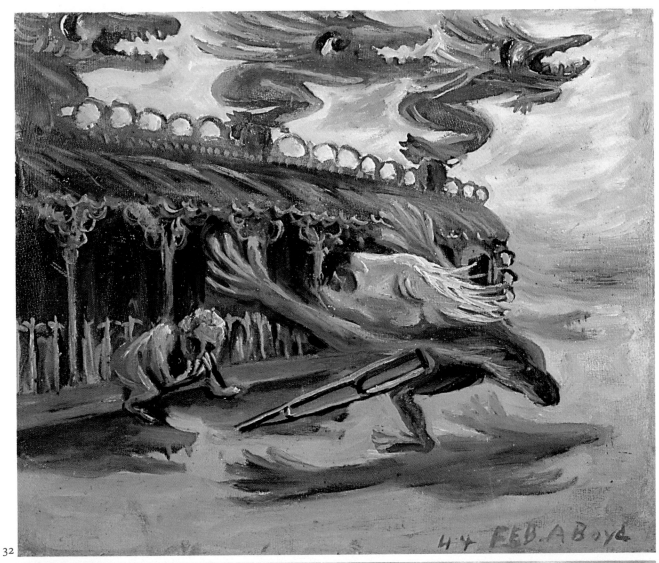

32

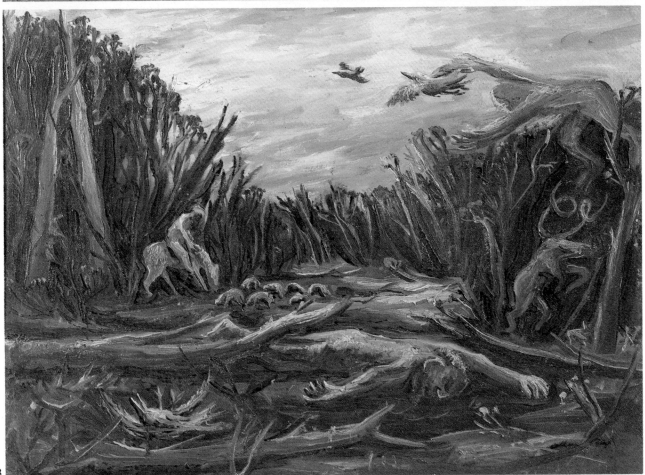

33

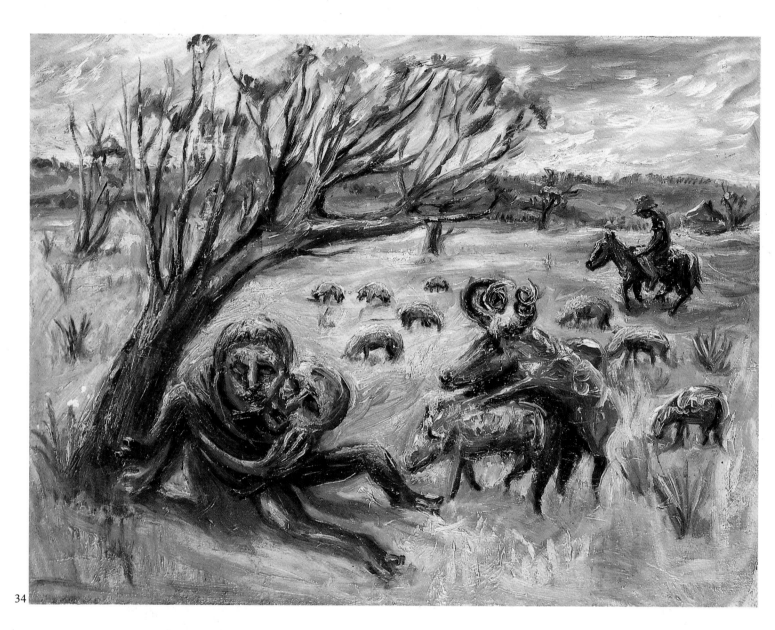

34

34 *The Lovers* 1944
35 *Melbourne Burning* 1946–7
36 *The Expulsion* 1947–8

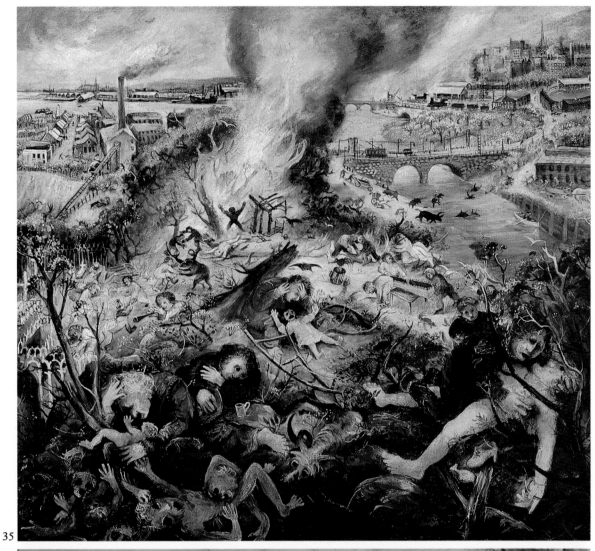

35

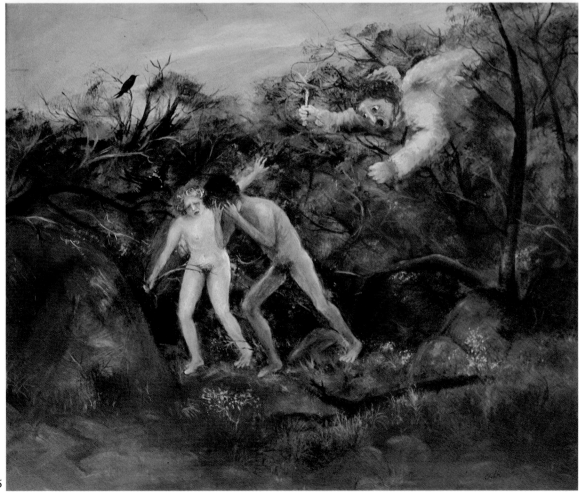

36

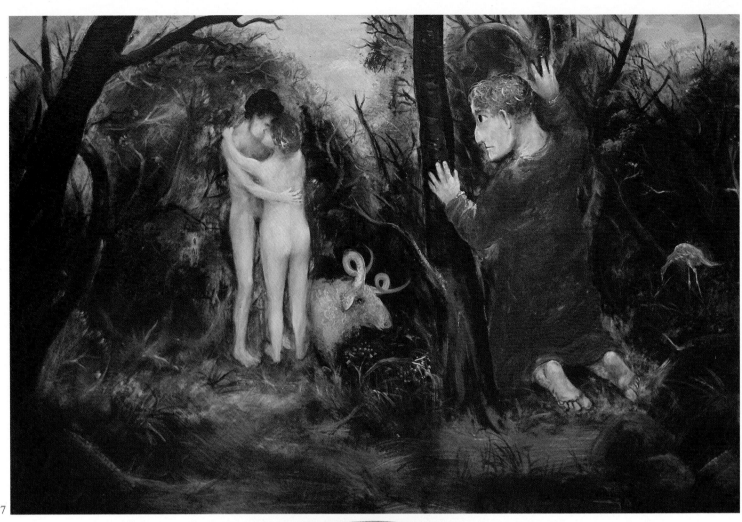

37

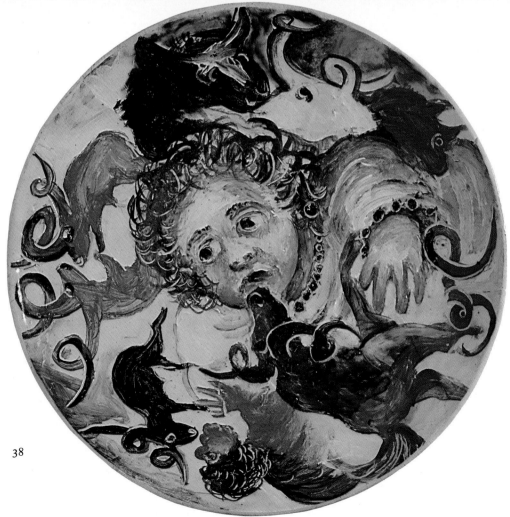

38

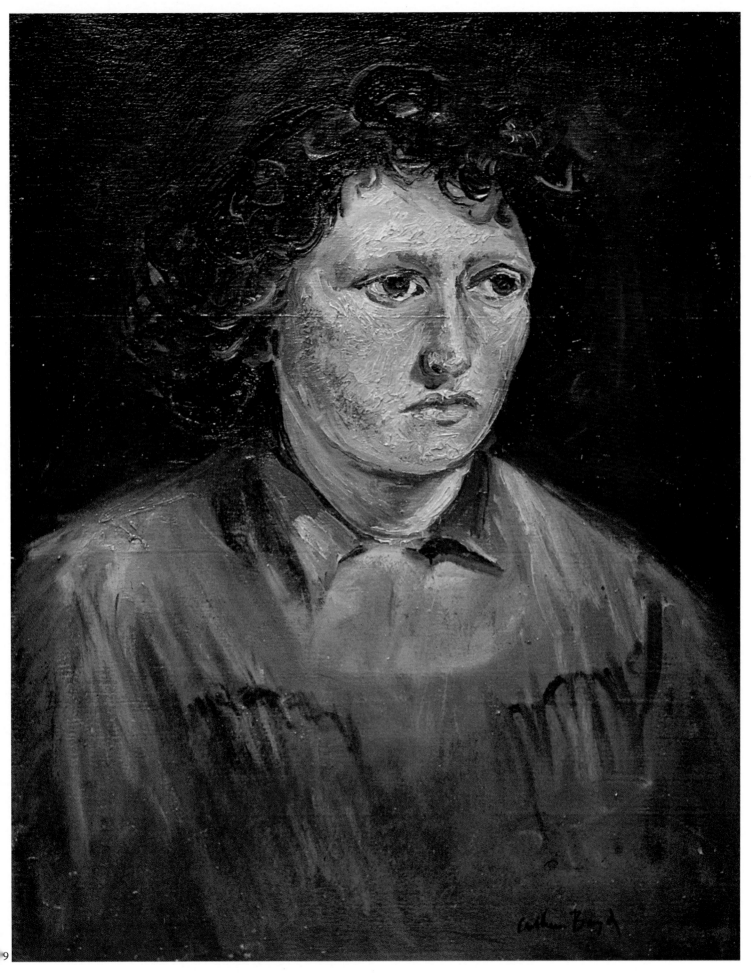

39

37 *Angel Spying on Adam and Eve* 1947–8

38 Bowl, polychrome with angel's face 1948

39 *Portrait of Betty Burstall* 1945

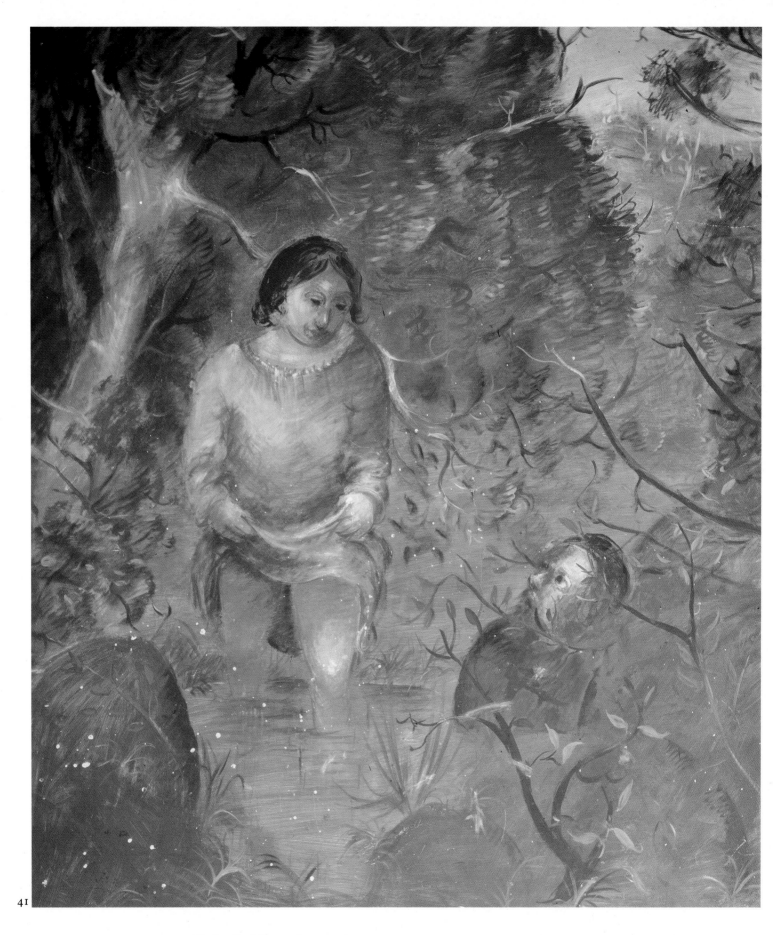

41

40 *The Prodigal Son* 1948–9
41 *Susannah* 1948–9
42 *Tobit and the Goat* 1950

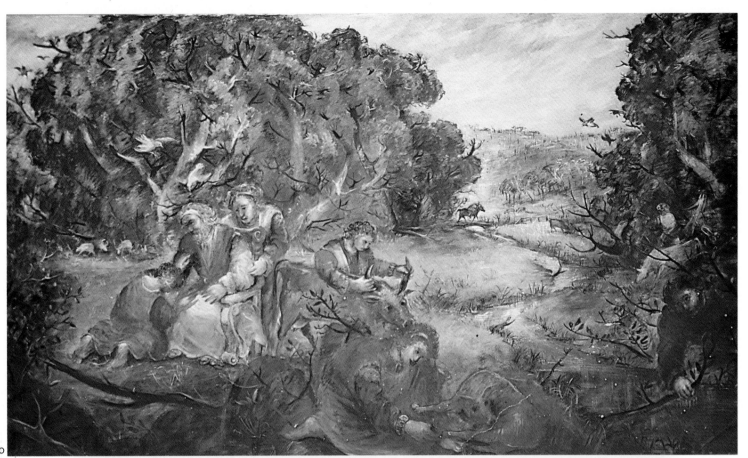

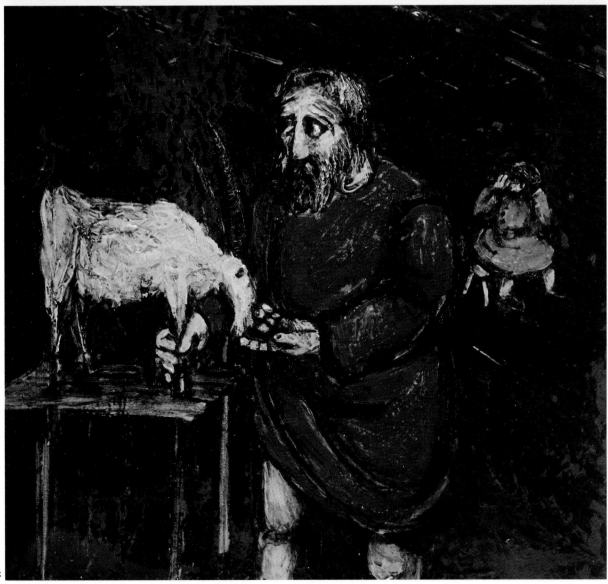

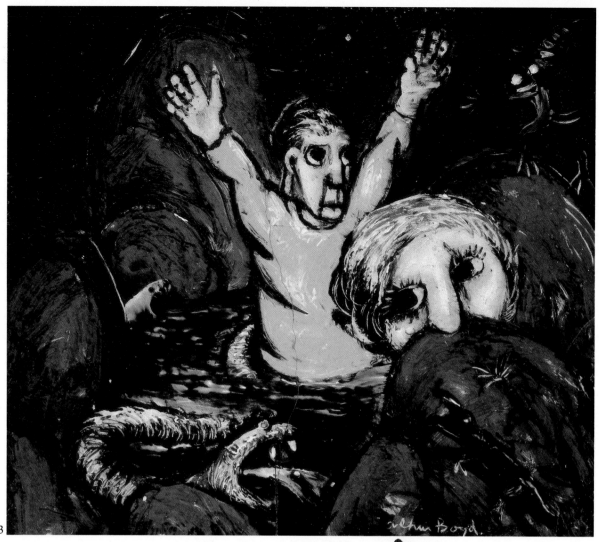

43

44

45

46

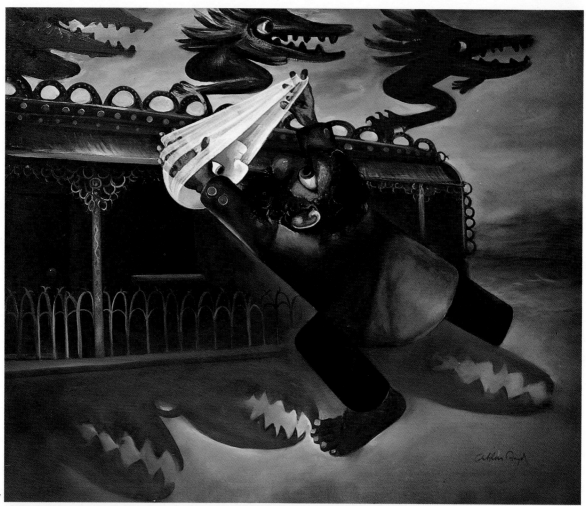

47

48

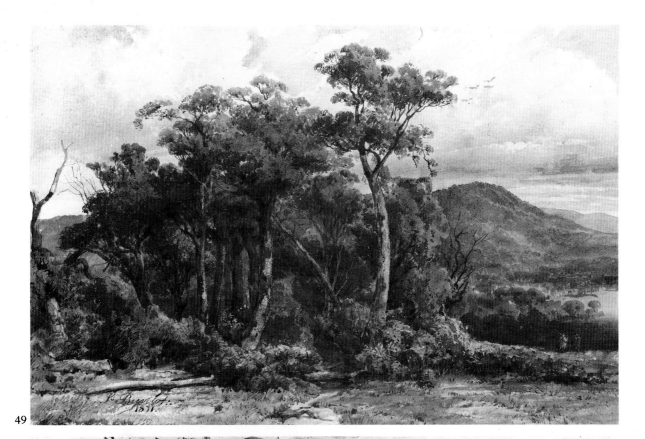

49

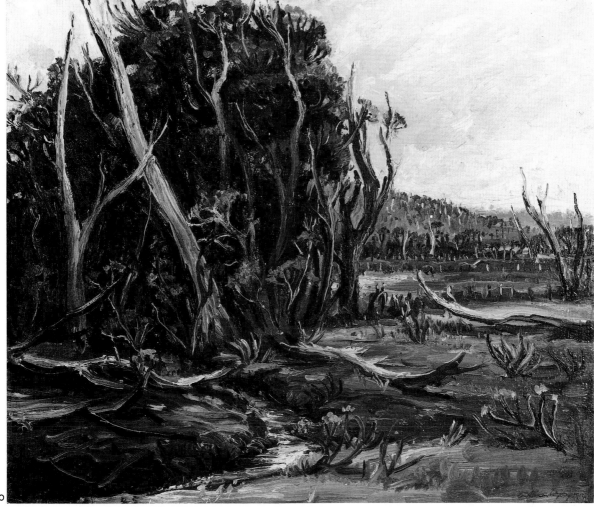

50

47 *Bridegroom and Gargoyles* 1958

48 *Lovers with a Bluebird* 1962

49 Abram Louis Buvelot (1814–1888)
 Yarra Flats (1871)

50 *Landscape (Bacchus Marsh)* 1943

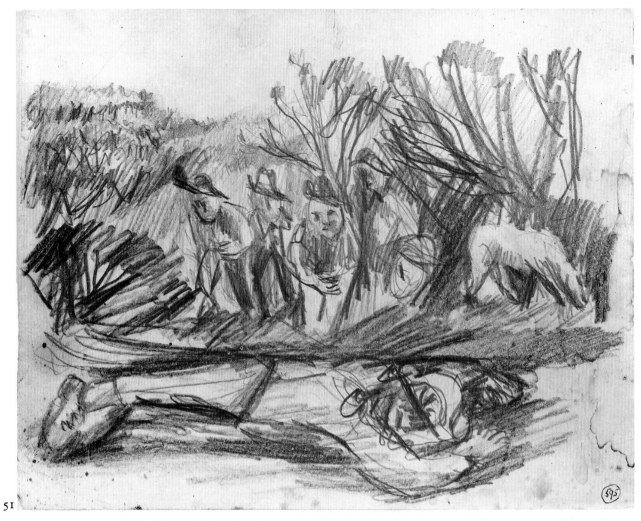

51

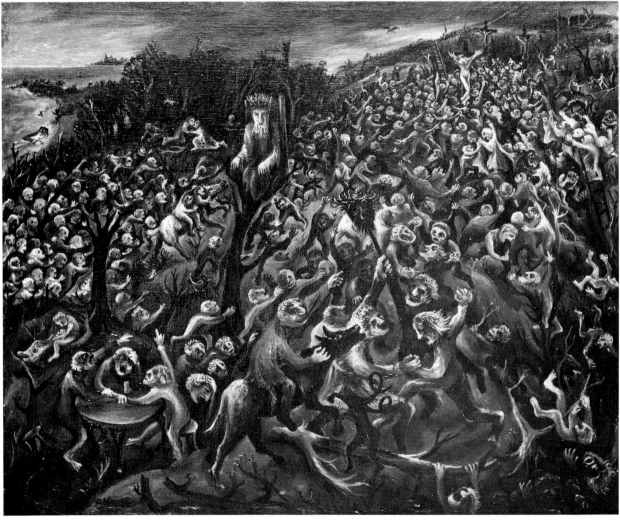

53

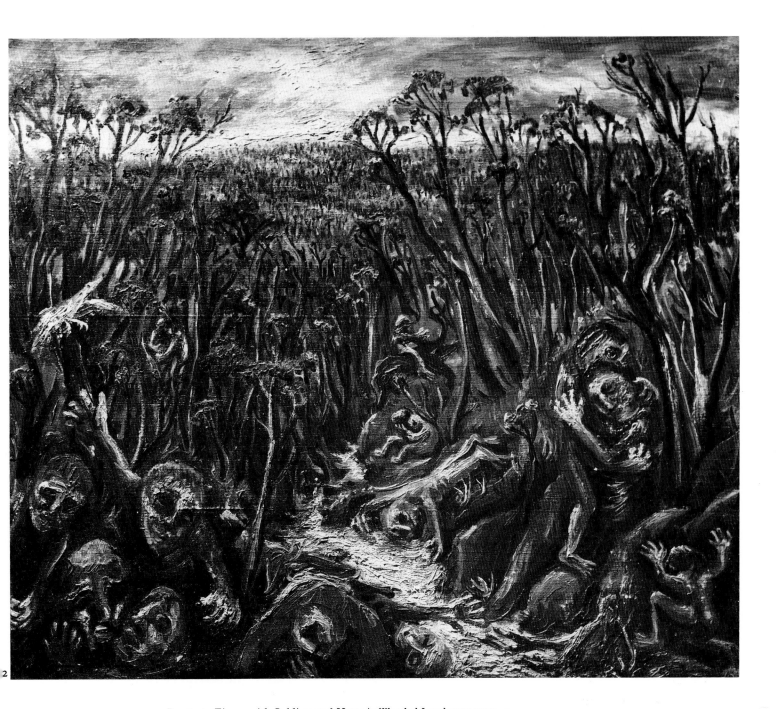

2

51 *Prostrate Figure with Soldiers and Horse in Wooded Landscape* 1943–4

52 *Figures by a Creek* 1944

53 *The Mockers* 1945

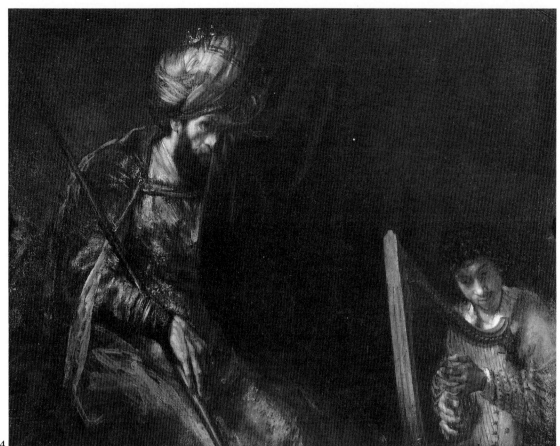

54

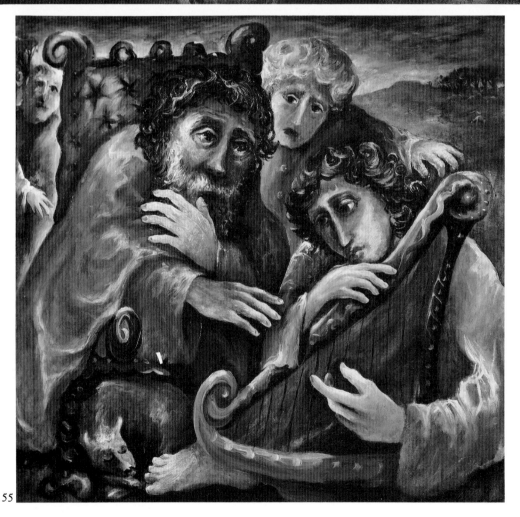

55

54 Rembrandt (1606–69)
David Playing the Harp before Saul

55 *Saul and David c.*1946

56 *Portrait of Frank Kellaway* 1945–6

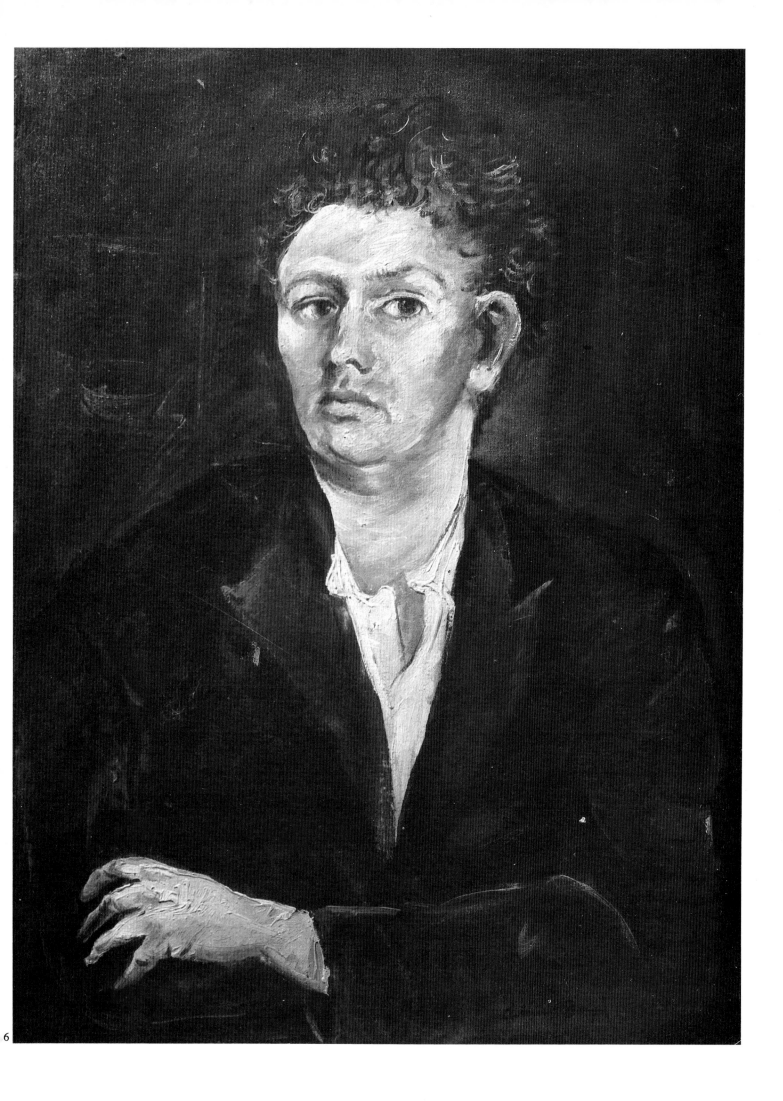

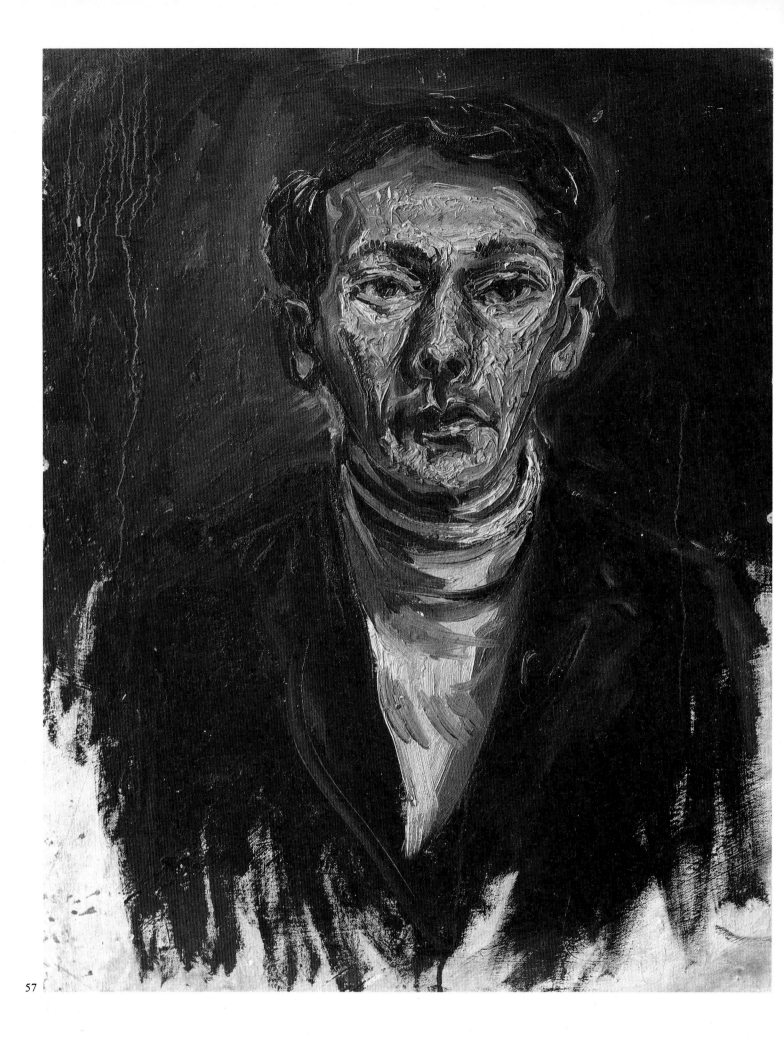

57

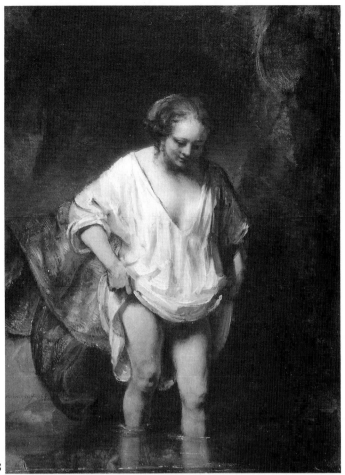

58

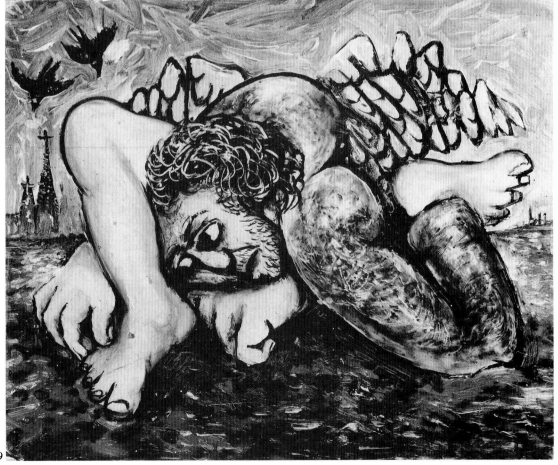

59

57 *Portrait of Max Nicholson* 1943

58 Rembrandt (1606–69)
 A Woman Bathing in a Stream 1655

59 *Icarus Fallen on a Field* 1951–2

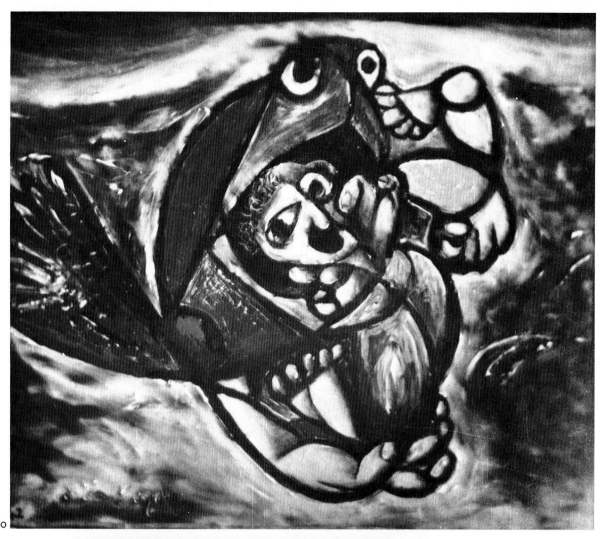

60

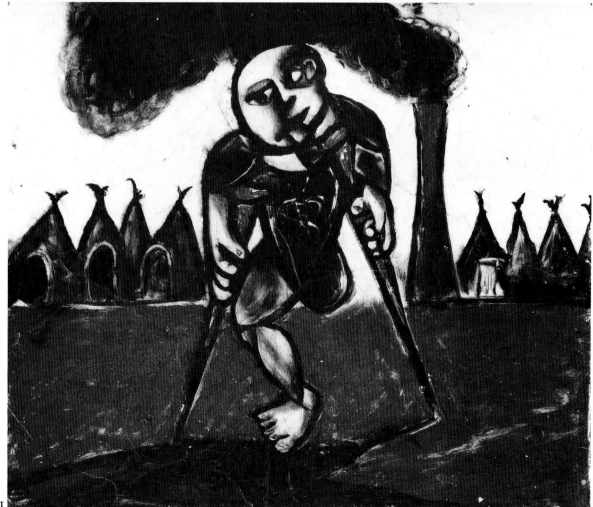

61

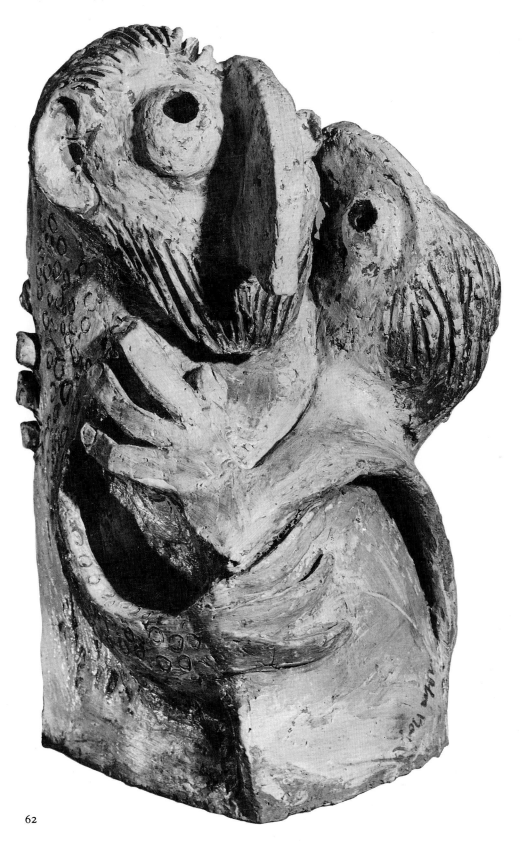

62

63

63 *A Beckett Road, Harkaway* 1949
64 *Burnt Wheat Stubble* 1950–1
65 *Landscape, Grampians* 1950–1

4

5

66

67 810 *a.39l*

66 *Grampians Waterfall c.*1950

67 *Aborigines Playing Cards outside Whorlie* 1951

68 *Aborigine Eating Cake outside Shop Window* 1951

69 *Bones and Hide* 1951

Also eating cakes
out side of
window

704

2

Hide

Bone

Bone

771

a.321

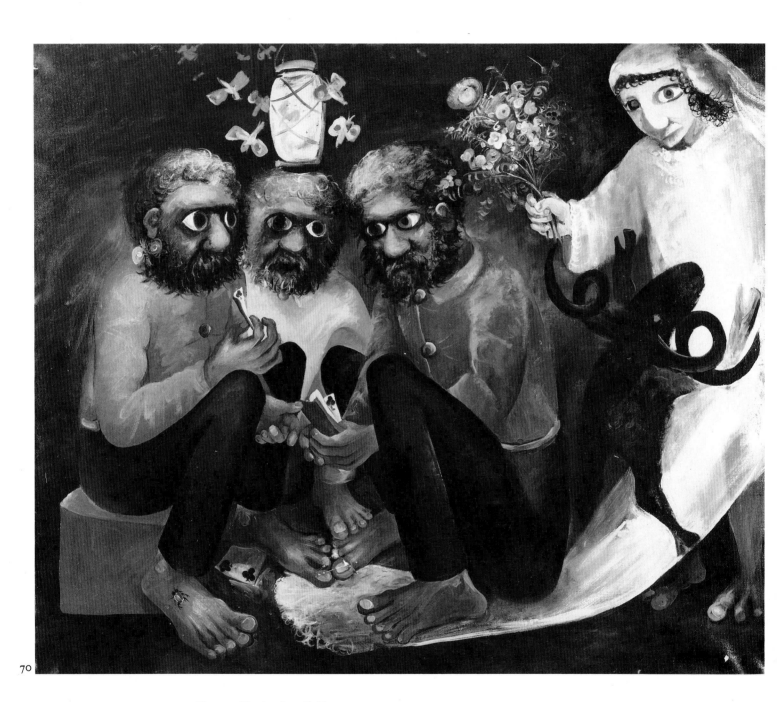

70

70 *Shearers Playing for a Bride* 1957
71 *Frightened Bridegroom I* 1958
72 *Persecuted Lovers* 1957–8

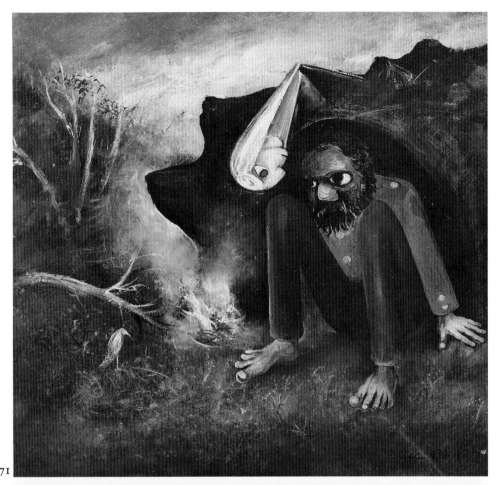

71

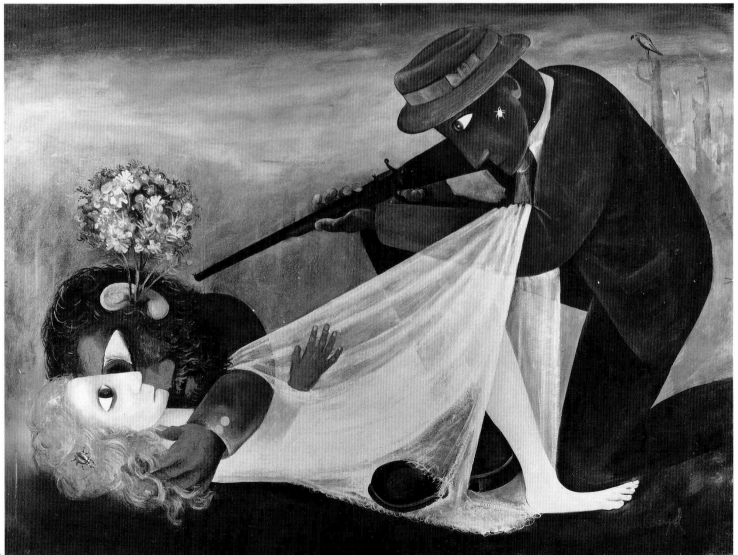

72

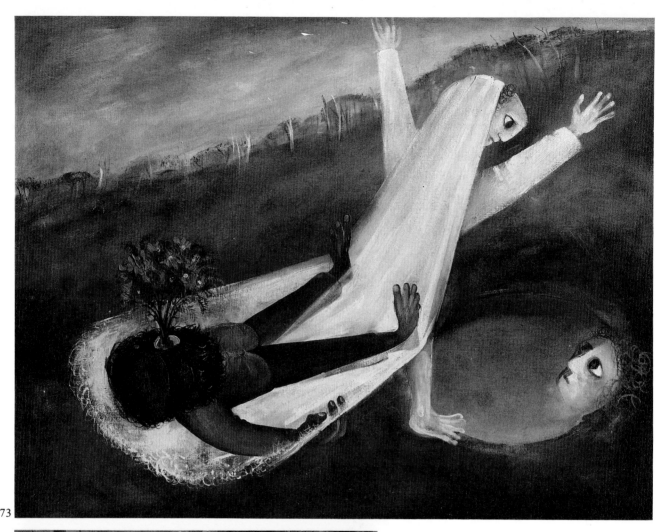

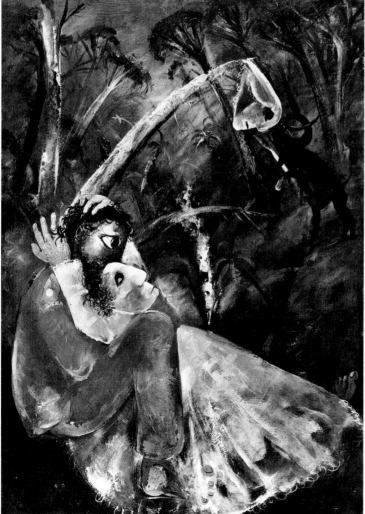

73 *Bride Reflected in a Waterhole* 1957–8

74 *Lovers by a Creek* 1960

75 *Nude Carrying a Ram* 1962

76 *Romeo and Juliet* polyptych 1963–4
 Centre panel

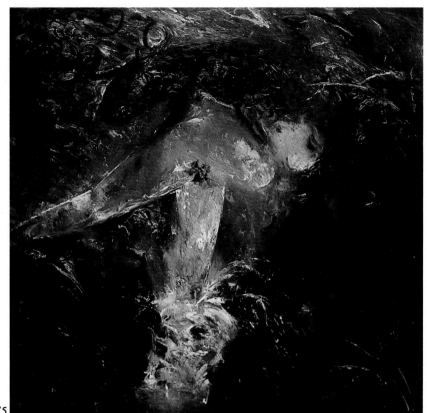

75

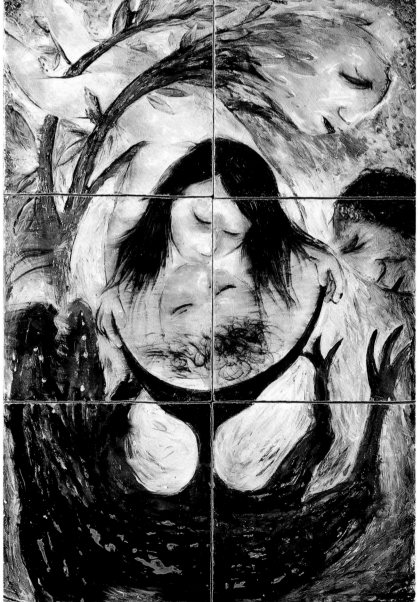

76

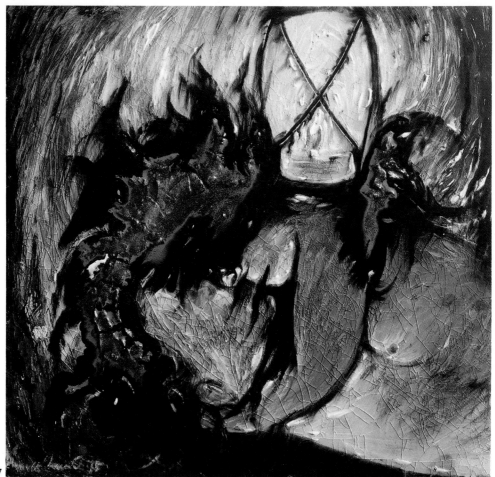

77

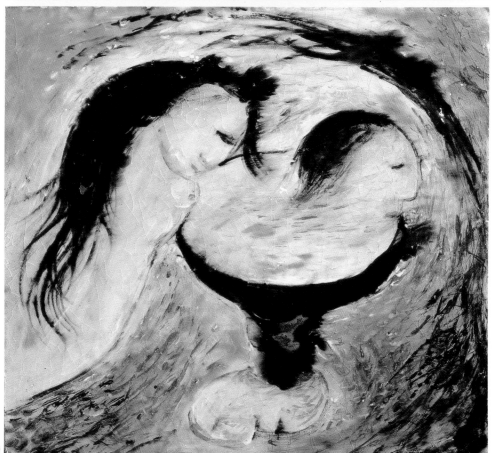

78

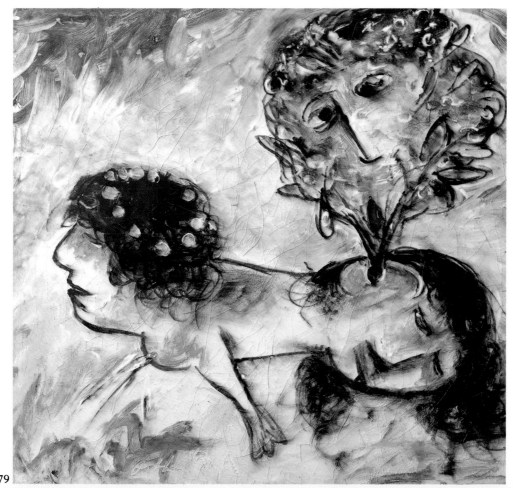

79

80

77 *Romeo and Juliet* polyptych 1963–4
Side panel

78 *Romeo and Juliet* polyptych 1963–4
Side panel

79 *Two-ended Figure with Bouquet* 1962–3

80 *St Francis turning Brother Masseo* 1964–5

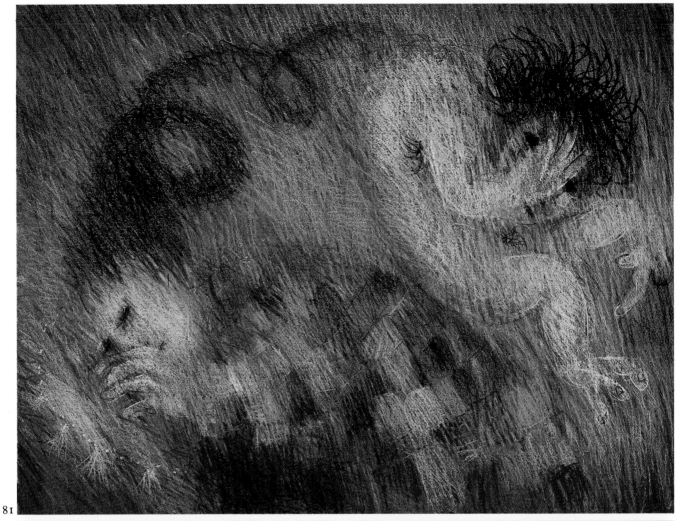

81

82

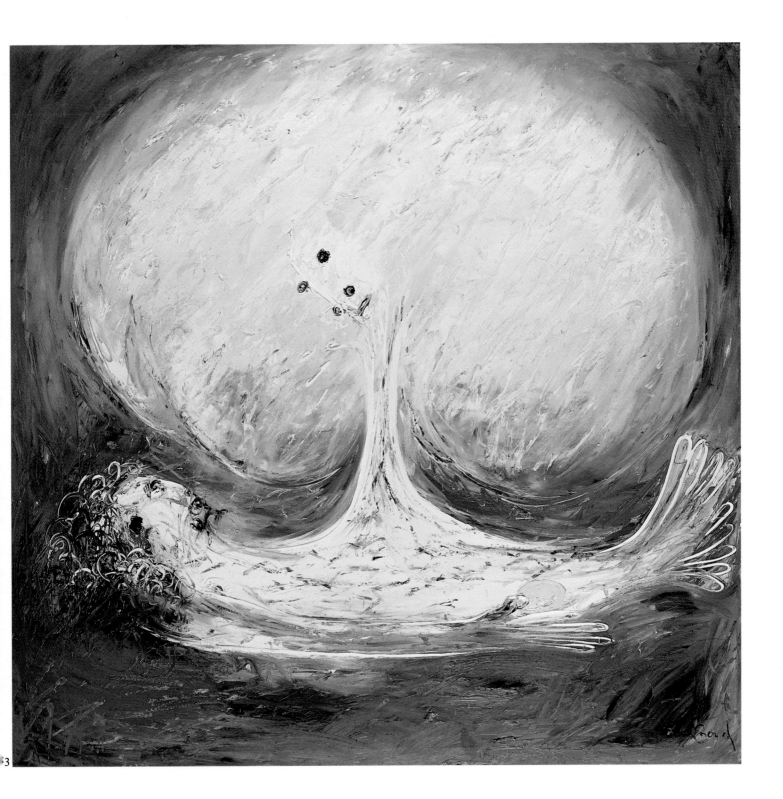

83

81 *St Francis dreaming of a hunchback* 1964–5

82 *St Francis cleansing the leper* 1964–5

83 *Nebuchadnezzar making a cloud* 1966–9

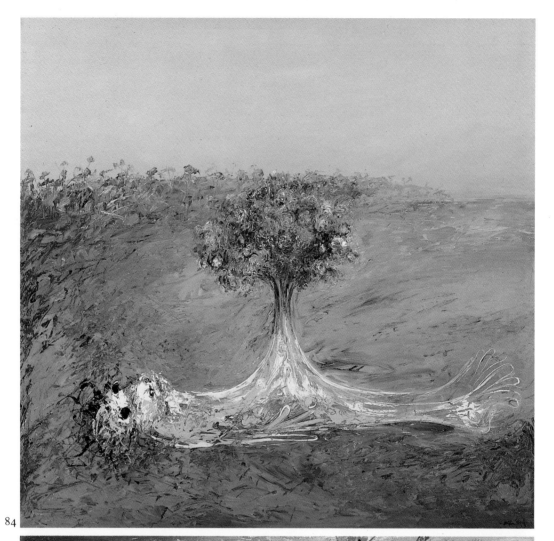

84

85

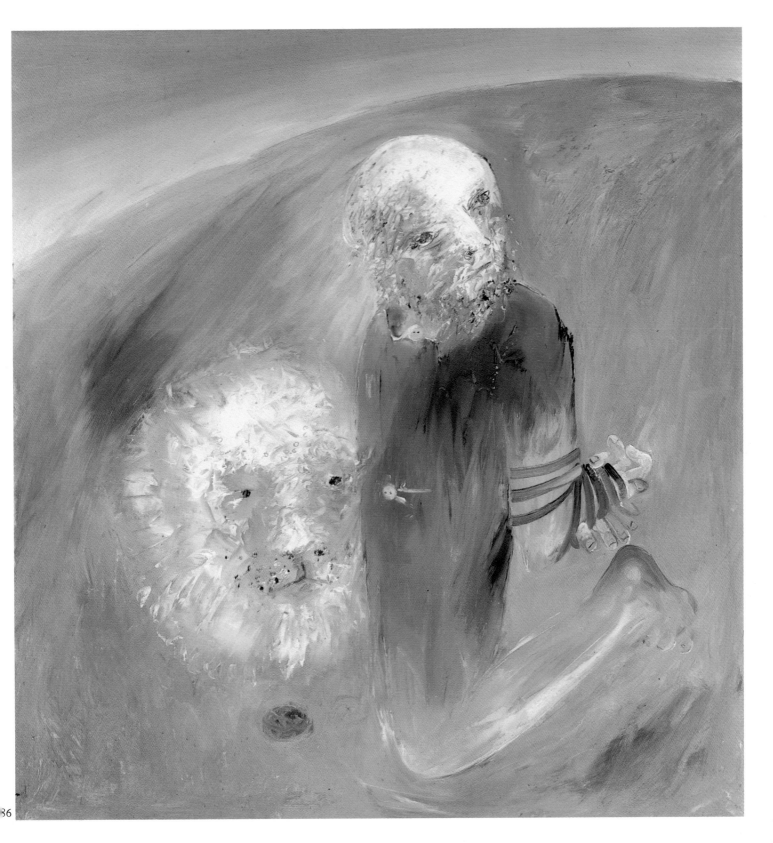

86

84 *Nebuchadnezzar's dream of the tree* 1966–9

85 *Red Nebuchadnezzar fallen in a forest with black birds* 1966–9

86 *Daniel in the lion's den* c.1970

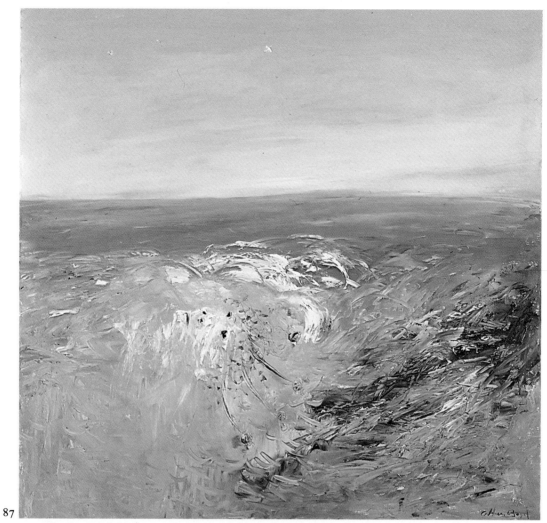

87

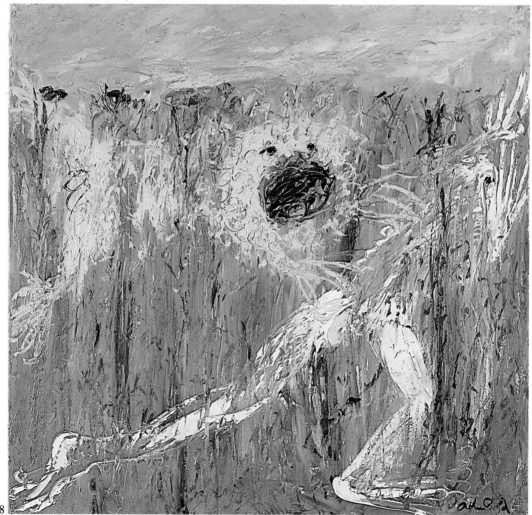

88

87 *Nebuchadnezzar's head in a wave* 1966–9

88 *White Nebuchadnezzar running through forest with lion roaring* 1966–9

89 *Nebuchadnezzar protecting his gold* 1966–9

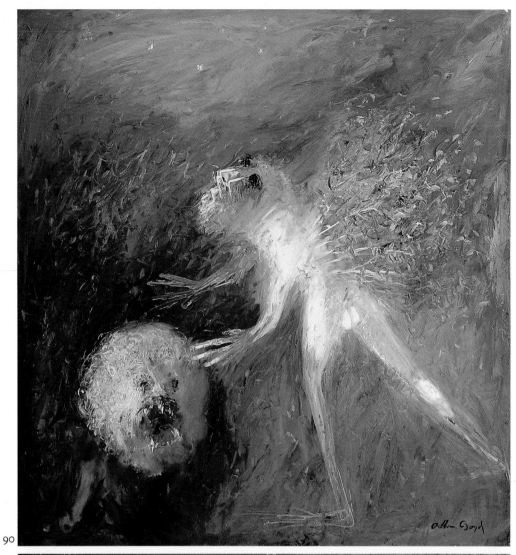

90

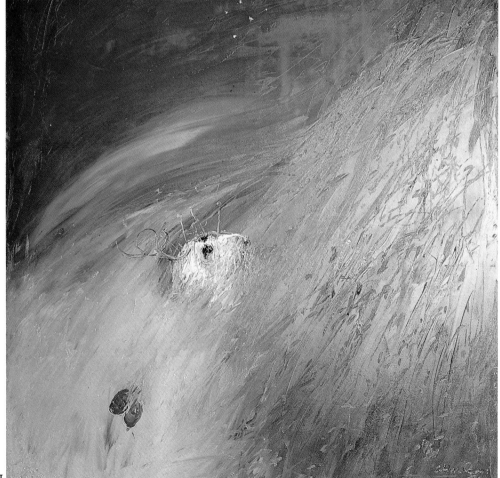

91

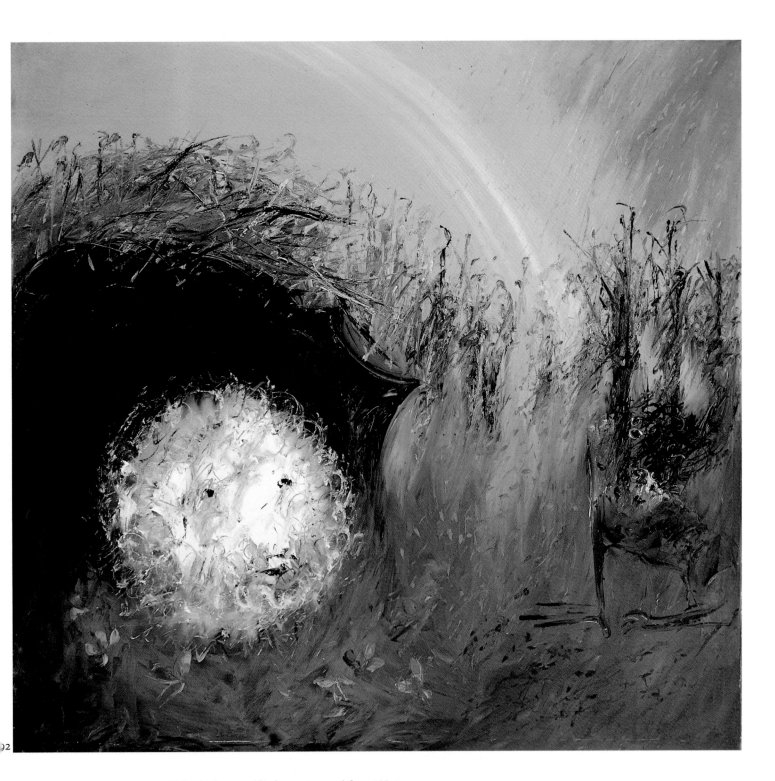

90 *Nebuchadnezzar blind on a starry night* 1966–9

91 *Nebuchadnezzar buried in sand and the Seven Sisters* 1966–9

92 *Lion's head in a cave and rainbow* 1966–9

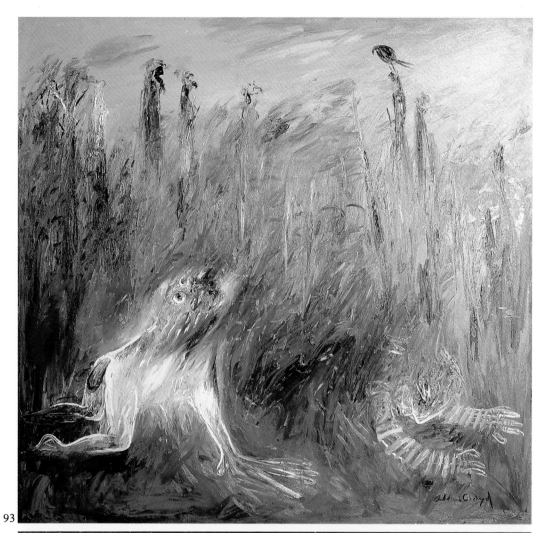

93

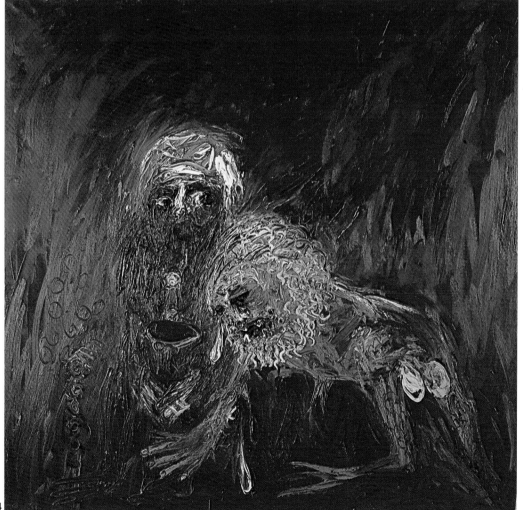

94

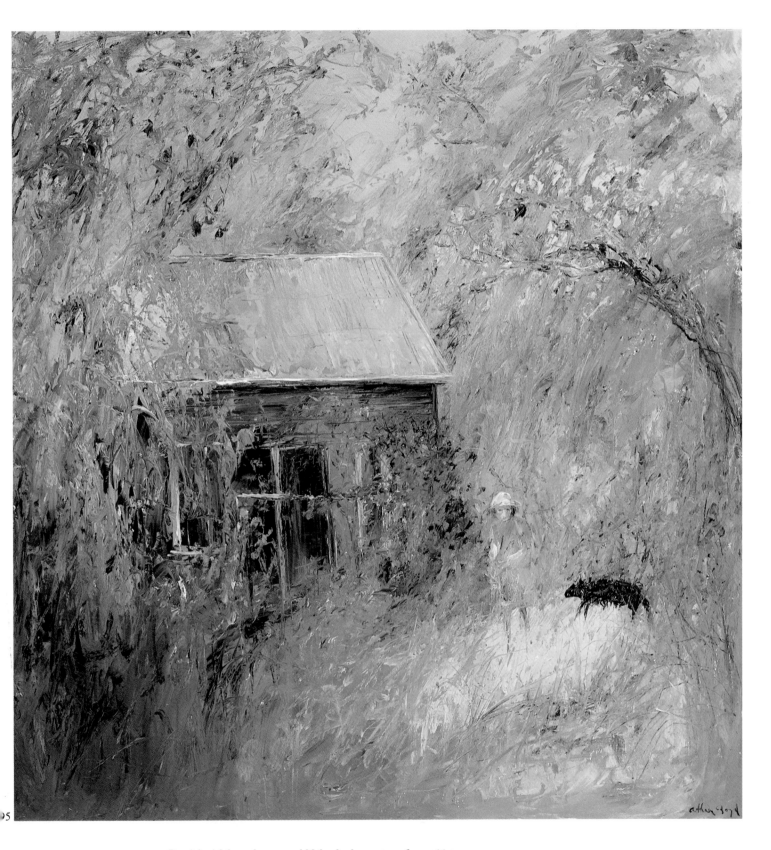

95

93 *Daniel with bound arms and Nebuchadnezzar on fire* 1966–9

94 *Seated Nebuchadnezzar and crying lion* 1966–9

95 *Potter's House at Murrumbeena* 1964–7

96

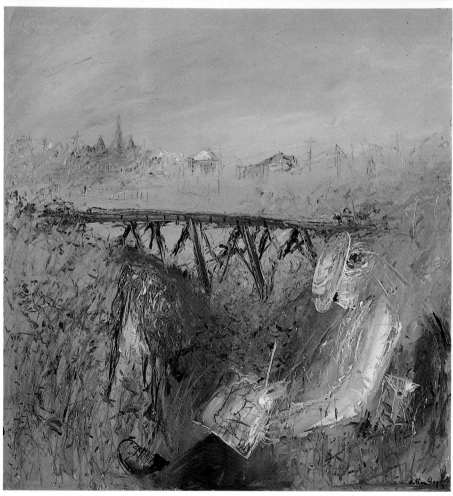

97

96 *Potter's Wife in Garden at Murrumbeena* 1964–7

97 *Potter Drawing a Brown Cow in the Suburbs* 1967–8

98 *Potter Drawing by the Sea* 1967–8

99 *Potter's Wife, Horse and Trap (Rosebud)* 1969–70

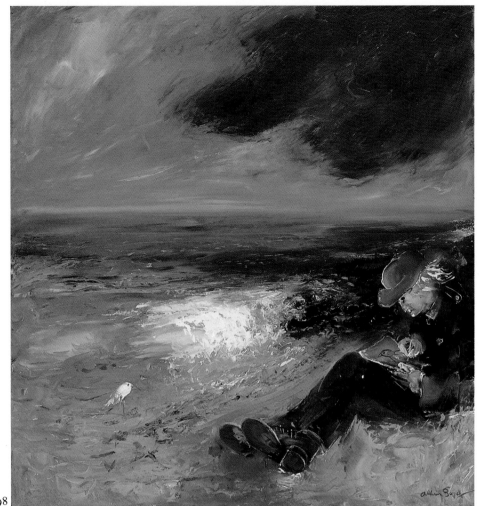

98

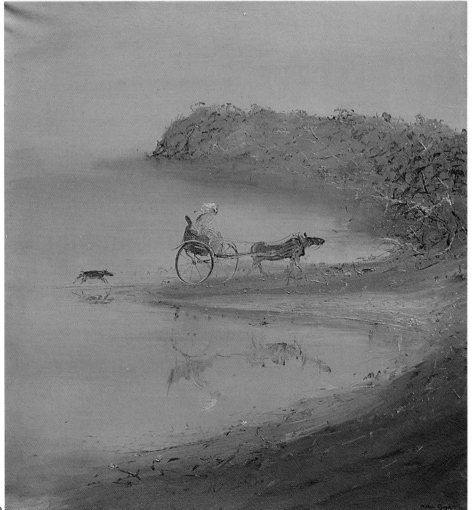

99

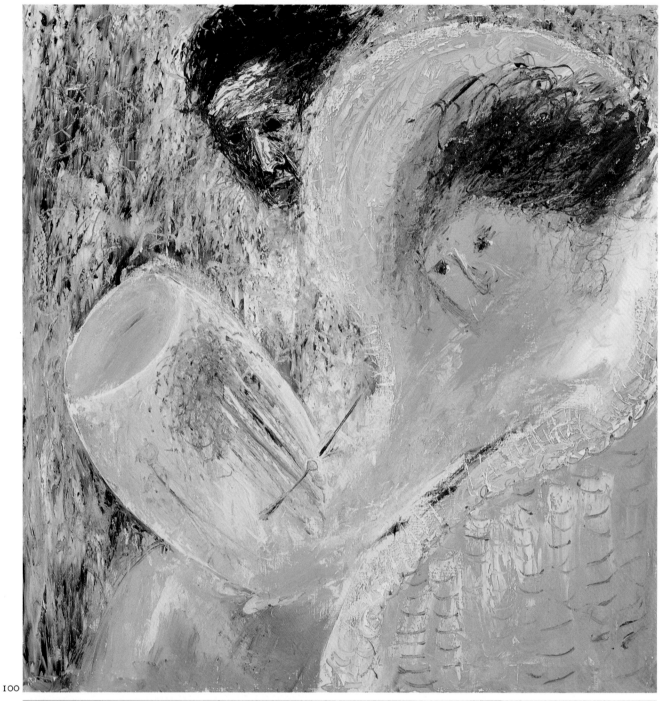

100

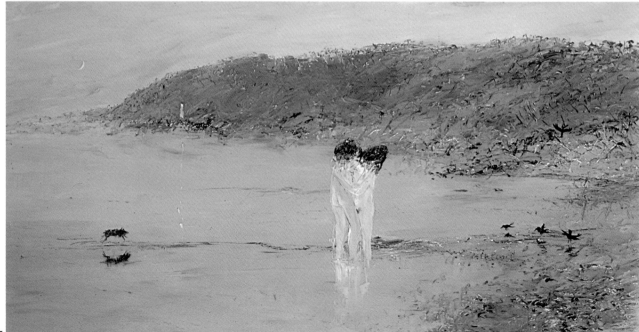

101

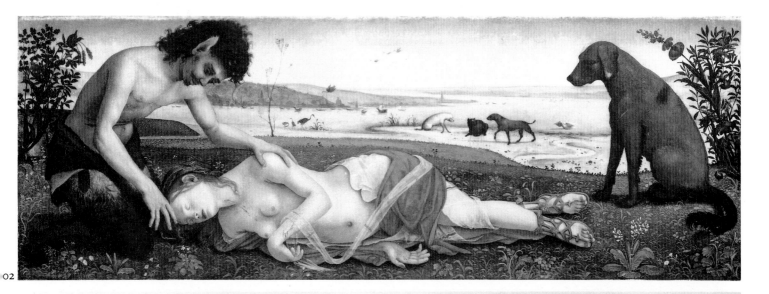

100 *Potter's Wife Decorating a Pot* 1967–9

101 *Potter and Wife on Beach at Arthur's Seat* 1968–9

102 Piero di Cosimo (*c.*1462–after 1515)
A Mythological Subject

103 *Nude over Pond c.*1962

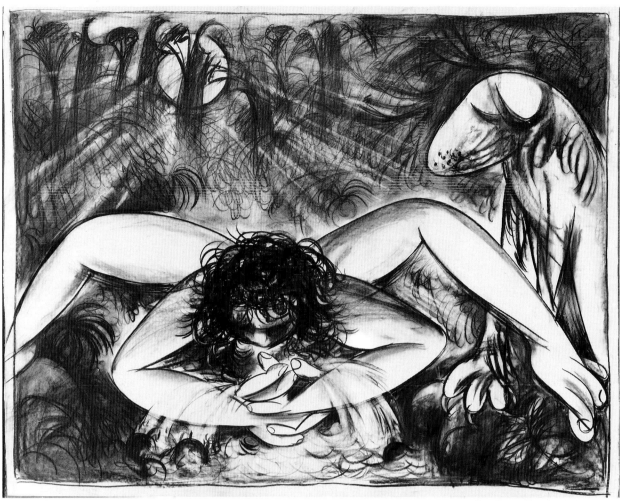

104

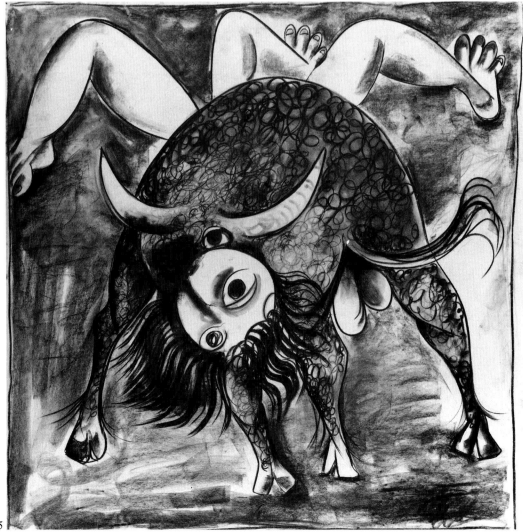

105

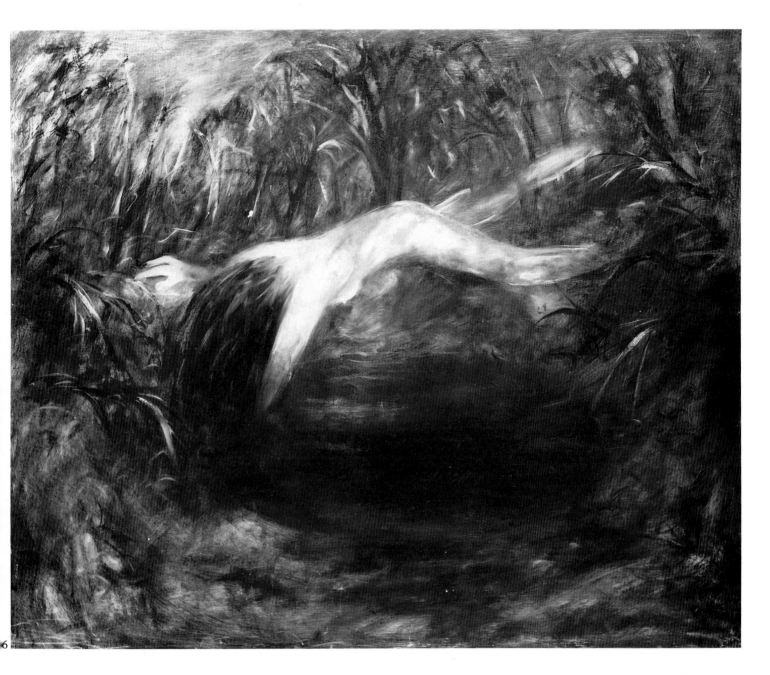

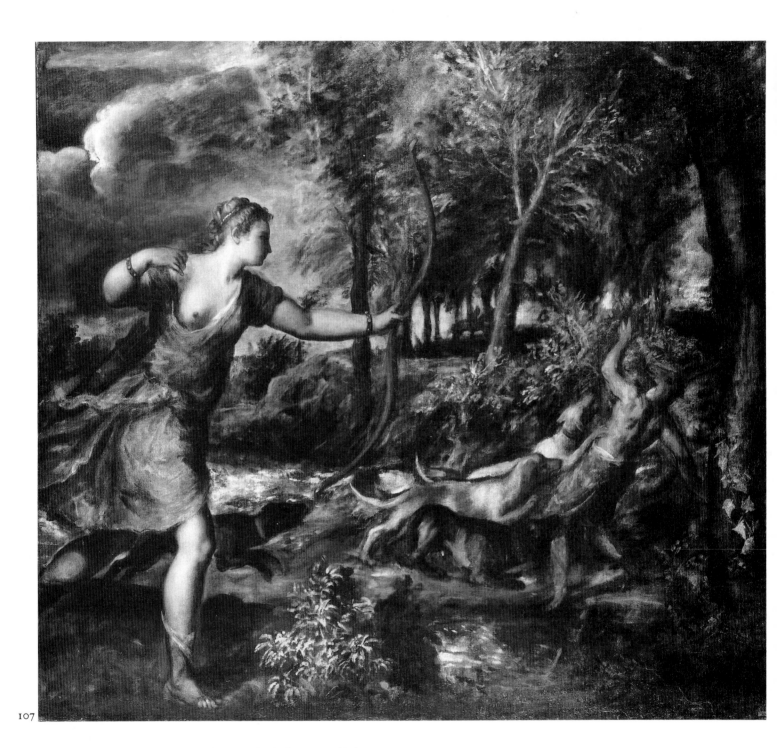

107

107 Titian (Active before 1511, died 1576)
 The Death of Actaeon

108 *Nude with Beast III* 1962

109 *White Joined Figures* (used for *Electra* backdrop) 1962–3

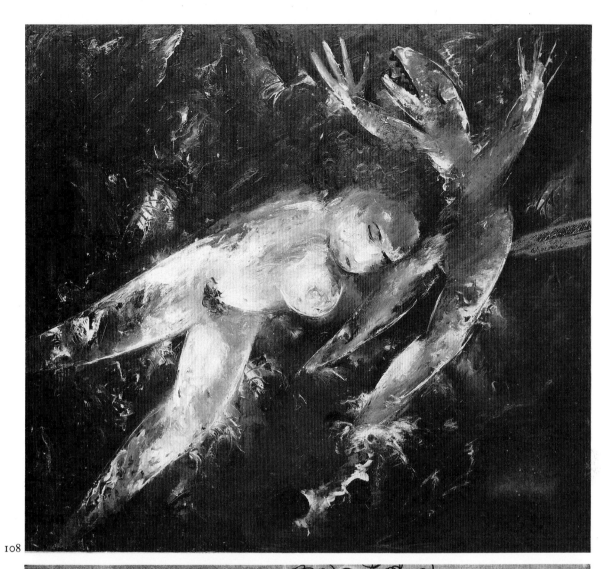

108

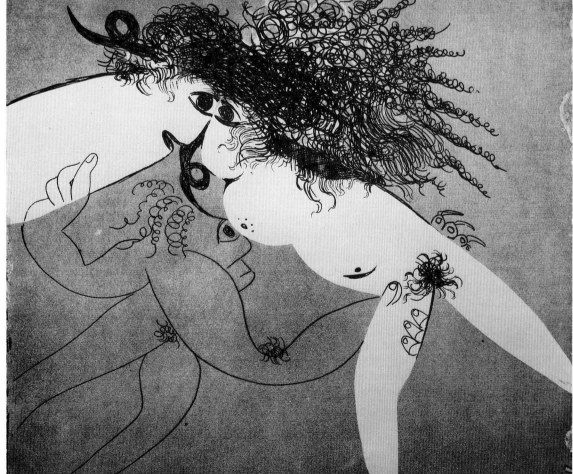

109

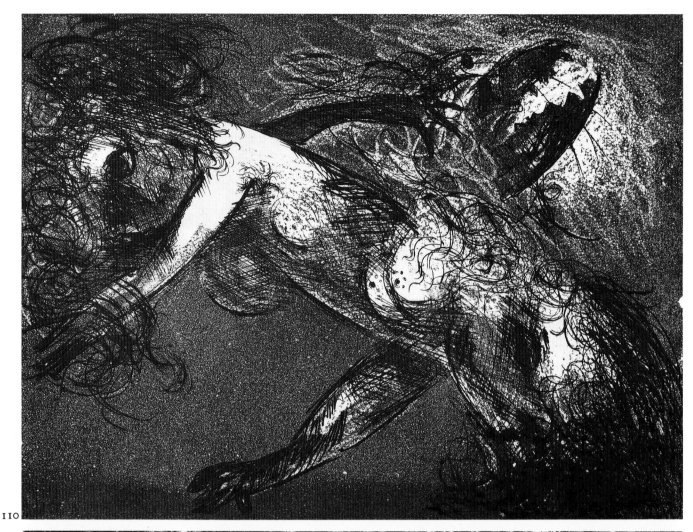

110

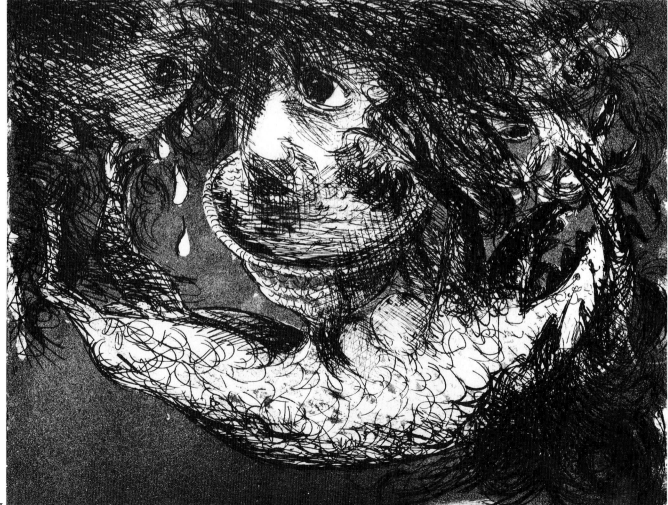

111

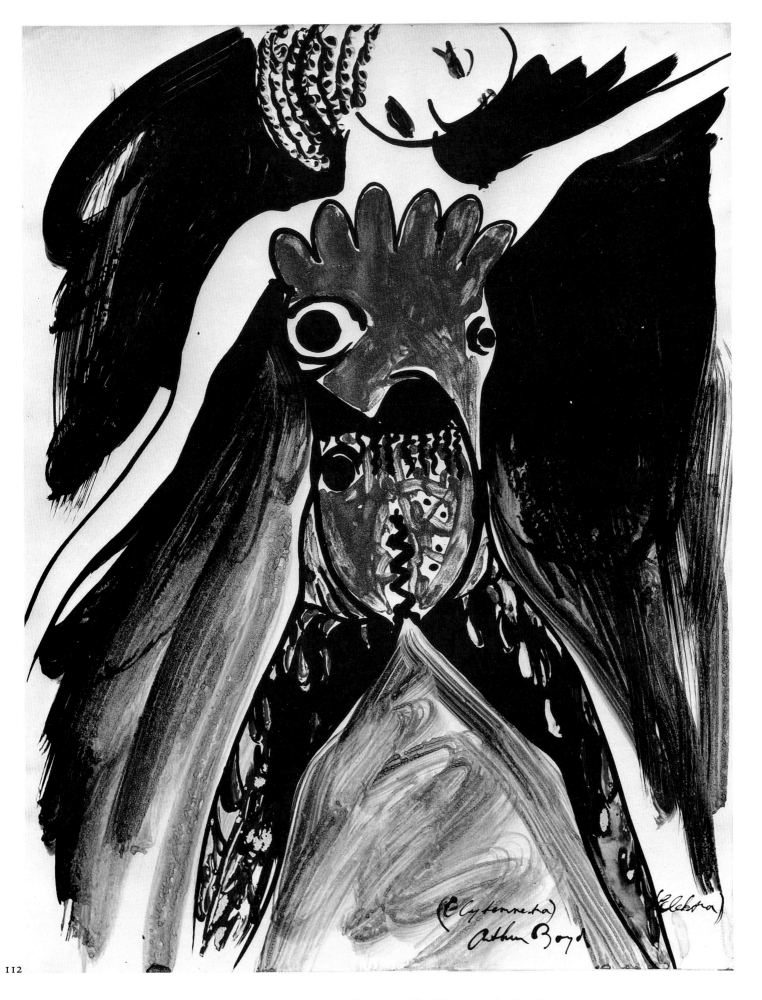

110 *Double Figure with Shark Head and Horns* (used for *Electra* backdrop) 1962–3

111 *Head in Cup with Crying Head* 1962–3

112 Clytemnestra, costume design 1962–3

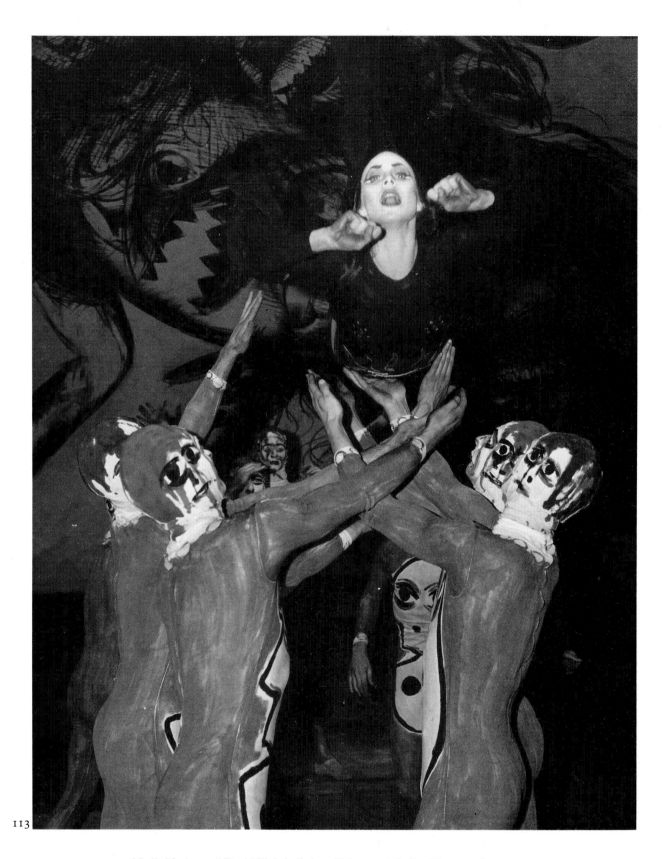

113

113 Nadia Nerina and David Blair in Robert Helpmann's ballet *Electra* 1963

114 Costume drawing for *The Eumenides (Electra)* 1962–3

115 *Mariner Spearing Bird* (Ancient Mariner) *c.*1967

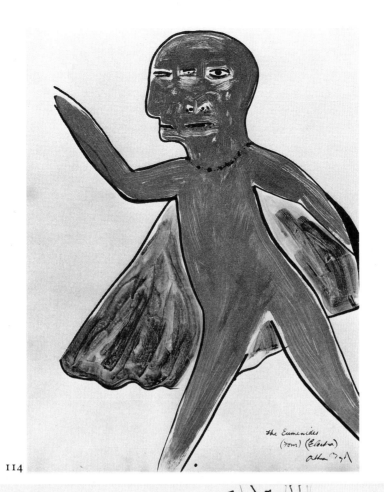

The Eumenides
(rom) (Electra)
Arthur Boyd

114

115 (1465)

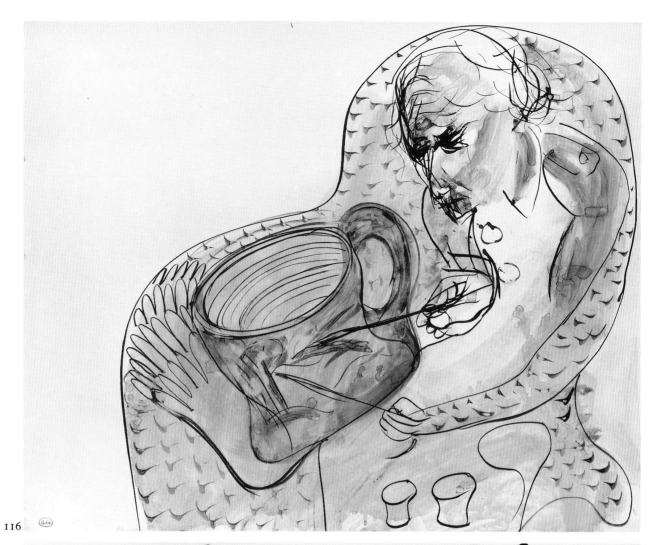

116

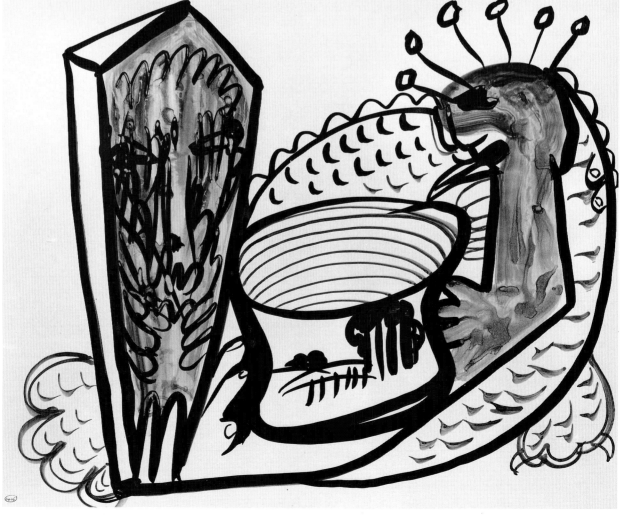

117

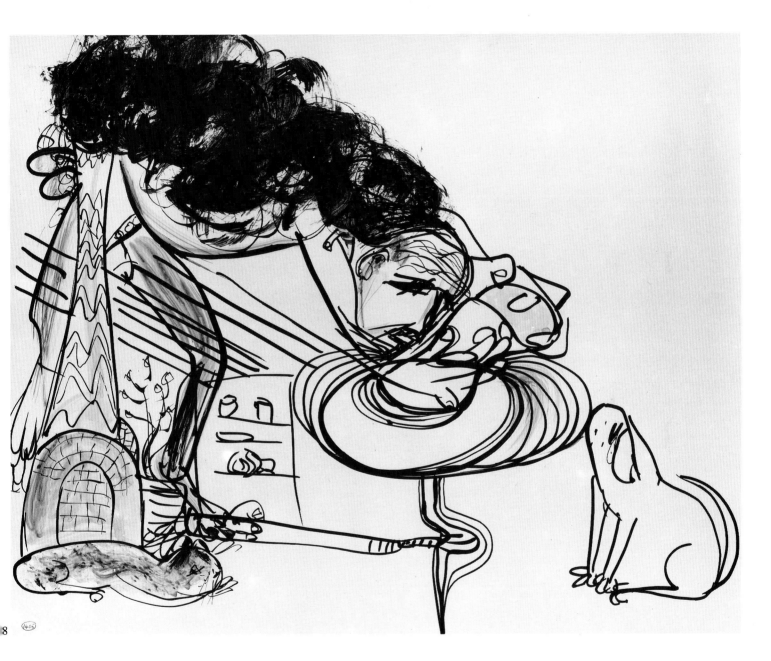

116 *Potter in Armchair Painting a Pot c.*1967

117 *Flowered Head with Coffin and Pot with Landscape Decoration c.*1967

118 *Potter Emerging from Smoking Kiln with Wheel and Dog c.*1967

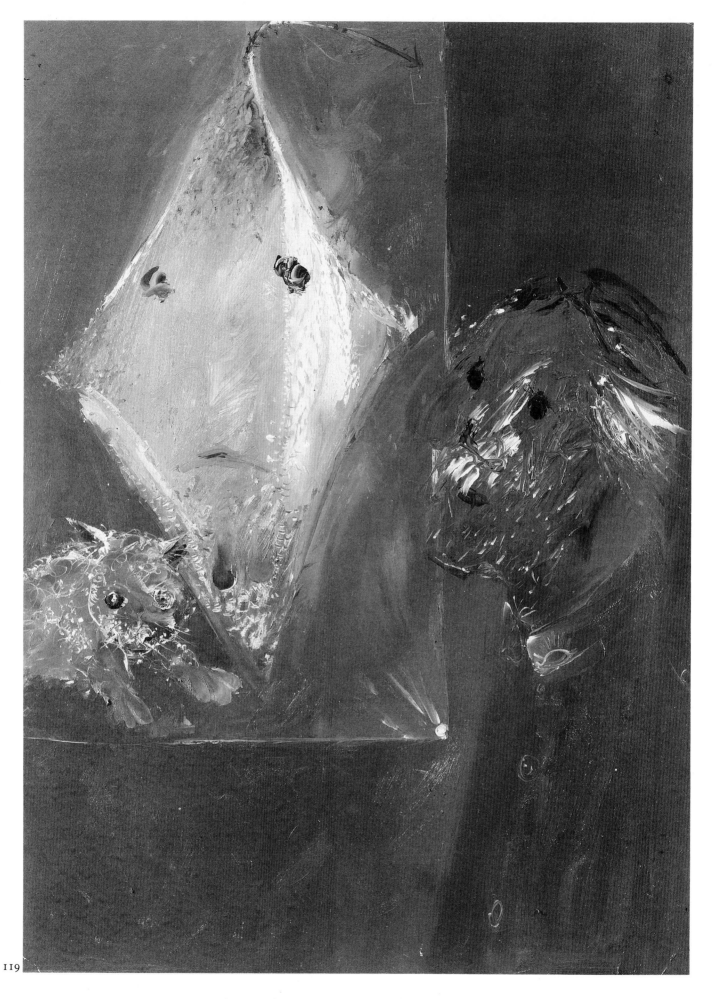

119

119 *Potter Looking at Chardin Print* 1969

120 *Potter – Artist's Father in Armchair with Pot and Bust* 1969

121 *Lovers Suspended over a Dark Pond* 1966–9

120

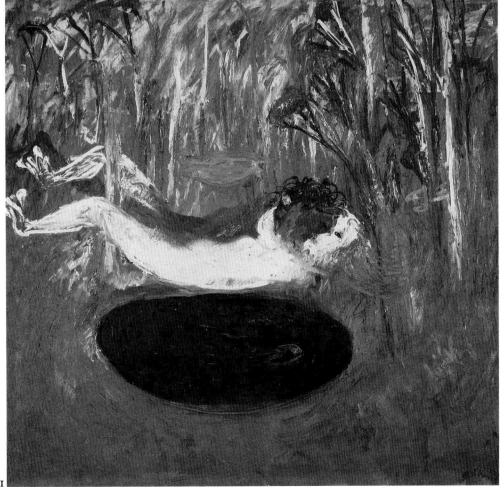

121

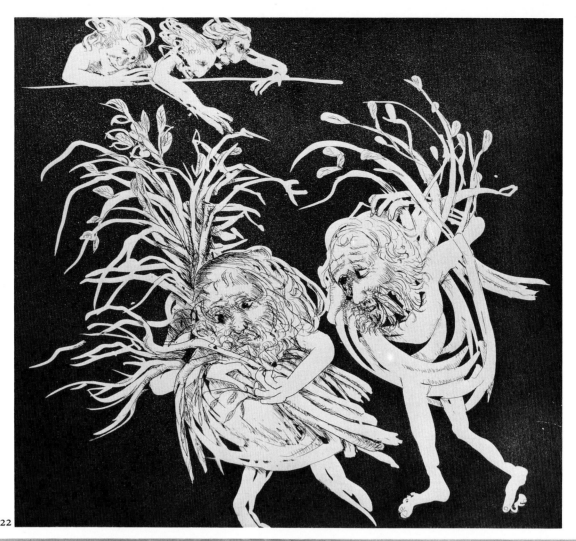

122

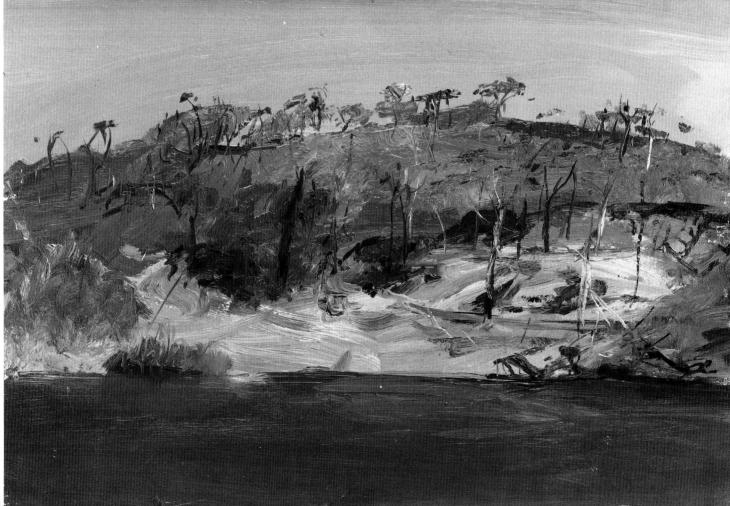

123

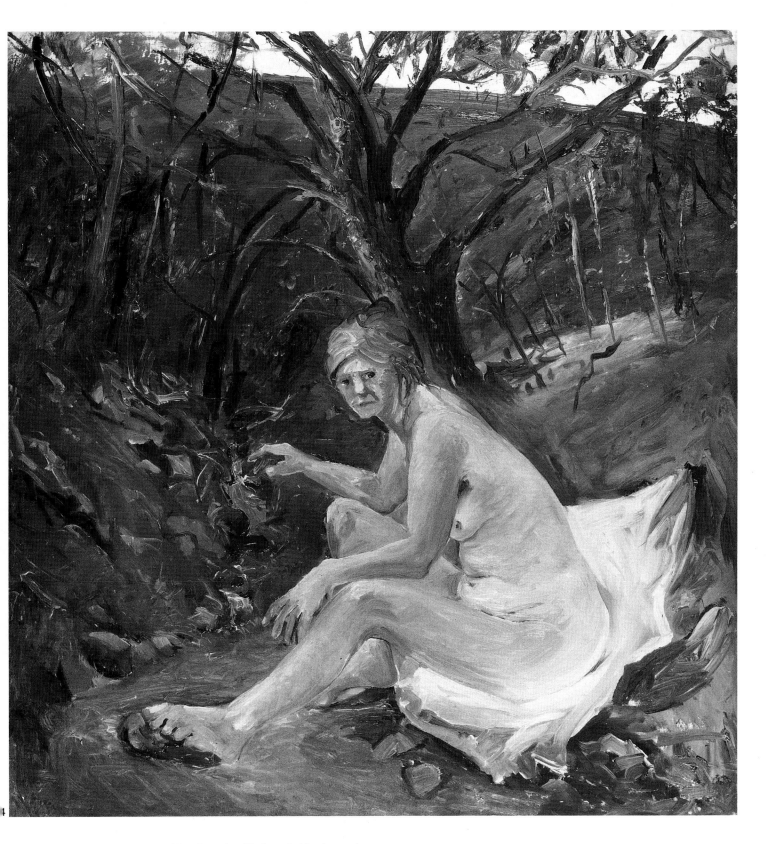

122 *Men Carrying Firebrands (Lysistrata)* 1971
123 *Riverbank* 1972
124 *Figure by a Creek* 1972

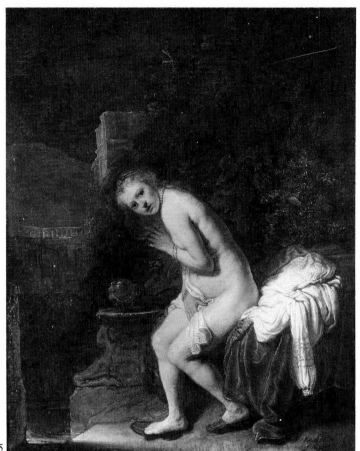

125

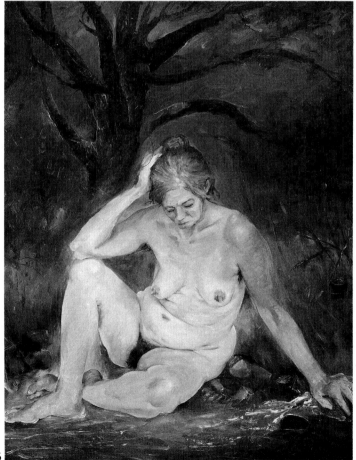

126

125 Rembrandt (1606–69)
Susannah surprised by the Elders 1637

126 *Seated Figure by Creek* 1972

127 *Potter's Wife: Figure in a Wave* 1967–9

128 *Potter by his Kiln* 1967–9

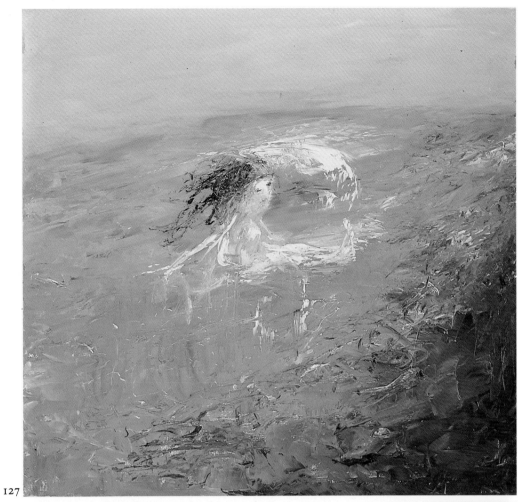

127

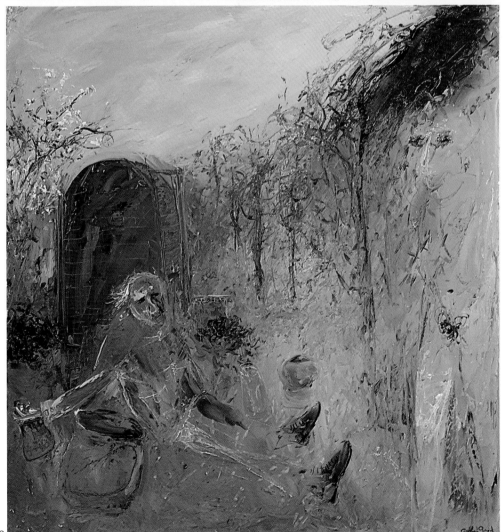

128

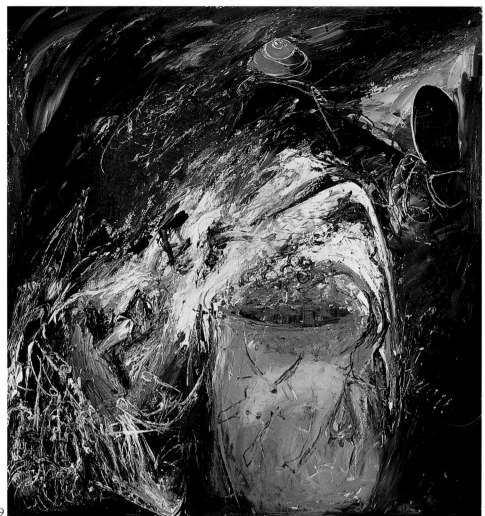

129

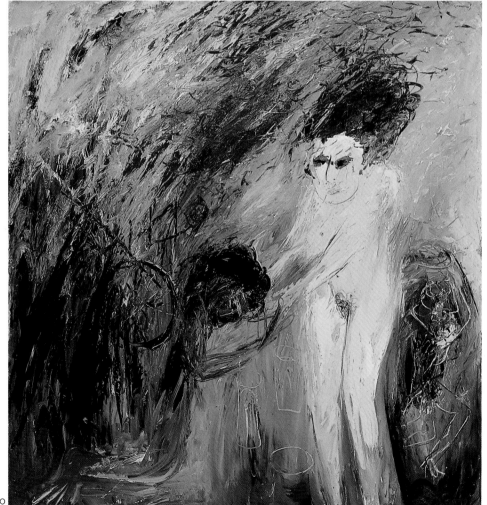

130

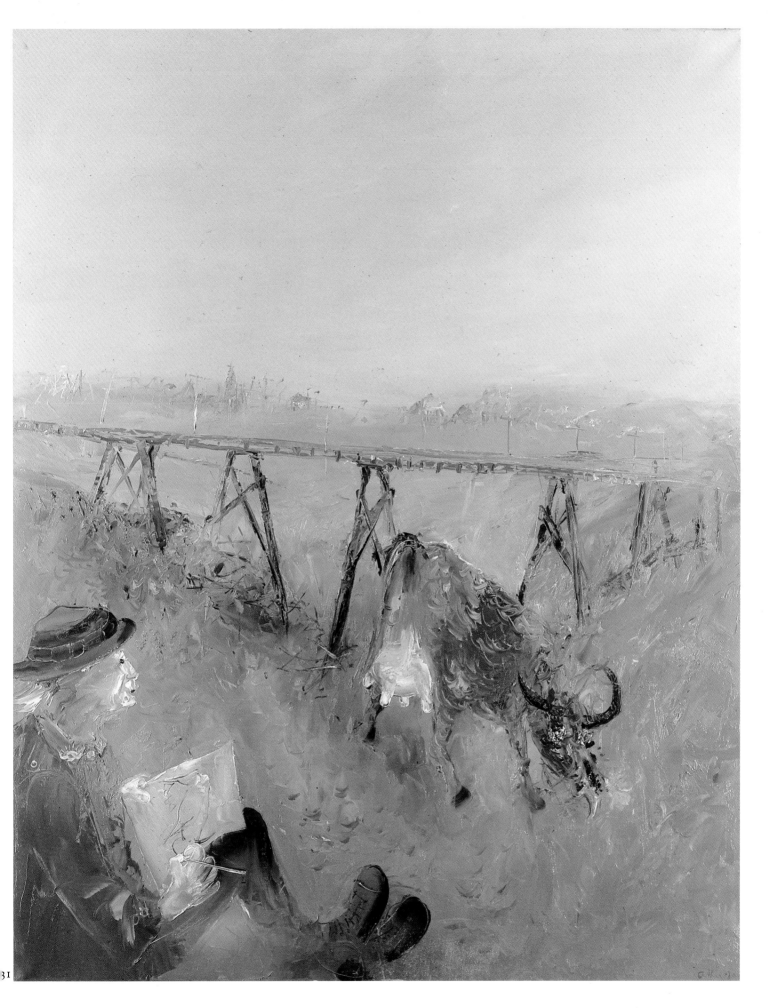

129 *Potter Falling over Decorated Pot* 1967–9

130 *Pottery Destroyed by Fire* 1967–9

131 *Potter Drawing Black Cow in Suburban Landscape* 1969

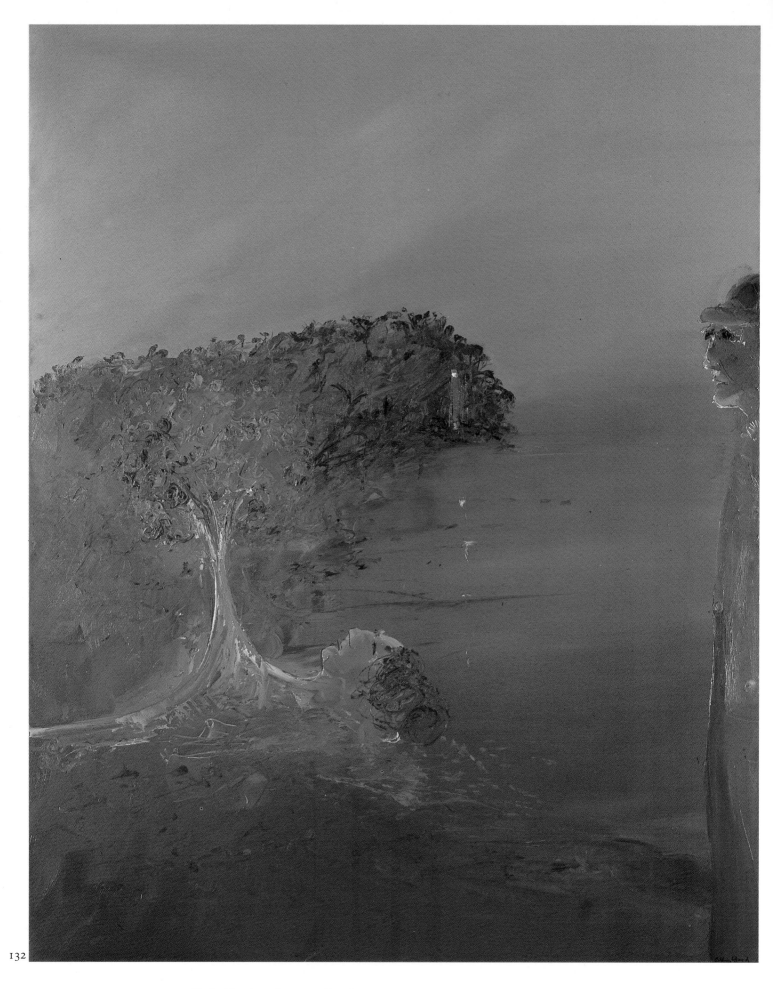

132 *Early Morning – Potter and his Wife on Beach* 1969

133 *Potter Holding Plaster Head* 1969

134 *Lysistrata II* 1971

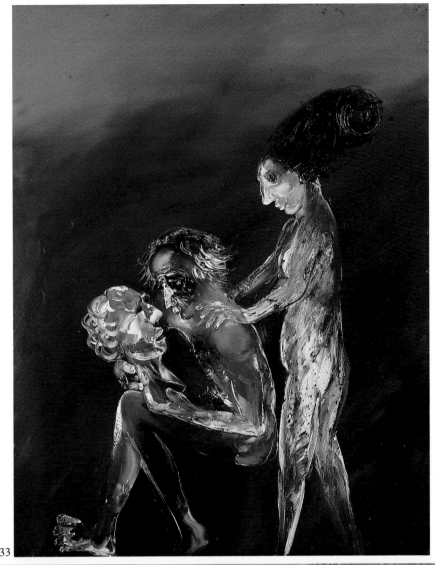

133

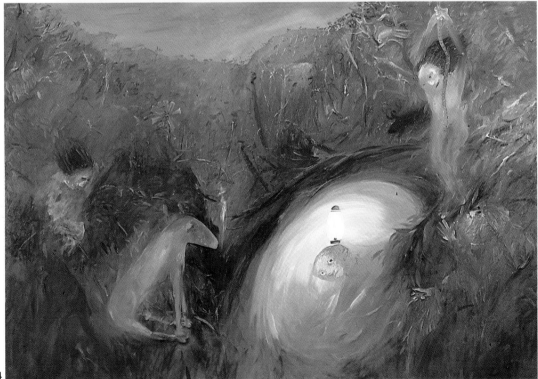

134

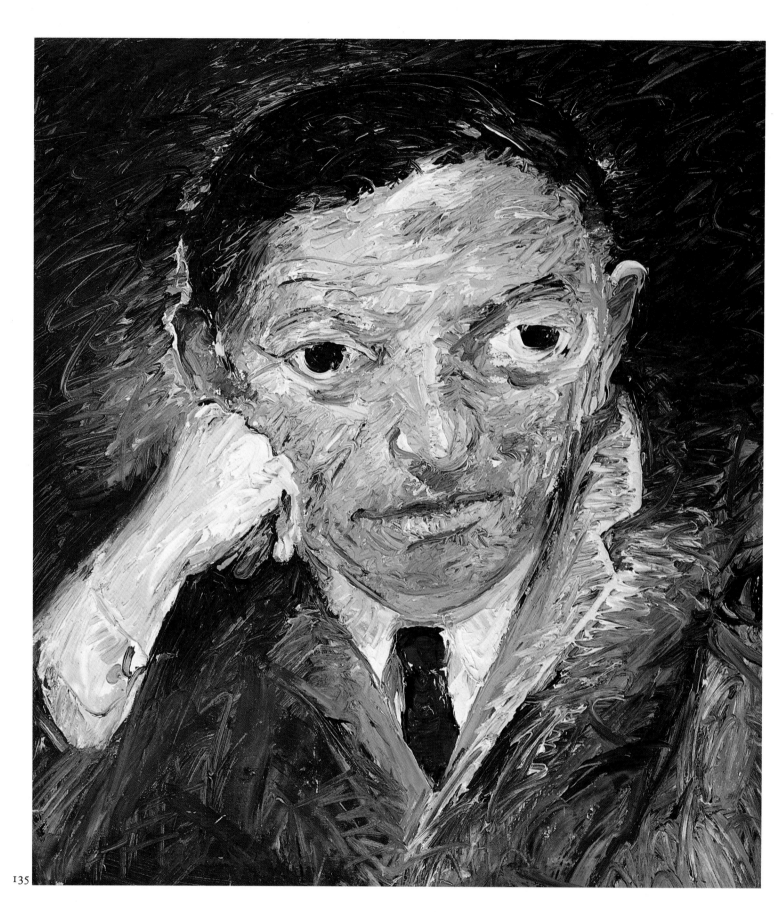

135

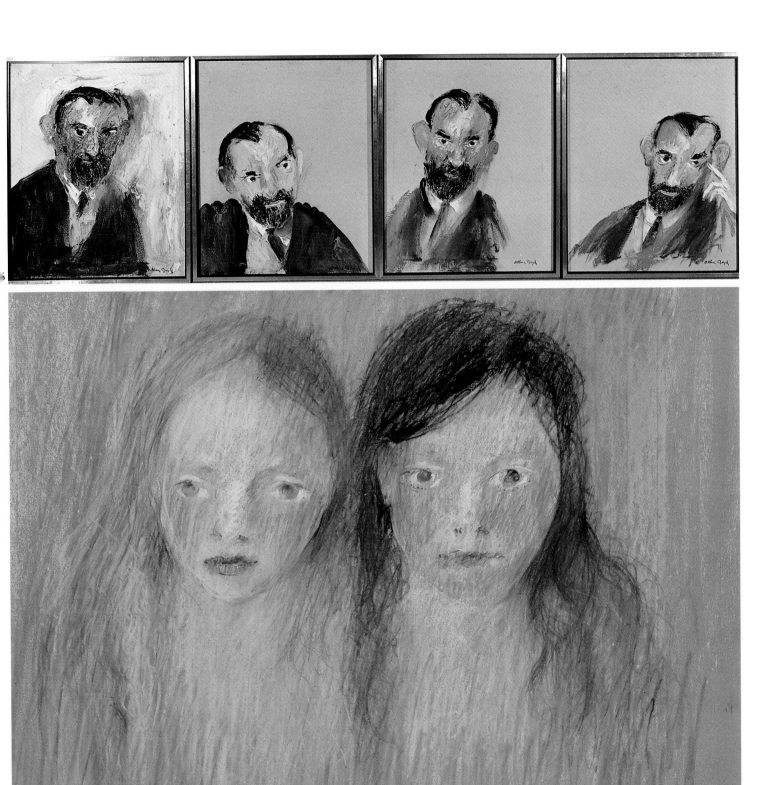

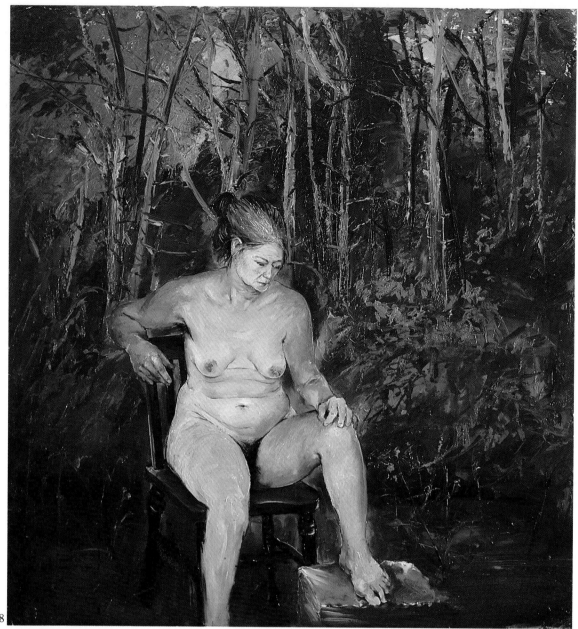

138

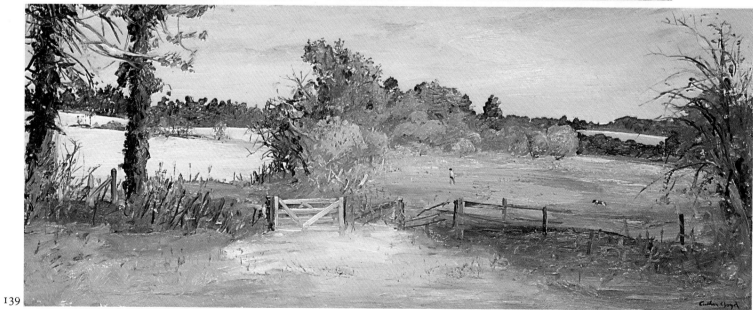

139

138 *Figure on a Chair in Suffolk Wood* 1972

139 *Suffolk Landscape with Gate* 1973

140 *Suffolk Copse, Figure and Book* c.1969

141 *Painting in the Studio, Figure Supporting Back Legs (of Painter)* 1972–3

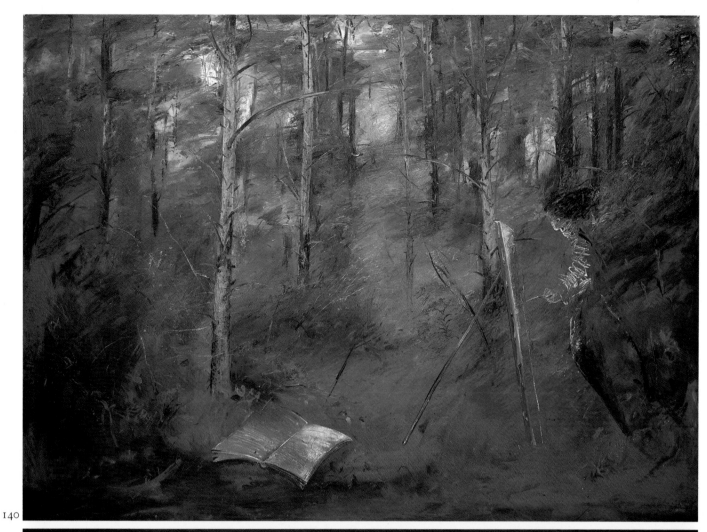

140

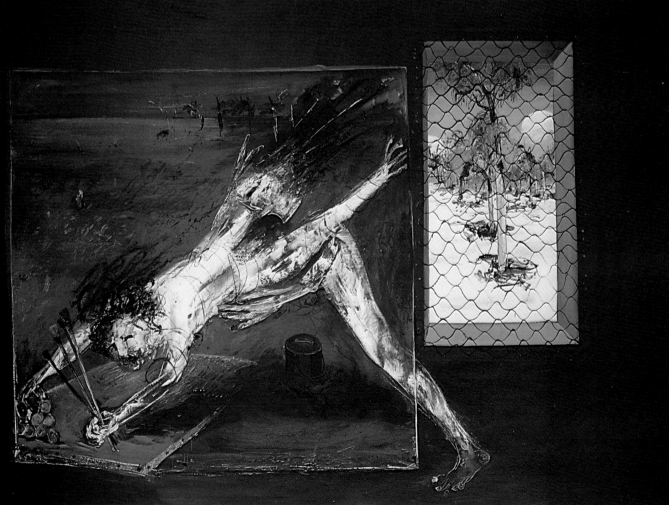

141

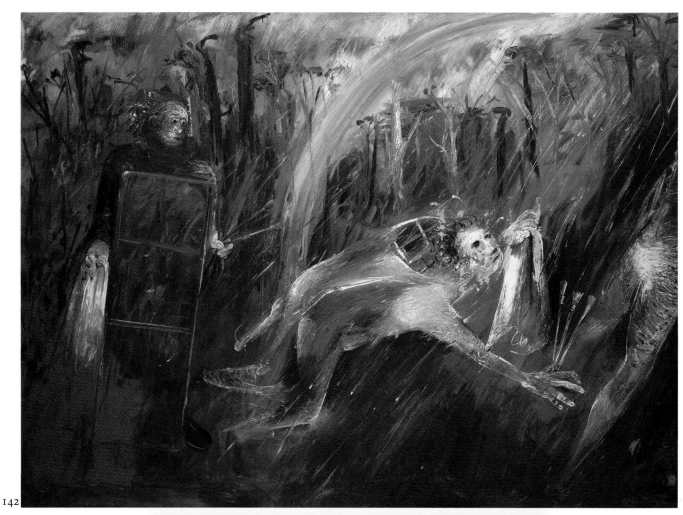

142

143

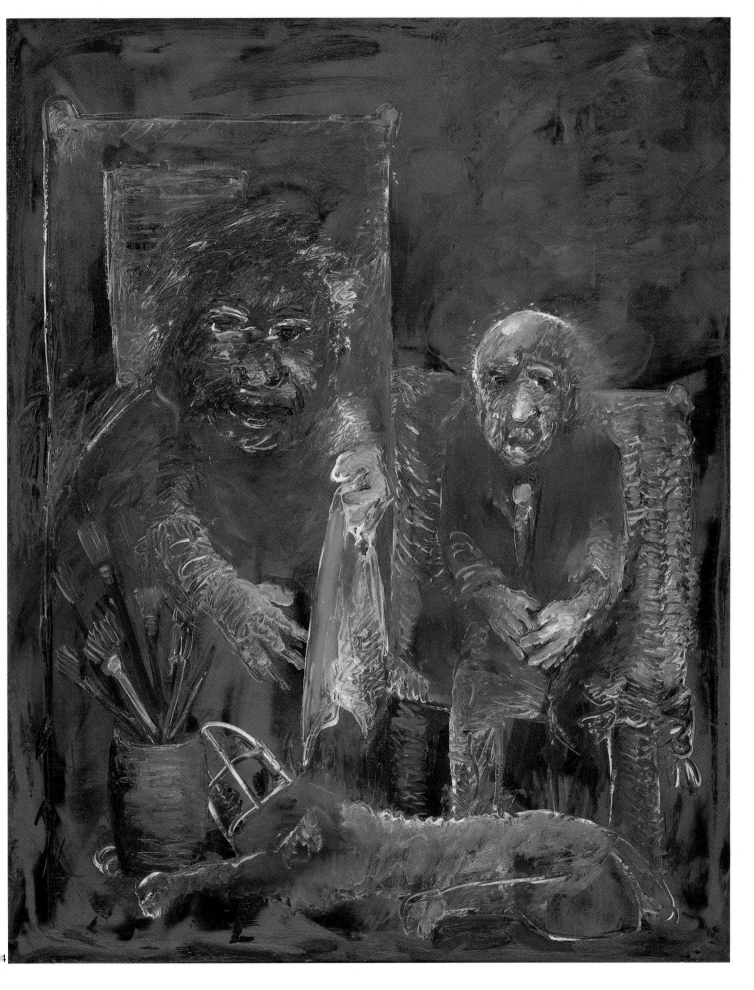

4

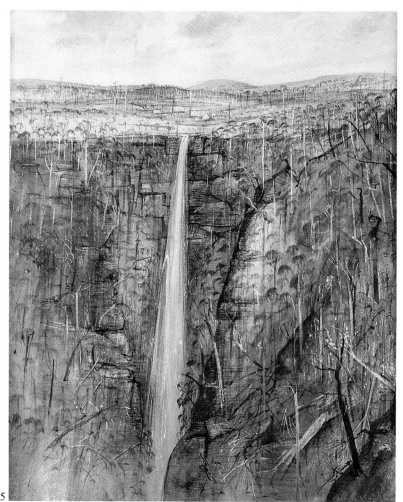

145

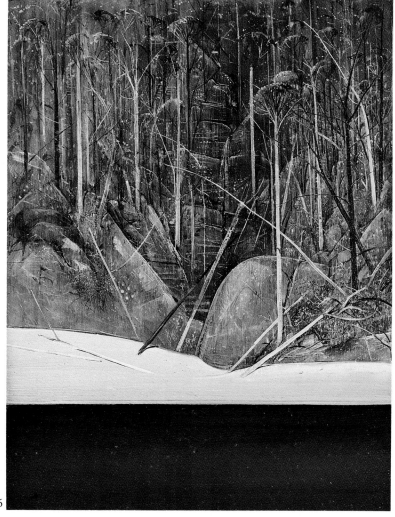

146

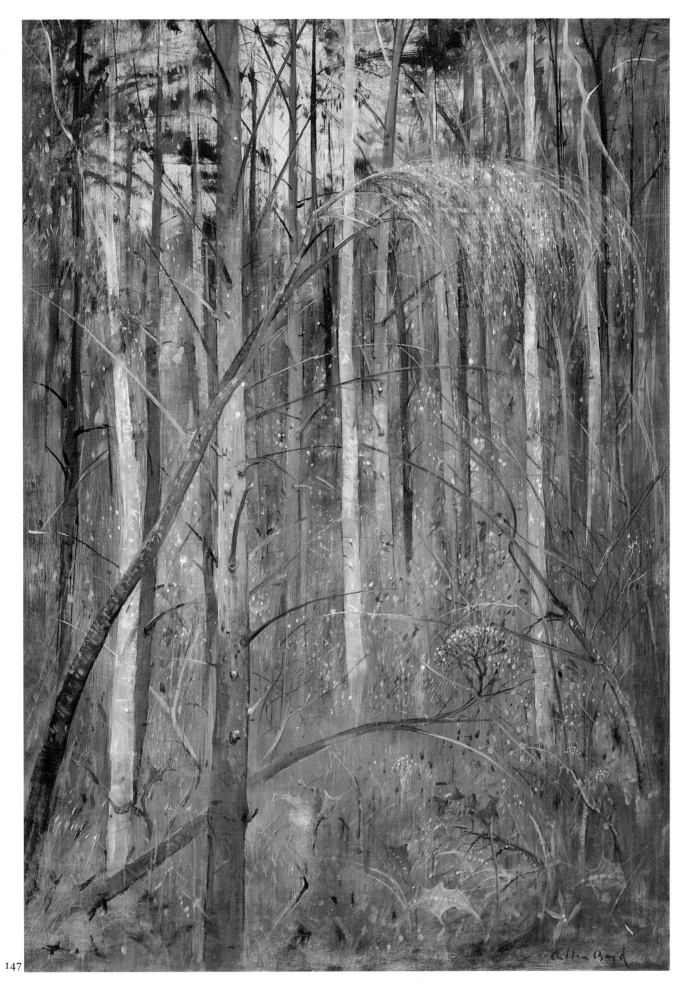

147

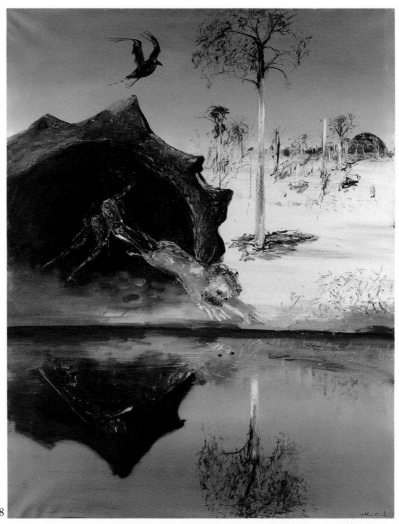

148

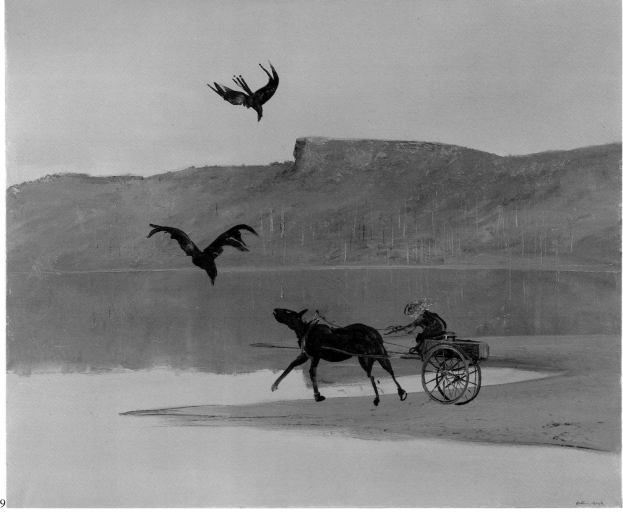

149

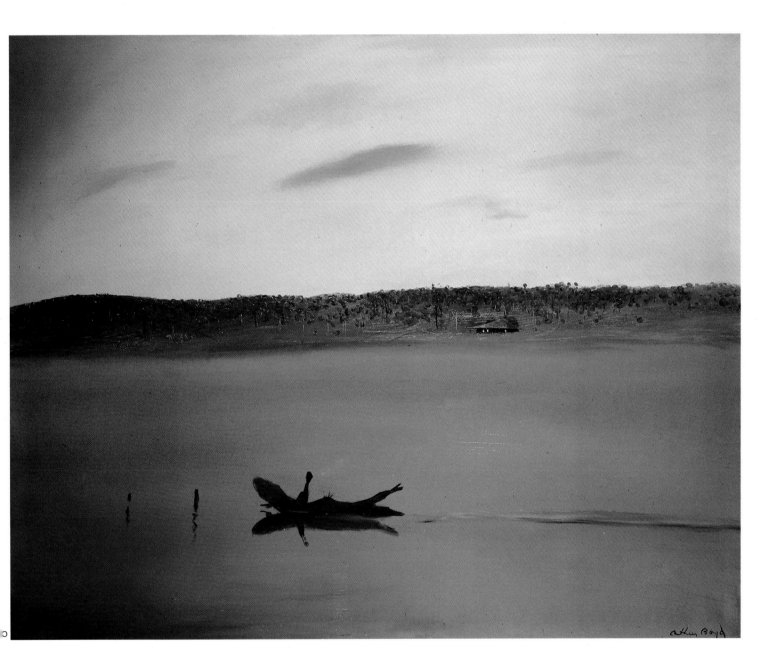

151

152

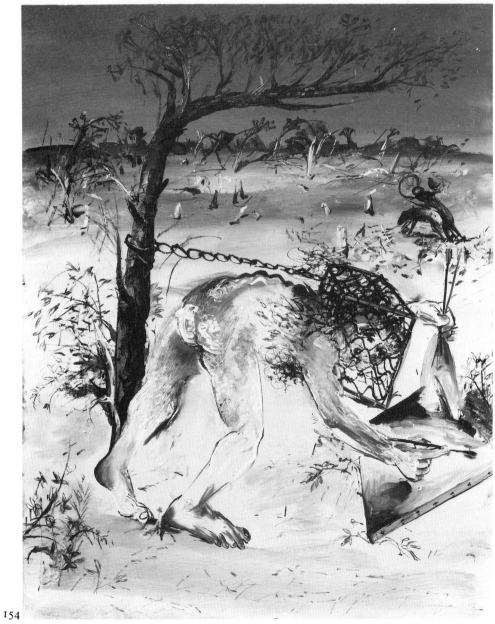

154

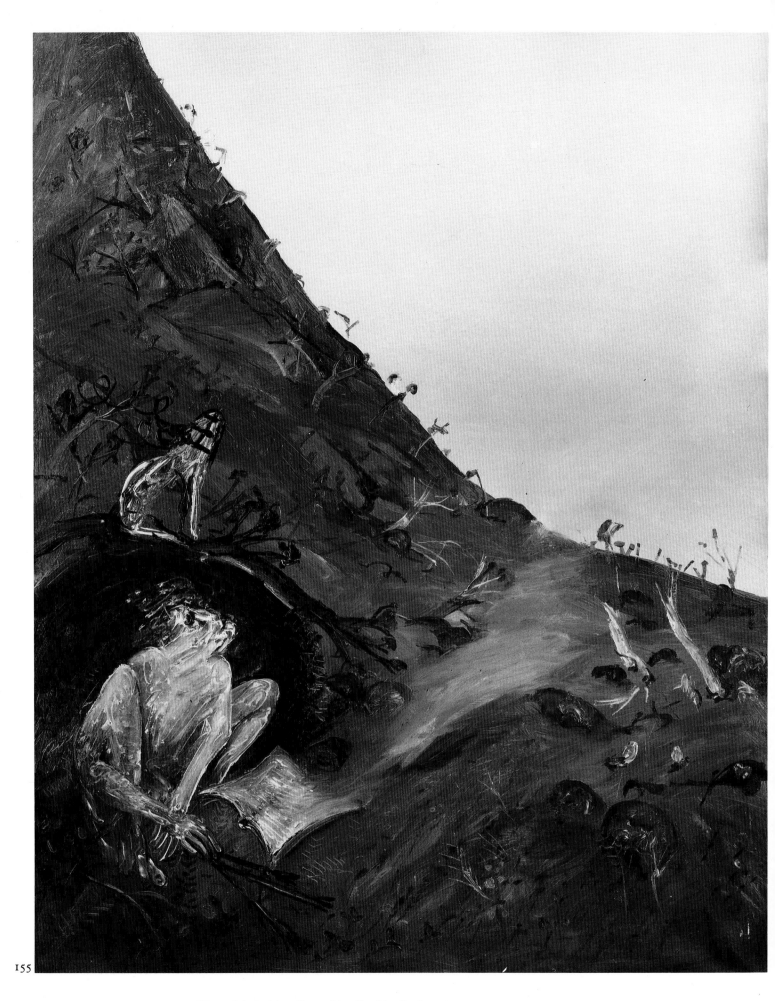

155

155 *Figure (Artist) in a Cave with a Smoking Book* 1972–3

156 *Figures, Money and Laughing Cripple* 1972–3

157 Rembrandt (1606–69)
 *Self-Portrait c.*1661

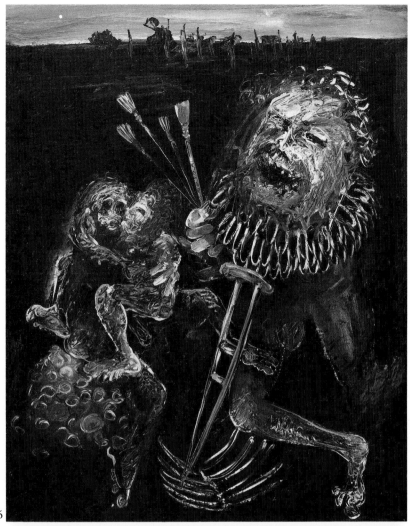

156

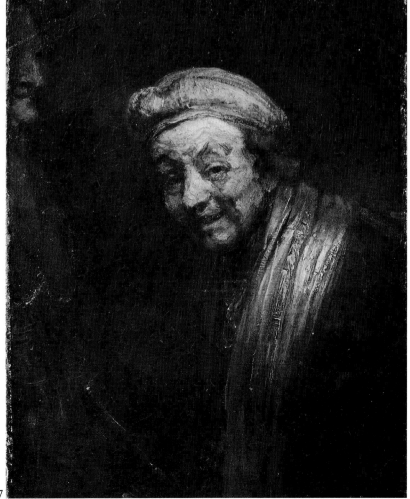

157

It used to be a military state

158

158 *Jonah: God's Briefing – 'It used to be a military state'* 1972–3

159 *Jonah before the Mirror* 1972–3

160 *Jonah outside the City* 1976

159

160

161

161 *The Hunters Set Out to Trap the Unicorn* 1973–4

162 William Blake
The Stygian Lake from illustrations to Dante's *Divine Comedy* 1824–7

163 *Eyes Reflected (Narcissus)* 1976

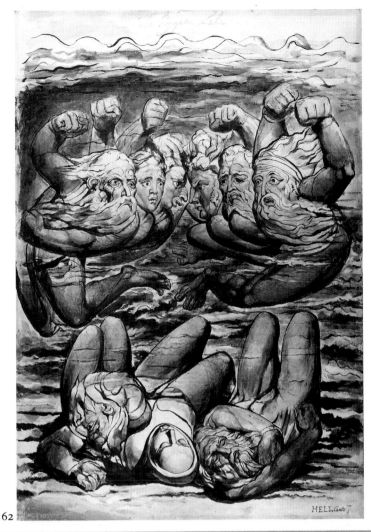

162

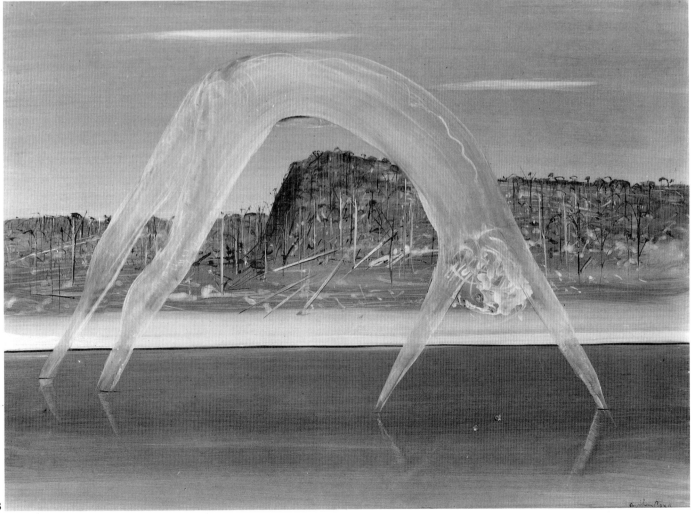

163

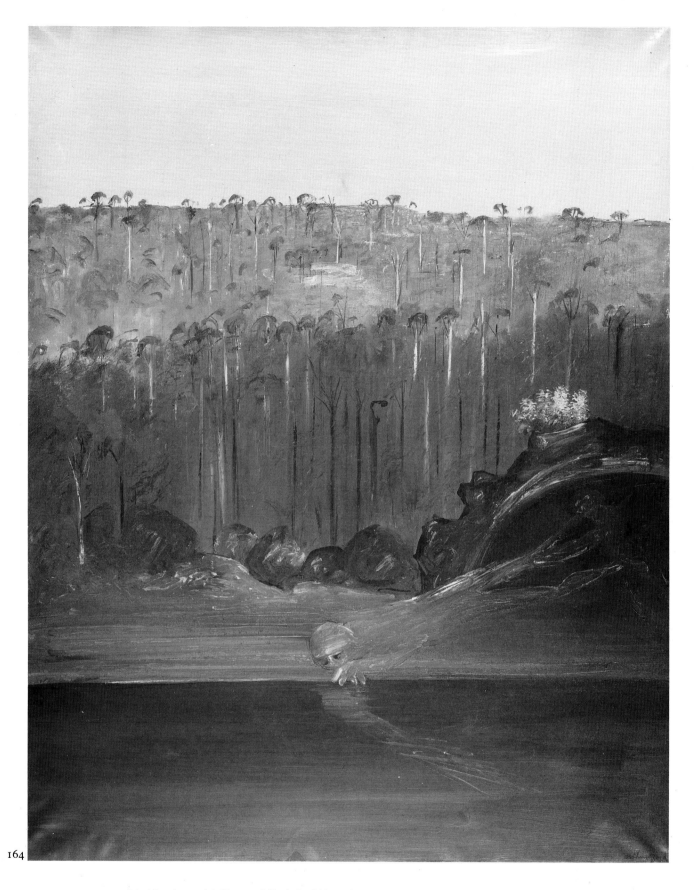

164

164 *Narcissus with Cave and Rock Orchid* 1976

165 von Guérard, Eugen (1811–1901)
 Head of the Mitta Mitta, Eagle's View

166 Piguénit, William Charles (1836–1914)
 Flood in the Darling 1890

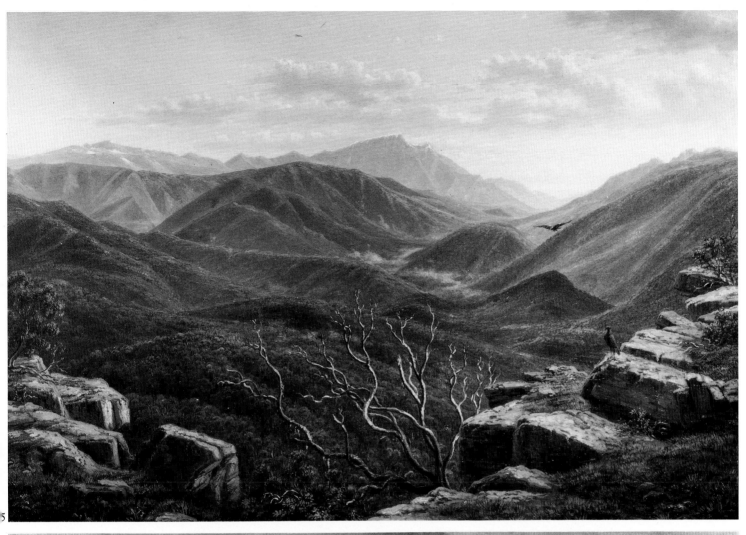

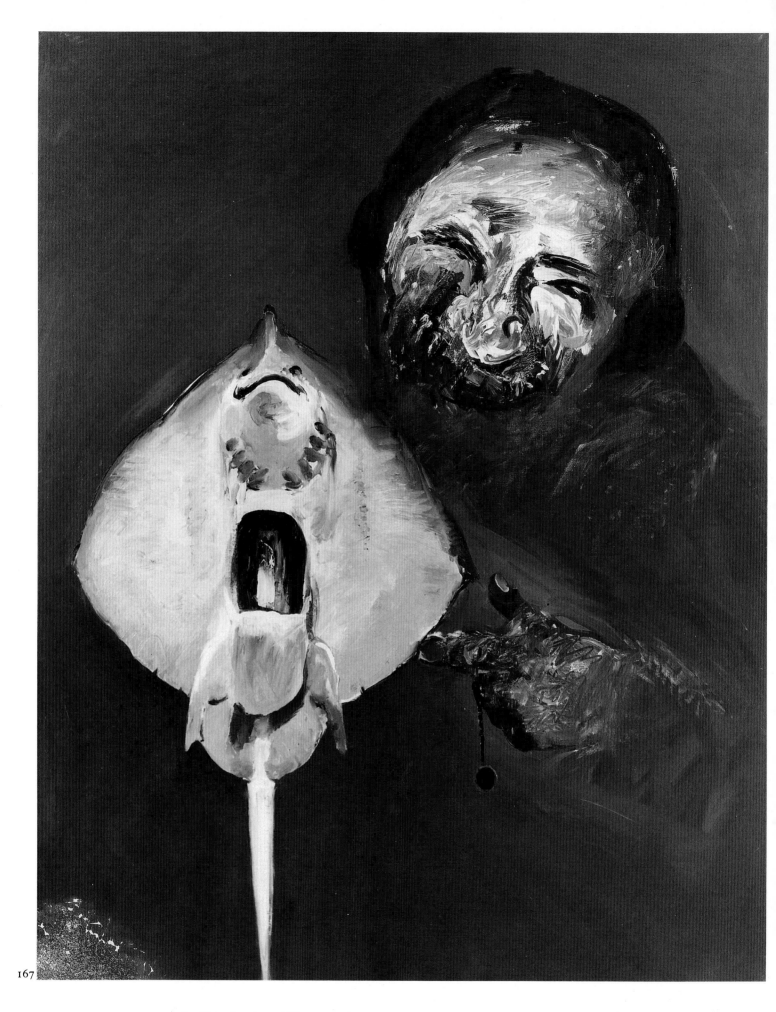

167

167 *Ventriloquist and Skate* 1979–80
168 *Mackerel* 1979–80
169 *Flower-headed Figure Holding Fish* 1942

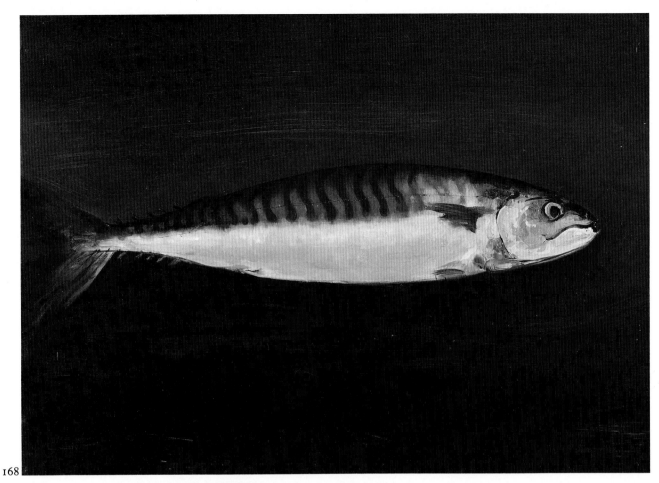

168

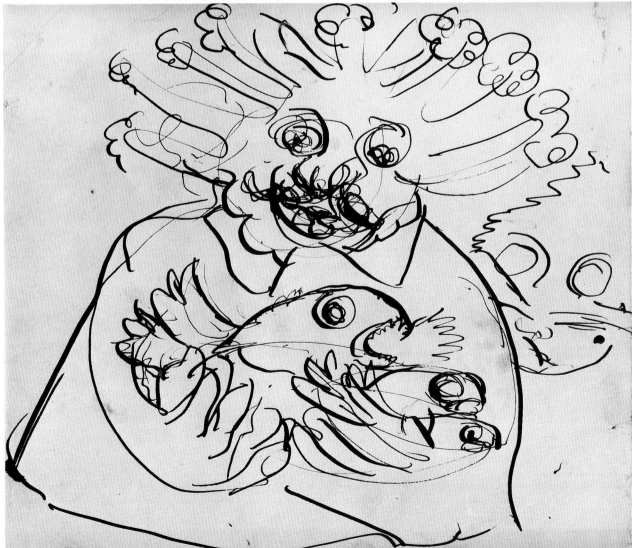

169

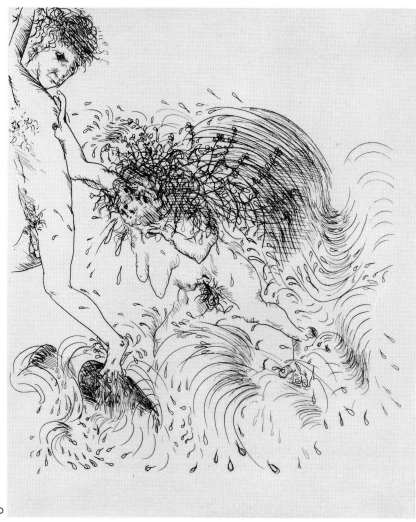

170

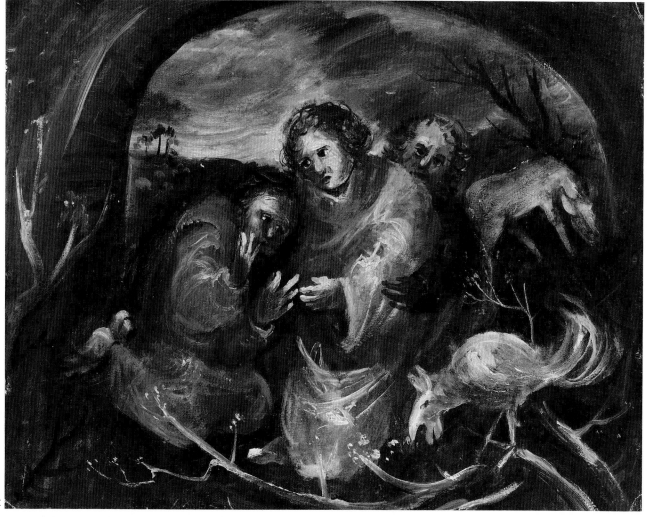

171

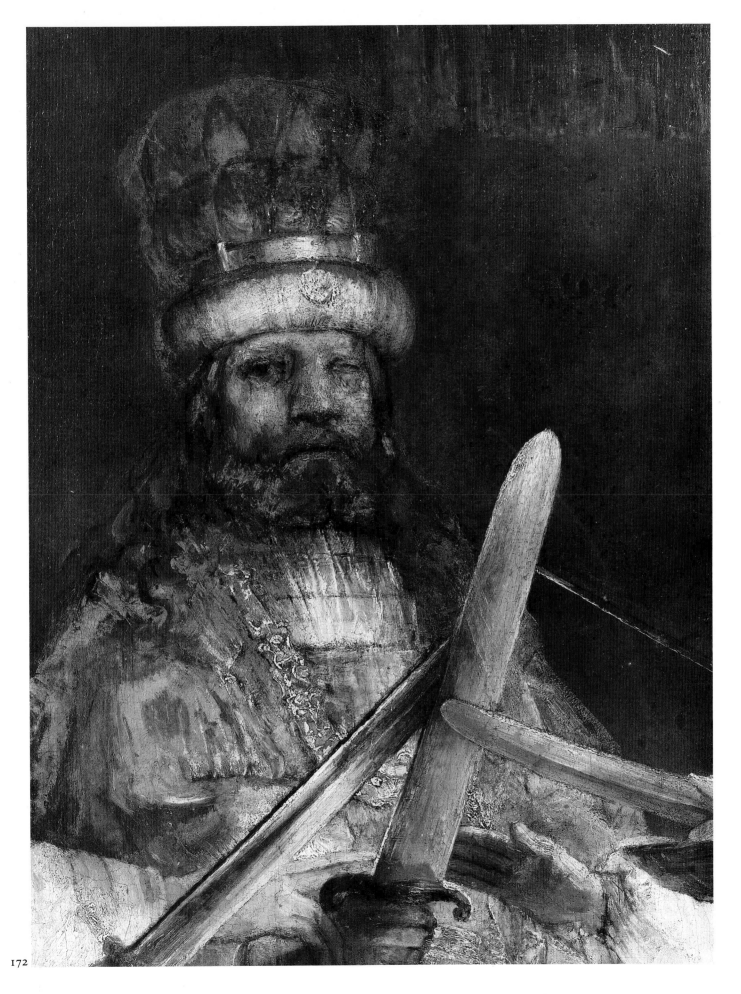

172

170 *Old Woman from the Sea* 1971

171 *The Return of the Prodigal Son* 1946–7

172 Rembrandt (1606–69)
Julius Civilis (detail from *The Conspiracy of the Batavians*) 1661

173

174

175

176

177

178

179 *Trout in Dish and Pointing Figure* 1979–80

180

181

182

180 *Budgong Creek Rocks* 1978

181 *A Pond for Narcissus with Lilly-Pilly Trees* 1978

182 Maquette for tapestry *The Return of the Prodigal Son* 1979

183

183 *The Princess of the Shoalhaven* 1978
184 *Picture on the Wall, Shoalhaven* 1979–80
185 *Colonial Poet under Orange-Tree* 1979–80

184

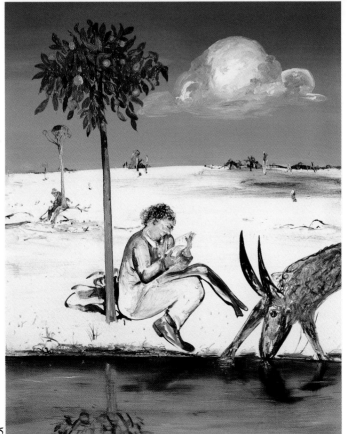

185

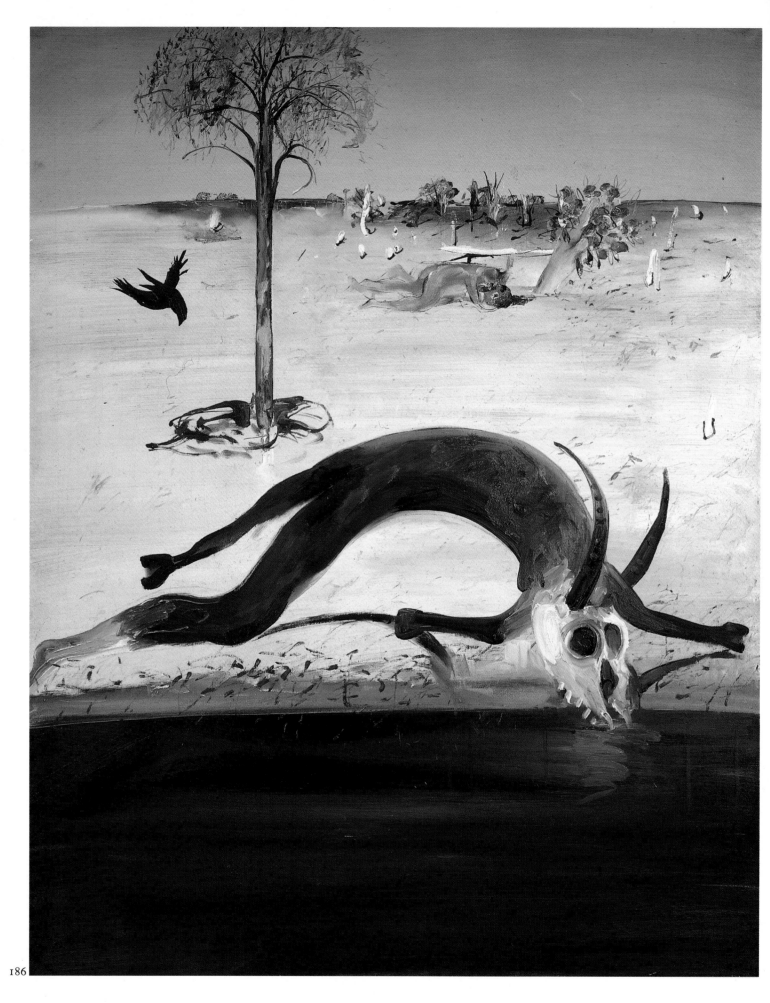

186 *Skull-headed Creature over Black Creek* 1979–80
187 *Horse's Skull, Blanket and Starry Sky* 1981
188 *The Stoat* 1981

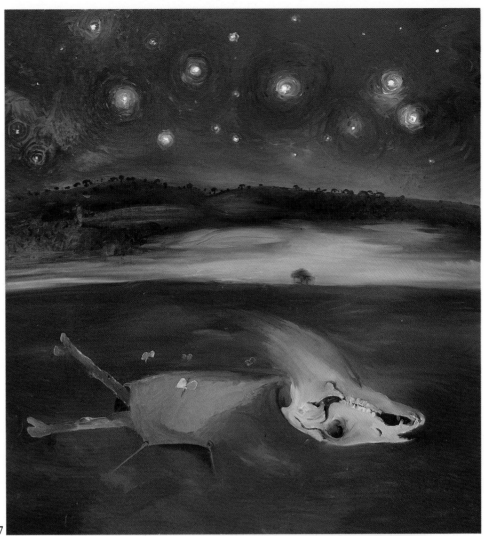

187

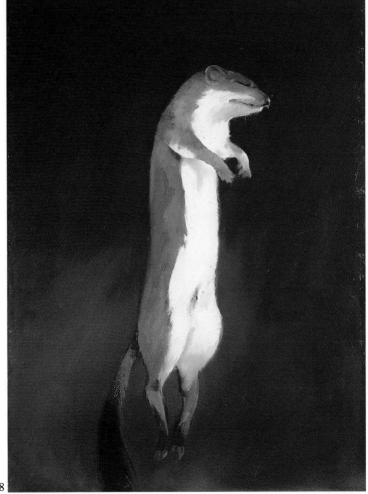

188

I

II

III

IV

190

189 *Trees I–IV c.*1979

190 *Shoalhaven Riverbank and Rocks* 1978

191 *Shoalhaven Riverbank and Large Stones* 1981

192 *Reflected Rock and Riverbank* Winter 1981

193 *Waterfall in the Shoalhaven Valley* 1982

192

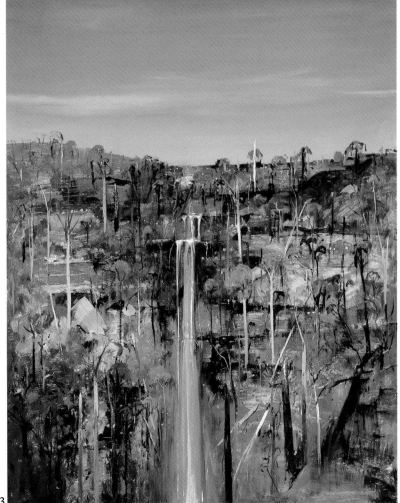

193

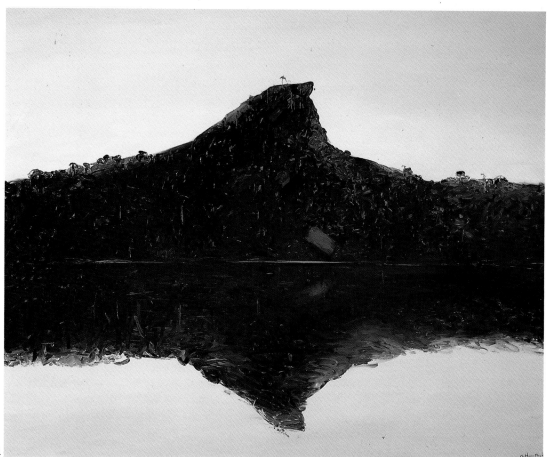

194

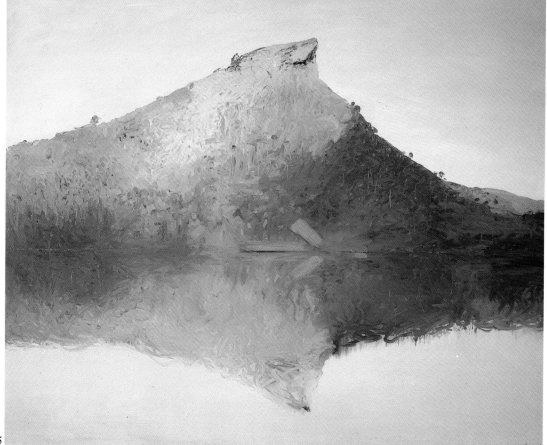

195

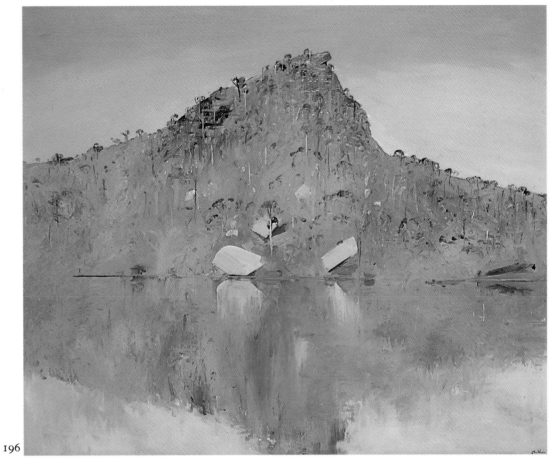

196

197

194–7 *Four Times of Day* 1982

194 *Early Morning, before Sunrise, Pulpit Rock*

195 *Morning, Pulpit Rock*

196 *Midday, Pulpit Rock*

197 *Evening, Pulpit Rock*

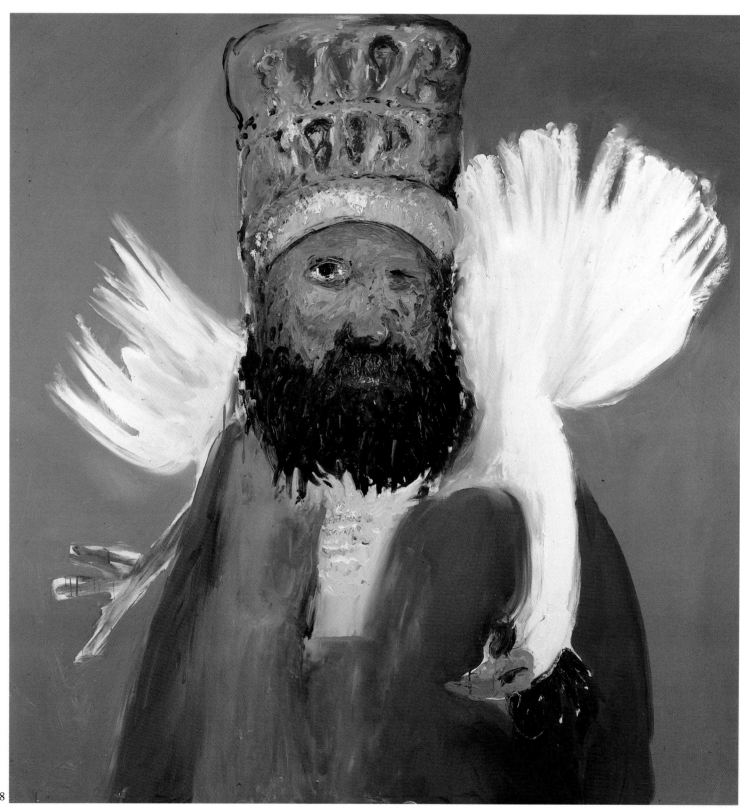

198 *Julius Civilis with a Dead Cock* 1983

199 Maquette for tapestry 1984–5

200 *Shepherd by a Black Creek* 1984–5

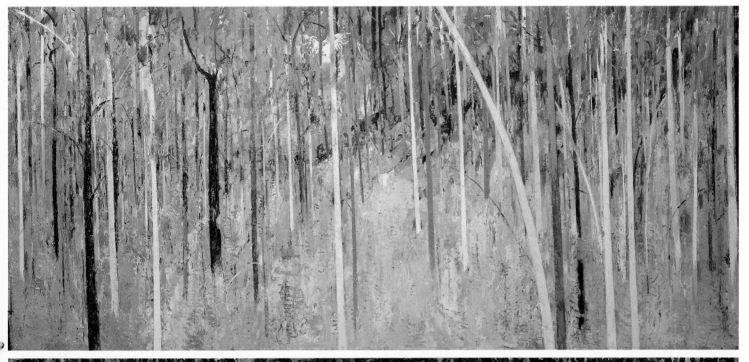

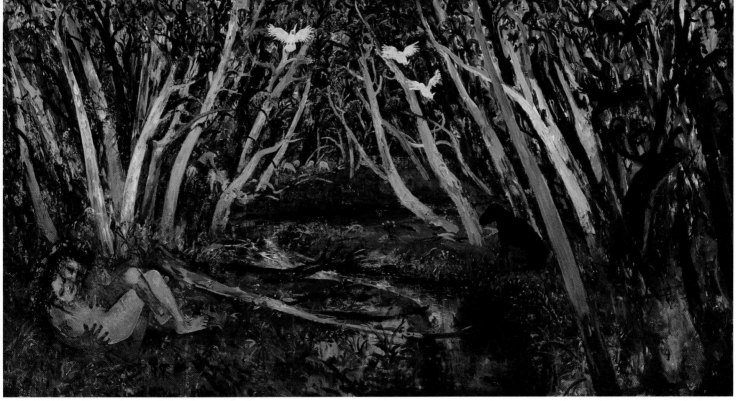

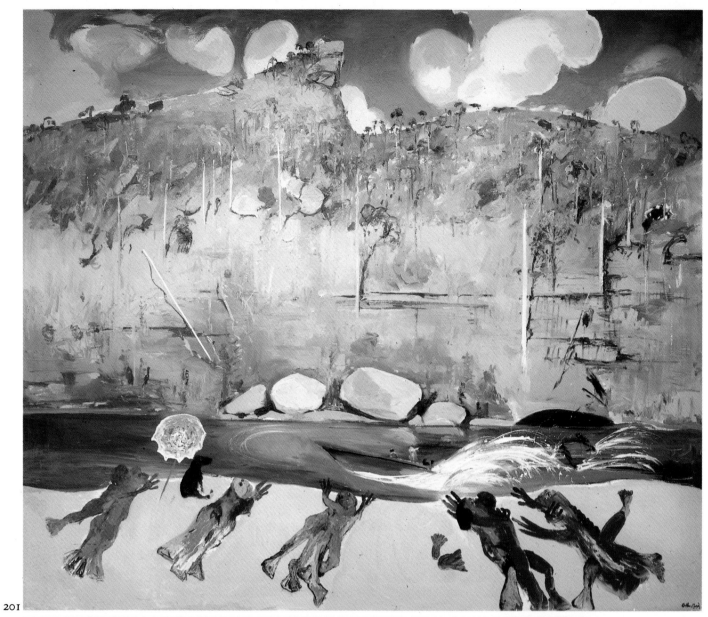

201

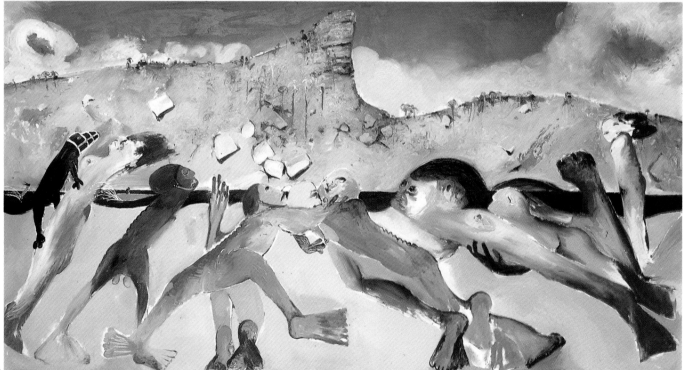

202

201 *Bathers Shoalhaven Riverbank and Clouds* 1984–5
202 *Bathers and Pulpit Rock* 1984–5

CHRONOLOGY

1920 July 24: Arthur Boyd born at Open Country, 8 Wahroonga Crescent, Murrumbeena, now a suburb of Melbourne. The house, pulled down in the mid-1960s had been built by Merric Boyd in 1908 in an old orchard. Arthur was the second child of Merric and Doris Boyd (née Gough), potters and painters.

1925 Attended State School, Murrumbeena. During his school years joined Cub Pack, later Boy Scouts, through Max Nicholson. Painted and modelled in clay from earliest years.

1934–5 After leaving school and during the Depression worked in his uncle Ralph Madder's paint factory in Fitzroy; for six months attended night classes at the National Gallery Art School.

John Bechervaise, geographer and later Antarctic explorer, who had been art teacher at Murrumbeena State School, continued to be a friend, as did the Scout Master and teacher of English Max Nicholson.

Became acquainted with the work of Van Gogh through reproductions owned by his cousin Robin Boyd, or seen in the Primrose Pottery Shop or at Gino Nibbi's Leonardo Art Shop.

Remembers in particular reproduction of *The Tempest* by Oskar Kokoschka.

1936 Went to live with his grandfather, the watercolourist Arthur Merric Boyd, at Rosebud on the Mornington Peninsula where he painted full-time landscapes, coastal scenes and many portraits and self-portraits; returned at intervals to Ralph Madder's factory for agricultural machinery in the Sunshine Harvesters and H. B. Massey Harris building in Bourke Street, near Spencer Street Station, for temporary jobs.

1937 Sold paintings to the Seddon Galleries in Elizabeth Street.

First one man show at Westminster Gallery, Little Collins Street.

1938 Through Max Nicholson met recently arrived Polish refugee painter Yosl Bergner; began to hear about conditions in Germany under National Socialism.

Returned to Murrumbeena to live at Open Country, in the grounds of which he built himself a studio from plans designed by Robin Boyd, who was to become one of the first modern architects in Melbourne.

Foundation member of Australian Contemporary Art Society.

Painted portraits.

1939 Exhibition of paintings by Yosl Bergner and Arthur Boyd at Rowden White Library, University of Melbourne. Max Nicholson assisted in the arrangement.

Painting trips into the country with Wilfrid McCulloch and Keith Nichol.

Painted bush scenes at Launching Place near Warburton with the painter Jo Sweatman.

1940 First full scale exhibition at Athenaeum Gallery, Collins Street, with Keith Nichol.

June: split in the Contemporary Art Society; George Bell forms secession, called Contemporary Group, Melbourne.

July 30: death of Arthur Merric Boyd, Snr., at Murrumbeena.

Painting expeditions to various parts of Victoria with cousins Pat and Robin Boyd.

1941 May 12: joined the army. Light Horse unit and machine gun unit. Encouraged by Keith Nichol, applied for place in Cartographic Company, where he met John Perceval. The company's headquarters in Melbourne were opposite the Public Library of Victoria, which also housed the National Gallery, where he discovered Buvelot's watercolours.

Met Yvonne Lennie who introduced him to Joy and Bert Tucker and John and Sunday Reed; close friendship with Sidney Nolan, which lasted a lifetime.

1942 John Perceval came to live at Open Country.

Through Max Nicholson met Peter Herbst, German refugee and philosophy student.

John Reed became Secretary of the Contemporary Art Society.

'Anti-fascist' exhibition at the Victorian Artists Society; did not participate because he was in camp at Bendigo.

1943 From 1941 moved between Map Storage Department in South Melbourne and Map Department in Bendigo. Lived at Fitzroy.

Joined Yvonne Lennie at evening drawing classes in studio in Dudley Building, Collins Street (near Spencer Street).

Briefly met Neil Douglas, later author, artist and conservationist.

Angry Penguins magazine moved from Adelaide to Melbourne.

Australian Present Day Art published by Ure Smith, containing illustrations of paintings by Russell Drysdale.

1944 March 25: discharged from the army together with John Perceval. Mary Boyd married John Perceval at Open Country.

1944–5 Conflicts between the 'Angry Penguins' and the Social Realists led to secession of the Sydney Branch of the Contemporary Art Society from the other branches.

Partnership with Peter Herbst and John Perceval in the Arthur Merric Boyd Pottery workshop at Neerim Road, Murrumbeena. Neil Douglas joined as decorator. Other artists working at the pottery as decorators were Tim and Betty Burstall, Dorothy Meyer, Martin Smith and John Yule; Carl Cooper was supplied with materials; Albert Tucker, John Yule, Betty Burstall and Charles Blackman gave occasional help as fettlers.

March 1945: married Yvonne Lennie.

1945–7 Purchasers of the biblical paintings of 1945–7 include Gerd Buchdahl, Franz Philipp and Allan McBriar, all members of the staff of Melbourne University.

1946 July: 'Contemporary Art: Arthur Boyd, Sidney Nolan, Albert Tucker' exhibition at Rowden White Library, University of Melbourne.

November: birth of Polly Boyd.

1947 Painted backdrop for Peter O'Shaughnessy's production of *Love's Labour Lost* at the Arrow Theatre, Middle Park, Melbourne.

Franz Philipp 'On Three Paintings by Arthur Boyd', seminal critical assessment of religious paintings in *Present Opinion*, Melbourne University Arts Association, Vol. II, No. 1, 1947, pp. 9–14.

Cessation of Contemporary Art Society.

Albert Tucker left Australia.

Sidney Nolan left Melbourne.

John Perceval temporarily stopped painting and concentrated on pottery.

1948 Max Nicholson left for Europe.

Novelist Martin Boyd, an uncle, arrived in Australia; moved into the former family house The Grange at Harkaway in Victoria.

Lived with Yvonne and Polly at The Grange while painting murals around the dining room commissioned by his uncle.

Berwick landscapes.

November: birth of Jamie Boyd.

1948–9 Summer: with Jack Stephenson, poet, at Horsham, painting landscapes.

1949 Return to Open Country.

Painting visits to North West Victoria, the Grampians and the Wimmera.

'Oil and tempera paintings by Arthur Boyd' exhibition at Kozminsky Gallery, Melbourne.

Geoffrey Dutton showed Boyd paintings to T. S. R. Boase in Oxford.

1950 September: first retrospective exhibition, David Jones Gallery, Sydney.

First (Wimmera) landscape (1950) to be bought by the Art Gallery of New South Wales.

First (Wimmera) landscape (1950) to be bought by the National Gallery of Victoria.

Peter Herbst departed for Oxford; Neil Douglas became partner in AMB Pottery instead of Herbst.

1951 Visit to Central Australia, Alice Springs and Arltunga.

Winner of Dunlop Prize

Martin Boyd sold The Grange and left Australia.

1952 *Landscape, Grampians* (painting, 1950) bought by the National Gallery of Victoria.

Irrigation Lake, Horsham (painting, 1950) bought by Art Gallery of South Australia.

August–September: exhibition of ceramic paintings, Peter Bray Gallery, Melbourne.

1953 Member of Contemporary Art Society re-established under the directorship of John Reed.

June: participated in 'Twelve Australian Artists' exhibition organized by the Arts Council of Great Britain at Burlington House, London.

August–September: retrospective exhibition at Peter Bray Gallery opened by John Bechervaise.

The Whale putting Jonah in its Mouth (ceramic painting, 1950) acquired by the National Gallery of Victoria.

'French Painting Today' loan exhibition National Gallery of Victoria.

1954 Ceramic pylon commissioned for Olympic Swimming Pool, Melbourne.

The Waterhole, Central Australia (painting, 1953) acquired by the National Gallery of Victoria.

Cyanide Tanks, Bendigo (painting, 1945–50) acquired by the National Gallery of South Australia.

Creek near Rosebud (painting, 1937) acquired by Art Gallery of Western Australia.

December: ceramic sculpture exhibition at Peter Bray Gallery, Melbourne.

Saul and David (ceramic sculpture) acquired by National Gallery of Victoria.

1955 Moved with his family to 26 Surf Avenue, Beaumaris, beach suburb on Port Phillip Bay.

Cessation of partnership with AMB Pottery.

Begins paintings of Aboriginal themes based on visit to Alice Springs in 1951.

Engaged in abstract work in small colour cubes, perhaps inspired by the paintings of Vieira da Silva (shown in French Exhibition, 1953) for the mural *Crucifixion* in St John's, Yallourn, Gippsland, later transferred to a new church in Morwell.

Stage designs for *King Lear*, produced by Peter O'Shaughnessy at Arrow Theatre, Middle Park, Melbourne.

The Sisters (ceramic sculpture, 1952–3) acquired by Art Gallery of South Australia.

1955
and
later Visitors to Surf Avenue included Clifton Pugh and his family, Robert Hughes, Robert Dickerson and his wife, John and Helen Brack, Georges Mora and his family; Charles and Barbara Blackman often came at weekends.

1956 Installation of ceramic pylon, Olympic Swimming Pool, Melbourne.

Night (abstract painting) for SS *Orcades*.

T. S. R. Boase, historian of English art, President of Magdalen College, Oxford, visited Australia; saw ceramic sculptures at Surf Avenue.

Painting trips to the Upper Reaches of the Goulburn River between Woods Point and Jamieson; visited Sorrento with Fred Williams and John Perceval.

Opening of the Australian Galleries under the directorship of Anne and Thomas Purves.

1956–7 Painting visits to Gippsland and other parts of Victoria followed by large output of landscape paintings.

Resumed Aboriginal themes in *Love, Marriage and Death of a Half-Caste* (the Bride series).

1958 April–May: exhibition of allegorical paintings (the Bride series) at Australian Galleries, Melbourne.

Winner of Ku-ring-gai Prize, Victoria.

May 1: birth of Lucy Ellen Gough Boyd.

Co-representative with the late Sir Arthur Streeton at the Venice Biennale (8 landscapes).

Shearers Playing for a Bride (painting, 1957) presented to the National Gallery of Victoria by Tristan Buesst.

Cessation of Arthur Merric Boyd Pottery as a partnership.

Museum of Modern Art of Australia (MOMAA) founded at Tavistock Place, Melbourne (Directors: John and Sunday Reed).

1958–9 Painting trip to the Barmah and Echuca forests with Fred Williams.

1959 Film *Love, Marriage and Death of a Half-Caste* by Patrick Ryan and Tim Burstall.

August: contributed to 'Antipodeans' exhibition, Victorian Artists' Society; catalogue foreword 'The Antipodean Manifesto' by Bernard Smith.

September 9: death of Merric Boyd at Murrumbeena.

Paid tribute to the late Danila Vassilieff in Memorial Exhibition catalogue of Vassilieff's paintings and sculpture.

November: travelled to London with his family, bearing introductions from Eric Westbrook, Director of the National Gallery of Victoria, and Professor Joseph Burke to Dr Lilian Sommerville, Director of the British Council, and to Sir Kenneth Clark; Dr Sommerville arranged meeting with Bryan Robertson, Director of the Whitechapel Art Gallery; made early contact with Anton Zwemmer of the Zwemmer Gallery through Yosl Bergner; Barry Humphries arrived in London.

Rented a house at 13 Hampstead Lane, Highgate.

1960	First visits to National Gallery, London, and the Louvre in Paris.
	Further development of the Bride series and of the 'Nude in Landscape' theme.
	Picasso retrospective at the Tate Gallery
	Leda and the Swan by Sidney Nolan at the Matthiesen Gallery.
	'Paintings by Arthur Boyd' exhibition at the Zwemmer Gallery; catalogue foreword by Bryan Robertson.
	Persecuted Lovers acquired by Robert Helpmann from Zwemmer, later sold to Art Gallery of South Australia.
	Extended car journey to Germany, Austria, Venice and Tuscany; impressed by Simone Martini, Piero della Francesca, Massaccio and other early Renaissance painters.
	June 13: death of Doris Boyd.
1961	June–July: substantial contributor to 'Recent Australian Painting' exhibition at the Whitechapel Art Gallery; catalogue forewords by Bryan Robertson and Colin McInnes.
	July–August: décor and costume designs for Stravinsky's ballet *Renard* for the Western Theatre Ballet production presented at the Edinburgh Festival and later at Sadler's Wells.
	December: visit with Charles Blackman and Barry Humphries to Goya exhibition at the Jacquemart André Museum in Paris.
1962	Met Walter Neurath, founder of publishing house Thames & Hudson, and publisher T. G. Rosenthal.
	Met Oskar Kokoschka.
	Kokoschka retrospective, Tate Gallery.
	June–July: retrospective exhibition at the Whitechapel Art Gallery; catalogue foreword by Bryan Robertson and Brian O'Shaughnessy.
	Moved to 42 Well Walk, Hampstead for two months.
	Rented house at 43 Flask Walk, Hampstead; installed kiln and printing press, began etching.
	Visits to European galleries with Leonard French.
1963	Stage designs for the ballet *Electra*, with choreography by Robert Helpmann and music by Malcolm Arnold; first performance (March 1963) at the Royal Opera House, Covent Garden; later at the Metropolitan Opera House, New York and, with new costumes, at the Adelaide Festival (March 1966) and other Australian cities.

March: exhibition of recent paintings and etchings at Australian Galleries, Melbourne.

June: 'British Painting in the Sixties', Tate Gallery (substantially represented).

September: Caselli Richards award, Brisbane 1963.

October: exhibition of ceramic paintings at Zwemmer Gallery.

November: paintings chosen for Dunn International Exhibition, Tate Gallery (substantially represented).

1964 March: retrospective exhibition, National Gallery of South Australia, Adelaide Festival (later at Museum of Modern Art and Design, Ball & Welsh, Melbourne).

April: 'Arthur Boyd' exhibition at the Bear Lane Gallery, Oxford; catalogue introduction by T. S. R. Boase, President of Magdalen College, Oxford.

Persecuted Lovers (painting, 1957–8) bought by Art Gallery of South Australia from Robert Helpmann.

A Trap for the Burglar by Taner Baybars, with drawings by Arthur Boyd, published by Ure Smith, Sydney.

1964–5 Pastels of the St Francis legend (21 works, 16 lithographs), to illustrate T. S. R. Boase's book on the saint.

1965 February: exhibition of pastels at the Skinner Gallery, Perth, during Perth Festival of Art.

Drawings for 'Voice and Verse' made into stage drops for evening of poetry readings at the Royal Court Theatre, London, during Commonwealth Festival of Art (under auspices of the Commonwealth Institute).

July–August: exhibition of pastels in celebration of the tenth anniversary of the Australian Galleries, Melbourne.

Buys 13 Hampstead Lane, Highgate, and moves there from Hampstead.

1966 March: new *Electra* costumes designed for Adelaide Festival.

Exhibition of nine drawings for Taner Baybars' *A Trap for the Burglar* at the Clune Galleries, Sydney.

Begins paintings of Nebuchadnezzar series.

Sixteen drawings of the 1940s acquired by the National Gallery of Victoria.

Hommage à Pablo Picasso, Grand Palais, Paris; sole aeroplane flight by Boyd, together with Sidney Nolan, to Paris.

1967 Abstract design on Nebuchadnezzar theme for Clune Galleries, to be woven by the Portalegre tapestry works in Portugal.

June: exhibition of Picasso's sculpture and Vollard Suite at Tate Gallery.

Arthur Boyd, definitive monograph by Franz Philipp, published by Thames & Hudson, London.

Joseph Brown Gallery established in Melbourne.

1968 March: Nebuchadnezzar exhibition, Kym Bonython Gallery, Adelaide, during Adelaide Festival.

Nebuchadnezzar caught in a Forest (painting, 1967) acquired by Art Gallery of South Australia.

St Francis of Assisi by T. S. R. Boase, with lithographs by Arthur Boyd, published by Thames & Hudson, London.

May–September: returned to Australia (via the Cape) revisiting the art galleries of Adelaide, Melbourne and Sydney. For the first time travelled north on the Eastern coast as far as Cooktown, by car and train.

1969 April–May: retrospective exhibition at Richard Demarco Gallery, Edinburgh; first showing in Great Britain of Nebuchadnezzar, Potter and Bert Hinkler subjects.

August: Potter and Bert Hinkler subjects at Johnstone Gallery, Brisbane.

September–November (between): visit to Rembrandt exhibition in Amsterdam, together with Tim Burstall and Patrick and Rose Ryan.

October–November: Nebuchadnezzar and Potter series at Tooth Gallery, London.

October–November: exhibition of lithographs, etchings and engravings at the Maltzahn Gallery, London.

November–December: exhibition of tapestries, pastels (St Francis series) and drawings at the Hamet Gallery London.

Bronze casts of ceramic sculptures made by Vittorio & Fernando, Melbourne.

Rented cottage at Ramsholt, near Woodbridge, Suffolk for weekends and holidays.

1970 March: winner of the 1969 Medallion of the International Co-operation Award Committee, Adelaide.

Paints landscapes in Suffolk.

Australia Britannica Prize for services to art.

Lysistrata etchings and aquatints portfolio published by The Ganymed Press, London; printer McQueen of Thomas Ross & Co., text by Jack Lindsay.

May: 'Arthur Boyd's Australia' exhibition at National Gallery of Victoria, organized by Franz Philipp as part of three exhibitions to mark the Cook Bicentenary and the visit of Her Majesty the Queen and the Royal family to Australia.

Visits to Manufactura de Tapeciarias de Portalegre, Portugal in connection with tapestries made from the Nebuchadnezzar paintings.

1971 Creative Art Fellowship from the Australian National University, Canberra, for six months.

Tomorrow's Ghosts, poetry by Peter Stark with 12 etchings by Boyd, printed by Mati Basis; published by Circle Press, Guildford, England.

October 1: arrives in Australia.

Paintings, graphics, ceramics and tapestries exhibited by the Arts Council of Australia, Australian National University, Canberra.

1972 January: paints his first open-air sketch on the Shoalhaven River while guest of Frank McDonald at Bundanon; after returning to Canberra engaged in life size nude paintings in the bush as well as landscape sketches.

February: retrospective exhibition, Skinner Galleries, Perth Festival. Leaves Australia at the end of February.

June: Fischer Fine Art Ltd established; Boyd taken on by Harry Fischer as one of their regular exhibitors.

October: interviewed in London by Rosemary Munday for *The National Times* (Canberra).

Nebuchadnezzar, with text by T. S. R. Boase and paintings and drawings by Arthur Boyd, published by Thames & Hudson, London.

1973 Riversdale, an estate on the Shoalhaven River, bought by Boyd on advice of Frank McDonald; Sydney architect André Porebski commissioned to renovate the old house and build a new Colonial-style house.

May–June: exhibition of recent paintings at Fischer Fine Art, London.

Jonah, with text by Peter Porter and drawings and etchings by

Arthur Boyd, published by Secker & Warburg, London.

Arthur Boyd Drawings 1934–1970 by Christopher Tadgell published by Secker & Warburg, London; drawings exhibited at Rudy Komon Gallery, Sydney.

1974 February: 'Drawings for Jonah' exhibited at Australian Galleries, Melbourne.

Work on small paintings on copper of Shoalhaven River motifs.

Graphic work, etchings and aquatints.

September: work begins on Riversdale.

October: returns to Australia to live at Eearie Park while Riversdale is being finished.

1975 Continues with copper landscapes and studio paintings.

Australian National Gallery, Canberra, purchases 20 unique tapestries including the St Francis series.

April: presents large collection of pastels, sculptures, ceramics, etchings, more than 200 paintings and more than 1000 drawings to the Australian National Gallery, Canberra.

May: moves to Riversdale.

Peter Porter visits Riversdale.

65 drawings acquired from the Rudy Komon Gallery, Sydney, by the Art Gallery of South Australia.

Portrait (etching) of Brett Whiteley at Riversdale.

Portrait (etching) of John Olson in Sydney.

The Lady and the Unicorn, with text by Peter Porter and etchings and aquatints by Arthur Boyd, published by Secker & Warburg, London.

Returns to England and moves to Ramsholt, near Woodbridge, Suffolk.

1976 July: exhibition of small Shoalhaven River landscapes at the Australian Galleries, Melbourne.

Narcissus paintings.

1976–7 Series of lithographs and etchings on Narcissus theme with the Port Jackson Press begun in Appledore Studios, Devonshire, with David Rankin, completed at Riversdale with Max Miller in 1978.

1977 February–March: exhibition of recent paintings (Narcissus and Shoalhaven River scenes), Fischer Fine Art Ltd, London.

June 12: discussion with Peter Porter in *The Australian*.

July: exhibition of paintings 1972–1973 at University Gallery, Melbourne.

September: exhibition of *The Lady and the Unicorn* etchings, Stadia Graphics, Sydney, in conjunction with Tolarno Galleries, Melbourne.

September: *Lysistrata* exhibition (20 etchings), Wagner Gallery, Sydney.

November/December: visits Courbet exhibition, Grand Palais, Paris.

1978 January: returns to Australia for the whole year, together with most household goods.

Visits Brisbane University's Graphics Department, at the suggestion of Laurence Daws, to use etching facilities.

Portrait of Laurence Daws.

Paints Shoalhaven landscapes.

'A Man in Two Worlds', with John Read (producer, writer and narrator), a BBC and Australian Broadcasting Corporation co-production; Australian sequences directed by Brian Adams.

Pushkin's Fairytales, translated by Janet Dalley, with introduction by John Bailey and lithographs by Arthur Boyd, published by Barrie & Jenkins, London.

1979 January: returns to Ramsholt.

Summer: becomes the owner of the house 'Bundanon' on the Shoalhaven River.

August: St Francis tapestries exhibited in the Great Hall, National Gallery of Victoria, Melbourne.

Awarded the Order of Australia (A.O.) for services to art.

1980 March: exhibition of paintings (skate and other fish), Bonython Art Gallery, Adelaide Festival of Arts.

March–April: exhibition of recent Paintings (Shoalhaven scenes, Narcissus, Budgong Creek, crucifixions, Colonial Poet, skates *et al.*) at Fischer Fine Art Ltd, London.

November: retrospective exhibition, Arts Centre, New Metropole, The Leas, Folkestone, Kent.

1981 Returns to the Shoalhaven to live at Bundanon, near Nowra, NSW.

September: exhibition of paintings (skate, Narcissus, *Four Times of Day*, Shoalhaven I–V *et al.*), Australian Galleries, Melbourne.

November: exhibition of paintings (skate), Rudy Komon Gallery, Sydney.

1982 February: 'Modernism, Murrumbeena and Angry Penguins, The Boxer Collection' exhibition at Nolan Gallery, Lanyon Homestead, A.C.T.

The house Paretaio (acquired in the early 1970s), near Palaio in Tuscany, is made available to the Australia Council's Visual Arts Board as a studio within their Artists in Residence programme.

March: present at the Adelaide Festival.

April: the Bundanon series, included in the 96 special edition copies of Christopher Tadgell's *Arthur Boyd Drawings 1934–1970*, published by Secker & Warburg, London, in 1973, exhibited at Rudy Komon Gallery, Sydney.

July: returns to Ramsholt.

October: exhibition of landscapes and portraits 1934–49, bronze castings of four ceramic sculptures 1935–54 and paintings 1982 (including *Four Times of Day*) at Australian Galleries, Melbourne.

1983 February: 'The Artist and the River' exhibition, Lister Gallery, Perth.

October–November: exhibition of recent work at Fischer Fine Art Ltd, London.

1984 January: leaves London to return to Bundanon, New South Wales. Receives commission for tapestry from the Parliament House Authority, Canberra. Commissioned to paint 16 canvases for the foyer of the State Theatre, Victorian Arts Centre, Melbourne. Begins work on the Bather series.

December: *Narcissus*, with text by Peter Porter and etchings and aquatints by Arthur Boyd, published by Secker and Warburg, London.

1985 April: leaves Australia to return to England.

May: exhibition of paintings and etchings at Holdsworth Galleries, Woollahra, Sydney.

'Arthur Boyd in the Landscape', film directed by Don Featherstone, being made in Shoalhaven for London Weekend Television's South Bank Show, edited by Melvyn Bragg, to be broadcast in 1986.

SELECTED BIBLIOGRAPHY

BOOKS ILLUSTRATED BY AUTHUR BOYD

Baybars, Taner, *A Trap for the Burglar*, with drawings by Arthur Boyd, Ure Smith, Sydney, 1965.

Boase, T. S. R., *St Francis of Assisi*, with lithographs by Arthur Boyd, Thames & Hudson, London, 1968.

Boyd, Arthur and Boase, T. S. R., *Nebuchadnezzar*, with paintings and drawings by Arthur Boyd, Thames & Hudson, London, 1972.

Boyd, Arthur and Porter, Peter, *Jonah*, with drawings and etchings by Arthur Boyd, Secker & Warburg, London, 1973.

The Lady and the Unicorn, with etchings and aquatints by Arthur Boyd, Secker & Warburg, London, 1975.

Narcissus, with etchings and aquatints by Arthur Boyd, Secker & Warburg, London, 1984.

Hope, A. D., *The Drifting Continent*, with drawings by Arthur Boyd, Brindabella Press, Canberra, 1979.

Pushkin, A. S., *Pushkin's Fairytales*, translated by Janet Dalley, with an Introduction by John Bailey and lithographs by Arthur Boyd, Barrie & Jenkins, London, 1978.

Stark, Peter, *Tomorrow's Ghosts*, with etchings by Arthur Boyd, Circle Publications, Guildford, England, 1971.

SOURCES

Interviews, tapes and film

Interview with John Hetherington. Transcript of tape recording made in 1961. Unpublished.

Interview with Francis Watson, 'Southlight', BBC Third Programme, 24 July 1963.

Interview with Hal Missingham, conducted by Hazel de Berg. Tape 109, cut 1, side 2, 22 September 1965, National Library of Australia, Canberra.

Interview with James Mellon, London, 1970. Two tapes and transcript, State Library of Victoria, Melbourne.

Conversation between Arthur Boyd and Peter Porter, in *The Australian*, 12 June 1971.

Selected Bibliography

Interview with Richard Haese, 'Australian Art and Artists', 1974. Tape and transcript, State Library of Victoria, Melbourne.

'A Man in Two Worlds', written and narrated by John Read. Australian sequences directed by Brian Adams. Produced by John Read. A BBC and Australian Broadcasting Corporation co-production, 1979.

Interview with Grazia Gunn of the Australian National Gallery, conducted at Bundanon, 23–4 April 1981.

Australian Magazines

(dates refer to years consulted for this book)

Angry Penguins, Melbourne, 1943

Angry Penguins Broadsheet, Melbourne, 1963

Art and Australia, Sydney, 1965

Ern Malley's Journal, Melbourne, 1954

Meanjin, Melbourne, 1951 and 1958

Present Opinion, Melbourne, 1947.

Books and articles

(I have listed only material of relevance to my text. Grazia Gunn, *Arthur Boyd, seven persistent images*, Canberra, 1985, unfortunately arrived too late for inclusion.)

Aloni, Nissim and Perry, Rodi Bineth, *Yosl Bergner Paintings 1938–1980*, Keter Publishing House, Jerusalem, 1981.

Auden, W. H., *The Enchafèd Flood, or The Romantic Iconography of the Sea*, Faber & Faber, London 1951.

Australian Dictionary of Biography (Vol. VII, A–CH), Melbourne University Press, 1979

Australian Encyclopedia (Vol. IV, Painting: Modern Period), Grolier Club, Sydney, 1977.

Boyd, Martin, *Day of my delight. An Anglo-Australian Memoir*, Lansdowne Press, Melbourne, 1965.

Bruce, Candice, *Eugen von Guérard*, with an Introduction by Daniel Thomas, Australian Gallery Directors Council, 1980.

Burke, Janine, 'The Museum of Modern Art in Australia', in *Art and Australia*, XV, 1, 1977, pp. 70–72.

Burn, Ian, 'Beating about the Bush: The Landscapes of the Heidelberg School', in *Australian Art and Architecture – Essays Presented to Bernard Smith*, edited by Anthony Bradley and Terry Smith, Oxford University Press, Melbourne, 1980, pp. 83–98.

Dutton, Geoffrey, 'The Work of Arthur Boyd', in *Bulletin of the National Gallery of South Australia*, XXV, 4, April 1964, pp. 4–8.

White on Black: The Australian Aborigine Portrayed in Art, Macmillan, Melbourne, 1974.

Edwards, Geoffrey, *The Painter as Potter: Decorated Ceramics of the Murrumbeena Circle*, with an essay by Peter Herbst, National Gallery of Victoria, Melbourne, 1982.

Fitzpatrick, Kathleen, *Martin Boyd*, in the series *Australian Writers and their Work*, edited by Geoffrey Dutton, Lansdowne Press, Melbourne, 1963.

Garlick, Margaret, 'The Extremes of Arthur Boyd', in *Dissent* (Melbourne), IV, 3, Spring 1964, pp. 21–3.

Haese, Richard, *Rebels and Precursors*, Allen Lane, Melbourne, 1981.

Herbst, Peter, 'Modernism, Murrumbeena and Angry Penguins', in The Boxer Collection catalogue, Nolan Gallery, Australian Publishing Service, Canberra, 1981.

'The Arthur Merric Boyd Pottery at Murrumbeena', in *The Painter as Potter*, National Gallery of Victoria, Melbourne, 1982.

Hetherington, John, *Australian Painters: Forty Profiles*, Cheshire, Melbourne, 1963.

Hill, Robin, 'Better Quick than Never', in *The Age*, Melbourne, 27 November 1965, p. 21 (illustration of The Grange, Harkaway).

Hoff, Ursula, 'The Paintings of Arthur Boyd', in *Meanjin*, XVII, 2 June 1958, pp. 143–7.

'Australian Paintings in British Public Collections', in *Art and Australia*, XVI, 2, 1978, pp. 172–178.

Hofmann, Werner, *Courbet und Deutschland* Exhibition catalogue, Kunsthalle, Hamburg, 1978, p. 609.

Hughes, Robert, 'Arthur Boyd's Meaning', in *Nation*, 23 March 1963, p. 19.

Lynn, Elwyn, 'Chagall goes native', in *Nation*, 11 October 1958, p. 19.

'A Study of Arthur Boyd, which dodges one important issue', in the *Bulletin*, 27 January 1968, p. 50

'Barbarity Transcended', in *The Australian Magazine*, 16 November 1981, pp. 28–9.

'Letter from America', in *Art International*, XXV, 5/6, May/June 1982, pp. 76–78.

Maltzahn, Imre von, *Arthur Boyd – Etchings and Lithographs*, Lund Humphries, London, 1971.

McCaughey, Patrick, 'The Artist *in extremis*: Arthur Boyd 1972–3' in *Australian Art and Architecture – Essays Presented to Bernard Smith*, edited by Anthony Bradley and Terry Smith, Oxford University Press, Melbourne, 1980, pp. 210–20.

McCulloch, Alan, 'Boyd Exhibition may stir up Controversy', in *The Herald*, Melbourne, 18 September 1951.

'The Drawings of Arthur Boyd' in *Meanjin*, Winter 1951, X, 2, 45, pp. 155–6.

Encyclopedia of Australian Art (3rd edn), Hutchinson, Melbourne, 1984.

'The Years 1940–65 as I knew them', Introduction to '1940–65: The Heroic Years of Australian Painting', The *Herald* Exhibition, Melbourne, 1977.

McGrath, Sandra, *The Artist and the River: Arthur Boyd and the Shoalhaven*, Bay Books, Sydney, 1982.

Makin, Jeffrey, Introduction to *Arthur Boyd Paintings 1972 and 1973*, University Art Gallery, University of Melbourne, 1977.

Manet 1832–1883, catalogue of the Manet exhibition, Grand Palais, Paris, and Metropolitan Museum of Art, New York, 1983. Entry for *Déjeuner sur l'herbe*.

Matthew, Ray, 'Arthur Boyd' in *London Magazine*, NS III, 5, August 1963, pp. 38–42.

Melville, Robert, 'Nebuchadnezzar', in *New Statesman*, 25 April 1969.

Millar, Ron, 'Boyd then and now', in *The Herald*, Melbourne, 1982.

Missingham, Hal, Introduction to catalogue of Sidney Nolan retrospective exhibition (paintings 1937–67), Sydney, 1967.

Mollison, James, 'Arthur Boyd', in *Art and Australia*, III, 2, September 1965, pp. 114–23.

Mollison, James and Bonham, Nicholas, *Albert Tucker*, Macmillan and Australian National Gallery, 1982, pp. 24–28.

Moore, Felicity St John, *Vassilieff and his art*, Oxford University Press, Melbourne, 1982.

Niall, Brenda, 'Martin Boyd', in *Australian Bibliographies*, ed. G. Johnston, Oxford University Press, Melbourne, 1977.

Oliver, Cordelia *see* Rosenthal, T. G.

O'Shaughnessy, Brian, 'Arthur Boyd, Painter of Ideas and People', in *Painter and Sculptor*, III, 4, Winter 1960–1, pp. 13–21.

Foreword to catalogue of Arthur Boyd retrospective exhibition, Whitechapel Art Gallery, London, 1962.

Philipp, Franz, 'On Three Paintings by Arthur Boyd', in *Present Opinion*, Melbourne University Arts Association, II, 1947, pp. 9–14

'Sculpture by Arthur Boyd', in *Quarterly Bulletin*, National Gallery of Victoria, IX, 1, 1955, pp. 3–4.

Arthur Boyd, Thames & Hudson, London, 1967.

Introduction to catalogue of 'Arthur Boyd's Australia', National Gallery of Victoria, Melbourne, 1970.

Plant, Margaret, 'The Extremes of Arthur Boyd', in *Dissent*, Spring 1964, p. 21f.

'Quattrocento Melbourne: Aspects of Finish, 1973–1977', in *Studies in Australian Art*, Department of Fine Arts, University of Melbourne, 1978, pp.99–111.

Read, Herbert, *Surrealism*, Faber & Faber, London, 1936.

Reed, John, 'Arthur Boyd, a personal reaction to his paintings and his career', in *Ern Malley's Journal*, I, 4, November 1954, pp.29–32.

Introduction to catalogue of 'The Formative Years, 1940–1945' (paintings by Arthur Boyd, Sidney Nolan, John Perceval and Albert Tucker), Museum of Modern Art of Australia, October–November, 1961.

'The Birth of the C.A.S. and some of the Aftermath', in broadsheet of the Contemporary Art Society of New South Wales, October 1963, pp.8–12.

Australian Landscape Painting, Longman, Melbourne, 1965.

Robertson, Bryan, Introduction to catalogue of 'Paintings by Arthur Boyd', Zwemmer Gallery, London, 1960.

Foreword to catalogue of 'Arthur Boyd, a Retrospective', Whitechapel Art Gallery, London, 1962.

Rosenthal, T.G., Introduction to catalogue of Arthur Boyd, Ceramic Paintings, Zwemmer Gallery, London, 1963.

'Arthur Boyd, the Australian Vision', in *Arts Review*, (London), XIV, 12, 30 June–14 July 1962, p.9.

Rosenthal, T. G. and Oliver, Cordelia, Introduction to exhibition catalogue, Richard Demarco Gallery, Edinburgh, 1969.

Smith, Bernard, 'Some Aspects of Contemporary Art in Australia', in *Education*, New South Wales Teachers Federation, Sydney, 22 February 1943, pp.85–6.

'The Antipodeans', in *Australia Today*, No. 55, 14 October 1959, pp.77–81 and 104.

'The Antipodean Manifesto', Foreword to the 'Antipodeans' Exhibition, August 1959, Victorian Artists' Society. Reprinted in *The Antipodean Manifesto, Essays in Art and History*, Oxford University Press, Melbourne, 1976, p.165f.

European Vision and the South Pacific. A Study in the History of Art and Ideas, Clarendon Press, Oxford, 1960.

'Image and meaning in recent Australian painting', in *The Listener*, 10 July 1962, pp.93–95. Reprinted in *The Antipodean Manifesto, Essays in Art and History*, Oxford University Press, Melbourne, 1976, p.41f.

Australian Painting 1788–1970 (2nd edn), Oxford University Press, Melbourne, 1971.

'Arthur Boyd', in *Hemisphere*, April 1972. Reprinted in *The*

Antipodean Manifesto, Essays in Art and History, Oxford University Press, Melbourne, 1976, p. 35f.

'Arthur Boyd', *The Oxford Companion to Twentieth Century Art*, ed. Harold Olsen, Oxford University Press, Oxford, 1981.

Tadgell, Christopher, *Arthur Boyd Drawings 1934–1970*, with a Foreword by Laurie Thomas, Secker & Warburg, London, 1973.

Merric Boyd Drawings, Secker & Warburg, London, 1975.

Thoene, Peter, *Modern German Art*, Penguin, London, 1938.

Ward, Peter, 'The Angry Young Penguins' in *Weekend Australian*, 3–4 October 1981, p. 3.

Whitelaw, Bridget, *Australian Drawings of the Thirties and Forties in the National Gallery of Victoria*, National Gallery of Victoria, Melbourne, 1980.

Yule, John, 'Merric Boyd', in *Modern Art News*, I, 2, 1959, p. 15.

Selected Exhibitions

Paintings of Yosl Bergner and Arthur Boyd. Rowden White Library, University of Melbourne, 1939.

Contemporary Art Society annual exhibitions: contributor to, 1942–1946 and 1954.

Paintings by Arthur Boyd and Keith Nichol. Athenaeum Gallery, Melbourne, 1944.

'Contemporary Art: Arthur Boyd, Sidney Nolan, Albert Tucker'. Rowden White Library, University of Melbourne, July 1946.

Retrospective exhibition. David Jones Gallery, Sydney, 1950.

Paintings. John Martin's Art Gallery, Adelaide, April 1951.

Paintings (landscape and religious themes). Stanley Coe Gallery, Melbourne, September 1951.

Ceramic paintings. Peter Bray Galleries, Melbourne, August–September 1952.

Paintings (retrospective exhibition). Peter Bray Gallery, Melbourne, September 1953.

Ceramic sculpture. Peter Bray Gallery, Melbourne, December 1954.

'A critic's choice', selected by Alan McCulloch, the *Herald* art critic. Australian Galleries, Melbourne, March 1958.

Allegorical paintings (the Bride series). Australian Galleries, Melbourne, April–May 1958.

Helena Rubinstein travelling Art Scholarship exhibition (the Bride series *et al.*). Art Gallery of New South Wales, August 1958.

The XXIX Biennale, Venice, August–September 1958.

Landscapes. Australian Galleries, Melbourne, April 1959.

'Antipodeans' (Charles Blackman, Arthur Boyd, John Brack, Bob Dickerson, John Perceval,Clifton Pugh). Victorian Artists' Society, Melbourne, August 1959.

Paintings (mainly the Bride series). Zwemmer Gallery, London, July–August 1960.

'Recent Australian Painting'. Whitechapel Art Gallery, London, June–July 1961.

'The Formative Years, 1940–1945' (paintings by Arthur Boyd, Sidney Nolan, John Perceval and Albert Tucker). Museum of Modern Art and Design, Melbourne, October–November 1961.

Retrospective exhibition. Whitechapel Art Gallery, London, June–July 1962.

'Australian Painting: Colonial, Impressionist, Contemporary'. Tate Gallery, London, January–March 1963.

Recent paintings and etchings (*Nude with Beast* series). Australian Galleries, Melbourne, March–April 1963.

'Australian Painting and Sculpture in Europe Today', organized by the Arts Council of Great Britain. New Metropole Art Centre, Folkestone, April 1963 (later sent to Germany and Holland).

Ceramic paintings. Zwemmer Gallery, London, October 1963.

Retrospective exhibition. Art Gallery of South Australia, Adelaide Festival, March 1964.

Decorative objects and ceramic paintings. Bear Lane Gallery, Oxford, March–April 1964.

Drypoints, etchings and ceramic paintings. Bear Lane Gallery, Oxford, April 1964.

'You Beaut Country', Australian Landscape Painting 1837–1964. National Gallery of Victoria, October–December 1964, and The Museum of Modern Art and Design (sponsored by the National Gallery Society of Victoria).

Programme on Commonwealth Verse called 'Voice and Verse'. Royal Court Theatre, London, 1965.

Pastels, Skinner Gallery, Perth Art Festival, Western Australia, February 1965.

Pastels (the St Francis series). Australian Galleries, Melbourne, July–August 1965.

Recent paintings from London (pastels). Bonython Art Gallery, North Adelaide, August–September 1966.

'Australian Painters 1964–66'. The Corcoran Art Gallery, Washington D.C., March–April 1967.

Nebuchadnezzar tapestry. Clune Galleries, Sydney, July 1967.

The Nebuchadnezzar series. The Johnstone Gallery, Bowen Hills, Queensland, July–August 1967.

Tapestries, paintings, pastels and drawings. South Yarra Gallery, Melbourne, September 1967.

Adelaide Festival of Arts Exhibition. (Nebuchadnezzar series, 44 items).
Bonython Art Gallery, North Adelaide, March 1968.

'The complete artist' (Nebuchadnezzar series, 58 items). Australian
Galleries, Collingwood, June–July 1968.

Retrospective exhibition of paintings, drawings and other works. Richard
Demarco Gallery, Edinburgh, April–May 1969.

Tapestries, pastels and drawings. Hamet Gallery, London, October–
November 1969.

Oils, etchings and drypoints (the Potter series). The Johnstone Gallery,
Bowen Hills, Queensland, August 1969.

Recent paintings (13 Nebuchadnezzar and 8 Potter paintings). Arthur
Tooth & Sons, London, October–November 1969.

Lithographs, etchings and engravings (St Francis, Potter, Bert Hinkler and
other subjects). Maltzahn Gallery, London, October–November 1969.

6 Nebuchadnezzar tapestries. South Yarra Gallery, Melbourne, April 1970.

Paintings, drawings and etchings (Nebuchadnezzar, *Lysistrata*, Potter, Bert
Hinkler and other themes). Skinner Galleries, Perth, Western Australia,
1970.

'Arthur Boyd's Australia' (23 paintings 1936–1968). To mark the Cook
Bicentenary and the visit of Her Majesty the Queen and the Royal family to
Australia. National Gallery of Victoria, Melbourne, April–May 1970.

Paintings, ceramics, graphics and tapestries. Melville Hall, the Australian
National University, Arts Council of Australia, October 1971.

Retrospective. Skinner Galleries, Perth, Western Australia Festival of
Perth, 1972.

Graphic work. Municipal Gallery of Modern Art, Dublin, December 1972.
Arranged by the Australian Embassy and AN Chomhairle Ealaíon, The
Arts Council.

Recent paintings (Shoalhaven Riverbank). Fischer Fine Art Ltd, London,
May–June 1973.

Drawings and etchings for *Jonah*. Australian Galleries, Melbourne,
February 1974.

Shoalhaven River (small landscapes on copper). 20th Anniversary
Exhibition of Australian Galleries, Melbourne, June–July 1976.

Recent paintings (Narcissus). Fischer Fine Art Ltd, London,
February–March 1977.

Narcissus paintings and others. Galleri Fabian Carlsson, Göteborg, Sweden, April 1977.

Paintings 1972–73 (Shoalhaven subjects). University Art Gallery, University of Melbourne, August 1977.

'The Heroic Years of Australian Painting, 1940–1965'. Sponsored by *The Herald*, Melbourne, in conjunction with the Victorian Government, April–August 1977.

The *Lysistrata* series (20 etchings, 1970). Wagner Gallery, Sydney, September 1977.

Paintings from London (Shoalhaven and Narcissus subjects). Bonython Art Gallery, Adelaide, November 1977.

The Lady and the Unicorn etchings. Tolarno Galleries, Melbourne, November 1977.

Seven lithographs. Barry Stern's Exhibition Gallery, Paddington, Sydney, 1977 or 1978.

Paintings, drawings and ceramics (Shoalhaven Riverbank, Narcissus *et al.*). Rudy Komon Art Gallery, Sydney, June–July 1978.

Shoalhaven River paintings and graphics. The Lister Gallery, Perth, Western Australia, May–June 1979.

St Francis tapestries. The Great Hall, National Gallery of Victoria, Melbourne, August 1979.

Shoalhaven Riverbank and others. Australian Galleries, Melbourne, August 1979.

'Australian Drawings of the Thirties and Forties in the National Gallery of Victoria'. National Gallery of Victoria, Melbourne, 1980.

Paintings (skates *et al.*). Bonython Art Gallery, Adelaide, Festival of Arts Exhibition, March 1980.

Recent paintings (skates and Shoalhaven landscapes). Fischer Fine Art Ltd, London, March–April 1980.

The Joseph Brown Collection. National Gallery of Victoria, Melbourne, October–December 1980.

Paintings. Australian Galleries, Melbourne, September–October 1981.

Paintings. Australian Galleries, Melbourne, September 1981.

Paintings. Rudy Komon Art Gallery, Sydney, November–December 1981.

Retrospective exhibition. Arts Centre, New Metropole, The Leas, Folkestone, Kent. November 1980–January 1981.

'Modernism, Murrumbeena and Angry Penguins'. Nolan Gallery, Lanyon Homestead, November 1981–March 1982.

Landscapes and portraits 1934–48, bronze castings of four ceramic sculptures 1935–54 and paintings October 1982. Australian Galleries, Melbourne 1982.

'The Artist and the River'. Lister Gallery, Perth, Western Australia, 1983.

Recent work. Fischer Fine Art Ltd, London, October–November 1983.

Narcissus; etchings and aquatints to Peter Porter's poem. State Theatre Gallery, Victorian Arts Centre, Melbourne, March 1985.

Paintings and etchings. Holdsworth Galleries, Woollahra, Sydney, May 1985.

'Seven persistent images'. Australian National Gallery, Canberra, June 1985 (touring exhibition).

Recent paintings. Australian Galleries, Melbourne, July 1985.

List of Plates

241

93 *Daniel with bound arms and*
 Nebuchadnezzar on fire 1966–9
 Oil on canvas 175.9 × 183.5 cms
 Formerly private collection, Melbourne

94 *Seated Nebuchadnezzar and crying lion*
 1966–9
 Oil on canvas 175.9 × 183.5 cms
 Private collection, Canberra

95 *Potter's House at Murrumbeena* 1964–7
 Oil on canvas 114.3 × 109.2 cms
 Private collection, Sydney

96 *Potter's Wife in Garden at Murrumbeena*
 1964–7
 Oil on canvas 114.3 × 109.2 cms
 Private collection, Brisbane

97 *Potter Drawing a Brown Cow in the*
 Suburbs 1967–8
 Oil on canvas 114.3 × 109.2 cms
 Private collection, Sydney

98 *Potter Drawing by the Sea* 1967–8
 Oil on canvas 109.2 × 114.3 cms
 Private collection, Melbourne

99 *Potter's Wife, Horse and Trap (Rosebud)*
 1969–70
 Oil on canvas 183 × 175.3 cms
 University of Western Australia, Perth

100 *Potter's Wife Decorating a Pot* 1967–9
 Oil on canvas 114.3 × 109.3 cms
 Owner unknown

101 *Potter and Wife on Beach at Arthur's*
 Seat 1968–9
 Oil on canvas 109.2 × 228.6 cms
 Private collection, Melbourne

102 Piero di Cosimo (*c*.1462–after 1515)
 A Mythological Subject
 Oil on wood 65.4 × 184.2 cms
 National Gallery, London

103 *Nude over Pond c*.1962
 Watercolour 40 × 58.5 cms
 Australian National Gallery, Canberra

104 *Figure Washing* 1961
 Charcoal, mounted 154.5 × 197 cms
 Australian National Gallery, Canberra

105 *Europa and the Bull* 1961–2
 Charcoal 132 × 127 cms
 Australian National Gallery, Canberra

106 *Nude Floating over a Dark Pond II* 1962
 Oil on board 48 × 60 cms
 Arts Council of Great Britain

107 Titian (Active before 1511, died 1576)
 The Death of Actaeon
 Oil on canvas 178.4 × 198.1 cms
 National Gallery, London

108 *Nude with Beast III* 1962
 Oil and tempera on board 160 × 183 cms
 Australian National Gallery, Canberra

109 *White Joined Figures* (used for *Electra*
 backdrop) 1962–3
 Etching and aquatint 35.5 × 40.6 cms

110 *Double Figure with Shark Head and Horns*
 (used for *Electra* backdrop) 1962
 Etching and aquatint 30.5 × 40.6 cms
 Australian National Gallery, Canberra

111 *Head in Cup with Crying Head* 1962–3
 Etching and aquatint 30.5 × 40.6 cms
 Australian National Gallery, Canberra

112 Clytemnestra, costume design 1962–3
 Ink and watercolour 51 × 63 cms
 T. G. Rosenthal, London

113 Nadia Nerina and David Blair in Robert
 Helpmann's ballet *Electra* 1963
 The Photo Source – Keystone

114 Costume drawing for *The Eumenides*
 (Electra) 1962–3
 Ink and watercolour 51 × 63 cms
 T. G. Rosenthal, London

115 *Mariner Spearing Bird* (Ancient
 Mariner) *c*.1967
 Ink 51 × 63 cms
 Australian National Gallery, Canberra

116 *Potter in Armchair Painting a Pot c*.1967
 Ink 51 × 63 cms
 Australian National Gallery, Canberra

117 *Flowered Head with Coffin and Pot with*
 Landscape Decoration c.1967
 Ink and wash 51 × 63 cms
 Australian National Gallery, Canberra

118 *Potter Emerging from Smoking Kiln with*
 Wheel and Dog c.1967
 Ink and wash 51 × 63 cms
 Australian National Gallery, Canberra

119 *Potter Looking at Chardin Print* 1969
 Oil on canvas 122 × 91 cms
 Australian National Gallery, Canberra

120 *Potter – Artist's Father in Armchair with*
 Pot and Bust 1969
 Oil on canvas 76 × 61 cms
 The artist

121 *Lovers Suspended over a Dark Pond*
 1966–9
 Oil on canvas 109 × 114.3 cms
 Private collection

122 *Men Carrying Firebrands (Lysistrata)*
 1971
 Etching and aquatint 35 × 40 cms

123 *Riverbank* 1972
 Oil on canvas 58.4 × 86.4 cms
 Australian National Gallery, Canberra

124 *Figure by a Creek* 1972
 Oil on canvas 114.3 × 109.2 cms
 Australian National Gallery, Canberra

161 *The Hunters Set Out to Trap the Unicorn*
1973–4
Etching and aquatint, sheet size
79.4 × 57.1 cms
National Gallery of Victoria, Melbourne

162 William Blake
The Stygian Lake – from illustrations to
Dante's *Divine Comedy* 1824–7
Watercolour 49.5 × 33.6 cms
National Gallery of Victoria, Melbourne

163 *Eyes Reflected (Narcissus)* 1976
Oil on copper 21.5 × 30.5 cms
Private collection, Sweden

164 *Narcissus with Cave and Rock Orchid*
1976
Oil on canvas 152.3 × 122 cms
National Gallery of Victoria, Melbourne

165 von Guérard, Eugen (1811–1901)
Head of the Mitta Mitta, Eagle's View
Oil on board 38.8 × 48.8 cms
State Library of Victoria, Melbourne

166 Piguénit, William Charles (1836–1914)
Flood in the Darling 1890
Oil on canvas 1225 × 1993 cms
Art Gallery of New South Wales, Sydney

167 *Ventriloquist and Skate* 1979–80
Oil on canvas 152.4 × 121.9 cms
The artist

168 *Mackerel* 1979–80
Oil on canvas 43.2 × 61 cms
Private collection, Melbourne

169 *Flower-headed Figure Holding Fish* 1942
Ink 29 × 26 cms
Australian National Gallery, Canberra

170 *Old Woman from the Sea* 1971
Etching and drypoint 30.3 × 25.1 cms
Australian National Gallery, Canberra

171 *The Return of the Prodigal Son* 1946–7
Oil on canvas 25 × 31 cms
Private collection, Melbourne

172 Rembrandt (1606–69)
Julius Civilis (detail from *The Conspiracy
of the Batavians*) 1661
Oil on canvas
National Museum, Stockholm, Sweden

173–8 *Narcissus*
Etching and aquatint, plate size
60.3 × 42.5 cms
Editioned by Mati Basis, London, 1983

173 Introduction: '. . . rage of revolution'

174 Narcissus Loses his Love: 'Hell,
hanging on . . .'

175 The Painter's Banquet: 'Little Andrea
has drawn a sheep . . .'

176 Narcissus among the Anthropologists

177 Echo's Answers: '. . . unbuckling the
ripples from his oar'

178 The Narcissus Emblems: '. . . eaten
myself off the water's top'

179 *Trout in Dish and Pointing Figure* 1979–80
Oil on canvas 122 × 152 cms
Private collection, Melbourne

180 *Budgong Creek Rocks* 1978
Oil on board 28 × 35 cms
The artist

181 *A Pond for Narcissus with Lilly-Pilly
Trees* 1978
Oil on hardboard 29.5 × 20.5 cms
The artist

182 Maquette for tapestry *The Return of the
Prodigal Son* 1979
Oil on board 61 × 51 cms
Private collection, Perth

183 *The Princess of the Shoalhaven* 1978
Oil on canvas 152 × 122 cms
Private collection, Melbourne

184 *Picture on the Wall, Shoalhaven* 1979–80
Oil on canvas 182.9 × 175.2 cms
The artist

185 *Colonial Poet under Orange-Tree* 1979–80
Oil on canvas 152.4 × 121.9 cms
Private collection, New York

186 *Skull-headed Creature over Black Creek*
1979–80
Oil on canvas 151 × 122 cms
The artist

187 *Horse's Skull, Blanket and Starry Sky*
1981
Oil on canvas 183 × 175 cms
The artist

188 *The Stoat* 1981
Oil on Board 122 × 91 cms
Private collection, Sydney

189 *Trees I–IV* c.1979
Oil on canvas 152.4 × 121.9 cms
Private collection, England

190 *Shoalhaven Riverbank and Rocks* 1978
Oil on canvas 120 × 90 cms
Private collection, Melbourne

191 *Shoalhaven Riverbank and Large Stones*
1981
Oil on canvas 152.4 × 122 cms
Private collection, Melbourne

192 *Reflected Rock and Riverbank* Winter 1981
Oil on canvas 152.2 × 122 cms
Joseph Brown, Melbourne

193 *Waterfall in the Shoalhaven Valley* 1982
Oil on canvas 152.5 × 122 cms
Eva and Marc Besen, Melbourne

194–7 *Four Times of Day* 1982
Oil on canvas 122 × 152 cms
The artist

194 *Early Morning, before Sunrise, Pulpit
Rock*